A JOURNEY INTO CHRISTIAN ART

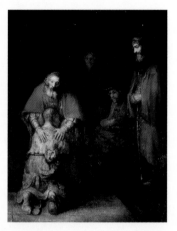

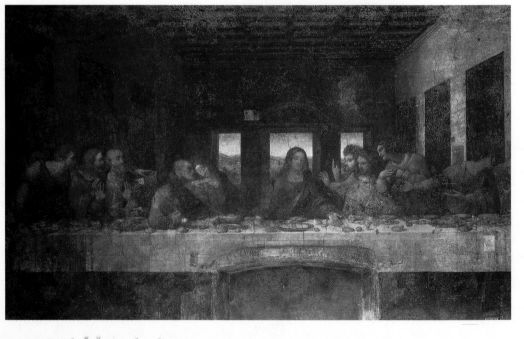

To Franco
With love
and gratitude

A Journey into Christian Art

HELEN DE BORCHGRAVE

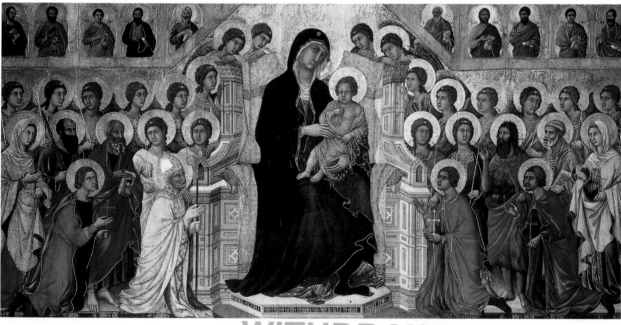

FORTRESS PRESS / MINNEAPOLIS

First Fortress Press edition 2000
Copyright © 1999 Helen de Borchgrave. This edition
published in cooperation with Lion Publishing, Oxford,
England. All rights reserved. Except for brief quotations
in critical articles or reviews, no part of this book may be
reproduced in any manner without prior written permission
from the publisher. Write to: Permissions, Augsburg Fortress,
Box 1209, Minneapolis, MN 55440.

Scripture translations are from the Revised Standard Version
of the Bible, copyright © 1946, 1952, and 1971 by the
Division of Christian Education of the National Council of
Churches of Christ in the United States of America, and are
used by permission.

ISBN 0-8006-3240-0

Acknowledgments
I would like to acknowledge my thanks to the following, who
have helped to make this book possible: my parents, who
imbued a love of culture at an early age; Eva Glenn Johnston,
Dennis Ramsay, and the late Professor Helmut Ruhemann who
generously shared their erudition and expertise; Father Billy
Baldwin OSA, Father James Naters SSJE, The Reverend Bill
Scott and assisting clergy at St Mary's Church, Bourne Street,
Gwenda Hordern, Penny Brodie, Caddie Doulton, and many
other supportive Christian friends who have patiently helped
me along the way of faith; Dr Brian Horne for theological
advice; Dr Peter Cannon-Brookes for art historical advice;
Henry Hely-Hutchinson for literary advice; my sons Rupert
and Simon for technical help; and David Wavre who suggested
the book in the first place.

Printed and bound in Indonesia AF 1-3240
05 04 03 02 01 00 1 2 3 4 5 6 7 8 9 10

Contents

Introduction

'God created man in his own image,' we are told in the first chapter of Genesis. And from the dawn of time, people have worshipped deities that were carved or painted in their own likeness. Only the Jews — then Muslims and, later, strict Protestants — did not, for their religious laws forbade graven images. Imagery was restricted to words, and as a result the Old Testament is rich in poetic literature.

But then God became man in the form of Jesus Christ. He was born in Palestine, of the Jewish people, but into the Graeco-Roman world. His cradle was the *Pax Romana* accomplished by Emperor Augustus. Jesus also brought peace, but it was not a peace of this world. And he brought the uncompromising love of the creator which the world finds so difficult to recognize and receive. He was sentenced to death by the Roman procurator on trumped-up charges and suffered the hideous humiliation and agony of dying on a cross — for love. It was not the end but the completion of the beginning. Jesus' resurrection and ascent into heaven heralded a new era of salvation through faith in him.

After the Day of Pentecost, when the Holy Spirit, the third person of the Trinity, set alight the followers of Christ, the gospel, or good news about salvation through Christ, was spread abroad. St Paul brought the Christian faith to the non-Jewish world on several journeys along the Roman roads. Like other New Testament writers he uses metaphors to illuminate his message. Hence, in his letter to the church at Corinth, Paul describes our bodies as 'a temple of the Holy Spirit within you' (1 Corinthians 6:19). In the letter to the Hebrews, the author writes, 'let us run with perseverance the race that is set before us' (Hebrews 12:1). Idol worship and sport absorbed the people then as now.

It was, therefore, quite natural for the early Christians to use the art forms of the classical world in the service of the gospel: to express their passionate inner convictions, as

visual aids to a deeper understanding of the faith, and to transform them into places of worship. A Christian iconography rapidly developed.

St Clement of Alexandria (c.150–c.215) paved the way. He emphasized the relevance of Greek philosophy to Christian thought and reminded the church of its Master's delight in the beauty of the world. He argued that, if our eyes are opened by the grace of God, we can see that everything in creation has been purified by the incarnation – God's birth as man – except sin. This idea enabled Christian artists to understand the value of cultivating beauty for the enrichment of the mind and the nourishment of the soul.

The church put down its roots in the *Pax Romana*. Consequently, when barbarians overran the crumbling empire, and Europe entered the so-called Dark Ages, the church had the strength to stand. St Gregory the Great averted the threat of iconoclasm at the end of the sixth century by stating, 'Painting can do for the illiterate what writing does for those who read.'

The way forward was clear for Christian artists and craftsmen. As the centuries unfolded, the story of Western art unrolled in a seamless theme of Christianity – until the Renaissance rediscovered man, science blew away mystery, the Reformation split the church, and the Age of Enlightenment ushered in a darkness of the soul.

This book is not a comprehensive history of Western Christian art, for the popularity of biblical subjects has attracted too wide a range of artists; it is a tour of Christian art through two millennia. We visit churches and museums and see how the fusion of Christianity and art has produced sublime paintings and sculptures in a rich variety of styles. We glimpse, through the work of artists of faith, reflections of the spiritual and cultural climate of their day. Some, such as Michelangelo, are among the greatest geniuses the world has ever seen; others are virtually unknown. Yet, whether experiencing persecution or

spiritual revival, war or peace, political repression or freedom, they have all been inspired by the person and message of Christ and his church to make visible the invisible in mosaic, paint and stone; to enrich the mind, touch the heart, and feed the soul.

This richness of life is in danger of death in our contemporary culture of facts and figures, where time is money, speed drives us, and noise blocks out the inner voice. This book has been written in the hope that it will stir the imagination, encourage contemplation, and stimulate wonder and praise to 'Ponder anew all the Almighty can do.'

CHAPTER I

The Image of Christ

Who shall separate us from the love of Christ? Shall tribulation, or
distress, or persecution, or famine, or nakedness, or peril, or sword?...
No, in all these things we are more than conquerors through him who
loved us.
Romans 8:35, 37

The three crudely painted figures seem to be dancing on the wall. They raise their arms and stretch out their hands to praise God as smiles light up an inner vision of his presence with them. Fear is a distant memory, and they are oblivious to the intolerable heat, for they have absolute faith in the one true God who protects them from evil. They have been thrown into the fiery furnace, yet flames do not singe one hair of their heads or leave even a whiff of smoke upon their clothing. The three figures are Shadrach, Meshach and Abednego who had refused to bow down and worship the golden image King Nebuchadnezzar raised up in the plains of Babylon. Yet, instead of being reduced to ashes, they walked out from the furnace unharmed, and in astonishment and awe the king decreed all must honour the God of Israel.

Such proclamations of faith, painted on the walls of the subterranean passages in the catacombs of Rome to sustain those who took refuge there, are among the earliest-known examples of Christian art. Their childlike simplicity beckons us back to those rough and ready days when Christianity was despised and even feared by the pagan authorities, when the faithful were completely detached from worldly values and preferred to die than betray their Lord by worshipping the emperor.

The early Christians were a powerful force despite their lack of power, 'having nothing, and yet possessing everything', as St Paul wrote to the Corinthians (2 Corinthians 6:10). They had known Jesus or those close to him, and their hope in him was stronger than their fear of death. Very soon the young church became highly organized under the leadership of its bishops. Inevitably this was considered dangerous to the stability of the empire, and when a fire broke out in Rome in AD64, Emperor Nero blamed the Christians. The blood of many martyrs was spilt including that of St Peter, who was crucified upside down. The historian Tacitus was an eyewitness. He left a vivid picture of the persecution:

They were dressed in the skins of wild animals to be torn to death by dogs; they were fixed to crosses or condemned to the flames; and when the daylight failed, they were burned to give light by night.

Roman law relating to burial was precise and compassionate. Bodies, even of criminals and martyrs, were handed over to relatives or friends – hence Pontius Pilate's immediate assent to Joseph of Arimathea's request for Christ's body. For health reasons, interment took place outside the city walls and burial grounds were considered sacred.

The first Roman Christians were buried along the Appian Way at Catacumbas. The soft volcanic tufa rock was easily worked, and a vast network of passages up to six levels deep was excavated, with recesses in the walls for bodies and larger spaces for family vaults, martyrs or bishops. The words 'rest' and 'sleep' were scratched everywhere in these cemeteries ('cemetery' derives from *koimeterion*, the Greek word for sleeping place) for death was merely a rest that would end in resurrection and eternal life.

By the beginning of the fourth century, when the killing times reached their crescendo under Emperor Diocletian, as many as six million Christians had been buried in fifty catacombs arranged in a circle around the city. The tortuous passages had become good meeting places – places where the faithful could preach the gospel and celebrate the eucharist, or Lord's Supper, in secret.

How dark and frightening those maze-like tunnels must have been, and still are – even with electric lights and a tourist guide. When he was a boy St Jerome used to wander through the crypts on Sundays with his friends. 'Everything is so dark that the words of the prophet are most fulfilled: "they descend alive into hell",' he wrote. What grace those faithful people were given; how the light must have shone in that dreadful darkness.

In those desperate times Christians needed reminders of the fundamental doctrines of their faith, especially reassurance that death was not the end. Painting was the most immediate method of passing on the message. Pagan artists painted landscapes, gardens and flowers on the walls of Roman houses. Christians transformed these subjects from mere decoration into celebrations of God's creation, showing the cycles of life and glimpses of paradise. By the second century, the first illustrations of Bible stories appeared and some can still be seen, such as those in the catacombs of St Priscilla and St Domitilla.

Wall-Paintings in the Catacombs of Rome

The wall-paintings in the catacombs were primitive, both in expression and execution. This was not art for art's sake, but art for inspiration and instruction – symbolism to underline Christian doctrine. These little illustrations of truth can be found scattered around. Although a second-century Noah wears Roman dress and a laurel wreath on his head, he stands in what is little more than a plain box with his arms outstretched in prayer. A dove flies towards him bearing an olive twig. There are no animals or members of Noah's family

in the ark to distract attention from the lesson: as God delivered Noah from the flood, so through the cross he saves believers from everlasting death. Isaac, obediently carrying a heavy pile of wooden stakes to the place Abraham points out for his sacrifice, was perceived as a forerunner of Christ. The picture of Moses striking water from the rock reminded Christians that as God provided water in the desert for the fleeing Israelites, he now blesses his people through the water of baptism. The images of mother and child reminded them of the incarnation.

Jesus Christ was portrayed on the walls of the catacombs as a fish, a vine or a lamb. Fish were historically linked with the miracle of the loaves and fishes, and with the apostolic vocation to become 'fishers of men'. The letters of the Greek word for fish, *ichthus*, stand for 'Jesus Christ, Son of God, Saviour', and the sign therefore became a logo for the faith, carved on gravestones and on walls. The vine was for Jesus a symbol of the union between himself and his people, and a memorial of his passion.

They were probably not trained artists, yet how ardently those early Christians depicted the bare bones of their belief on these walls. Glass chalices were sometimes placed beside the body, within the tomb, until AD393 when the custom of burying the sacrament was forbidden. There are hundreds of these glasses in the Vatican Museum, and they reveal the earliest-known portraits of St Peter and St Paul, engraved in gold leaf on the bases. Both men appear middle-aged and bearded. St Peter sports a fine head of curly hair, while St Paul is almost bald, and they have been portrayed thus by artists ever since. Words of faith such as *Vivas in Deo* and *In pace Christi* ('Alive in God' and 'In the peace of Christ') were inscribed on the lids of sarcophagi. Perfumes were kept burning to sweeten the damp air.

While the early Christians expressed the passion of their faith in simple paintings, there

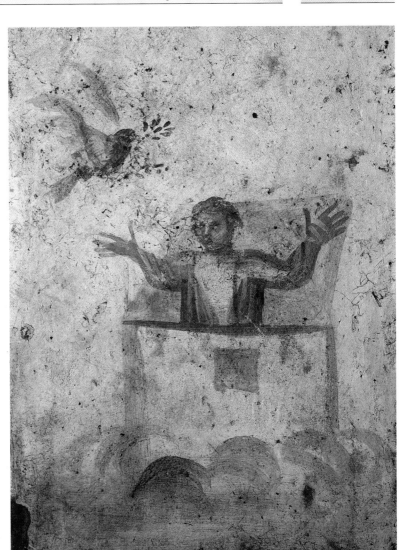

Noah and the Dove (300–500), Catacombe dei San Marcellino e San Pietro, Rome.

were no pictures of the passion – Christ's suffering and death on the cross – in the catacombs. The allegory of Jonah spewed out of the mouth of the whale after three days in its belly, the raising of the dead Lazarus, and Jesus enthroned in glory with the apostles, were the closest allusions made. Crucifixion was so degrading that only slaves and non-Romans were punished in this way. This atrocious form of torture was abolished by Emperor Constantine, after AD313, as part of his pro-Christian policy. Painted crucifixes did not appear until after the first millennium, when they became the most powerful and the most frequently painted symbol of the faith.

The Good Shepherd *(before 314)*

Sculptures of Christ from the catacombs portray him as the good shepherd. There is a beautifully carved example in the Lateran Museum in Rome – *The Good Shepherd*. At first sight this clean-shaven, curly haired, handsome young man in Greek dress could be Apollo the god of light, or David the shepherd boy. He carries a lamb on his shoulders, but this is not why we recognize him to be Jesus. Despite the perfect, pagan classical proportions, not to be seen again in Western Christian art until the Renaissance, holiness vibrates from this figure. This is the good shepherd, who laid down his life for his sheep, and the inanimate stone seems to have been mystically transformed by the burning faith of its sculptor.

When Christianity became the state religion at the end of the fourth century, the catacombs were still being used as burial grounds. When Rome was sacked by barbarians a hundred years later, church laws forbidding the removal of remains were relaxed. Cartloads of bones were transported into the safety of city churches, and most of the catacombs were neglected and then forgotten. Only in 1578, when a farmer was digging in his vineyard and inadvertently forced a way through, was the innocent beauty of the early faith exposed to the light.

The Greek Influence

The development of Christianity owes much to the language, philosophy and art of ancient Greece. The Greeks' spiritual quest relied on reason rather than law, on clarity of mind and order. 'In the beginning was the Word,' wrote St John (John 1:1); and *logos* is Greek for 'word' or 'reason'.

As another John has clarified:

Faith and Reason are like two wings on which the human spirit rises to the contemplation of truth; and God has placed in the human heart a desire to know the truth – in a word, to know himself – so that, by knowing and loving God, men and women may also come to the fullness of truth about themselves (Pope John Paul II, *Faith and Reason*).

During the 'Golden Age' of Athens in the fourth century BC, three great philosophers uncovered elements of truth which were to affect Christianity profoundly. The humble Socrates, who said, 'One thing I know, and that is that I know nothing,' encouraged people to work out the meaning of life by asking endless questions. When he was unjustly executed in 399BC, his disciple Plato wrote down his experiences. Socrates revealed the faith behind his fervour as he explained to his judges:

The Good Shepherd (before 314).

> I owe a greater obedience to God than to you; and so long as I draw breath and have my faculties, I shall never stop... trying to persuade you, young and old, to make your first and chief concern not for your bodies nor for your possessions, but for the highest welfare of your souls, proclaiming as I go: 'Wealth does not bring goodness, but goodness brings wealth and every other blessing, both to the individual and to the State' (Plato, 'The Apology', *The Last Days of Socrates*).

Plato believed man consisted of a mortal body and an immortal soul, and that we live this life in the shadows of eternal reality. St Paul described this as, 'now we see in a mirror dimly, but then face to face' (1 Corinthians 13:12). Aristotle looked beyond the world of ideas to the natural world around him, and he was the first to study and classify creation – from the simplest growth to God, the 'prime mover'.

This search for truth lifted the Greeks beyond the fears and darkness of primitive societies, enabling reason to prepare the way for revelation. When the moment arrived for that unique intersection of time and eternity when God became man, many Greeks were ready to receive his message. The ancient Greeks also discovered that beauty is a vital element of religion. They realized that magnificent buildings encourage praise, and draw the receptive mind towards the unseen and eternal.

The Roman Influence

When Christianity became the state religion, there were mass converts throughout the empire, from Rome to Jerusalem, Antioch to Alexandria. The moral supremacy of the bishop of Rome was recognized, and Latin took over from Greek as the language of the Western church. Although Christians wanted to obliterate all signs of pagan life by smashing statues and destroying temples, Latin civilization was saved from ruin. It was

incorporated into the church, just as earlier the Romans had taken the best from ancient Greece. The Roman basilica, for example, became the archetypal church. Designed for public assembly as an enclosed market place or a law court, the rectangular layout could be converted easily into a nave, and the apse (where the chairman or judge had sat on a dais) was perfect for the altar and choir.

Classical architecture was baptized into the faith, which it still dignifies today. As Julian, the apostate emperor, complained, 'The Galilean has conquered.'

The Byzantine Influence

The first challenge to Christian creativity took place in an eastern setting. In AD330 Emperor Constantine transferred his capital from Rome to Byzantium, the ancient Greek city state on the Bosphorus. He renamed the city Constantinople and dedicated it to the Virgin Mary. The western half of the empire was soon to be overrun by the barbarian Ostragoths, but Constantinople remained the heart of the eastern empire for more than a millennium. Although Rome's artistic tradition was largely borrowed from Greece, Byzantium was also heir to the ancient cultures of Egypt, Mesopotamia, Persia and Asia Minor. The cross-fertilization of Oriental and Graeco-Roman art forms gave birth to the distinctive style known as Byzantine.

The Rise of Mosaic

The ancient Greeks developed mosaic work into a sophisticated and elaborate art which became more popular than painting as a form of ornamentation. The Romans spread the skill across the empire – from North Africa to the Black Sea, from Asia to Spain – and floor mosaics became so popular in patrician, or noble, homes that Diocletian introduced a price scale for mosaicists.

Set into the walls of churches, mosaics were transfigured. In Constantinople, Ravenna, Rome, Venice and, later, Sicily, this became one of the most successful and effective uses of a medium in the history of art. And, by sticking to ancient models, the Byzantine church preserved the ideas and achievements of Greek art in the depiction of drapery, faces and gestures, in the modelling of light and shade, and in the principles of foreshortening.

Mosaics are created from small *tesserae*, cubes of coloured glass, stone or marble embedded in plaster. In Constantinople, gold leaf trapped between layers of transparent glass was introduced to produce an overall gold background. Each *tessera* is embedded at a slightly different angle to its neighbour and, together, they vibrate in the light like cut diamonds, giving a unique richness of surface and an intensity beyond that of any pigment.

This is apparent in *Sheep Caressed by Moses*. Mosaic is an unbending medium. It produces a pure image of thought uncluttered by subtleties. Laid into large expanses of wall, it becomes an integral part of the building – and in Ravenna, it was virtually the only part that was not taken away by Lombards, iconoclasts, or Charlemagne. Mosaics have to be seen in person to be experienced. Unlike frescoes or easel paintings, they cannot be adequately reproduced.

Ravenna and Classe

Rare relics of the Byzantine age still exist in Ravenna in central Italy. A meeting point for the western and eastern Christian worlds, Ravenna has left us extraordinarily rich and beautiful mosaics which were created under Latin, Gothic and Greek emperors. They reflect the universality of the gospel.

Ravenna was an unassuming town built on several small islands near the sea. Greatness was thrust upon her. Julius Caesar assembled his troops in Ravenna before crossing the Rubicon to take Rome and, after defeating Mark Anthony, Caesar Augustus founded the naval harbour of Classe nearby. For several centuries, until superseded by Venice, this was one of the most important harbours in the western Mediterranean. Two hundred and fifty ships could lie in her waters, and through this port Christianity reached Ravenna, to where St Apollinaris came from Antioch, founded the bishopric, and developed a cosmopolitan community.

Ravenna's artistic significance began when the imperial court moved there in AD402 after Emperor Honorius fled from Milan, rightly fearing an invasion of Italy by the Visigoths. Ravenna remained the royal residence for 300 years.

Mosaics in the churches, baptistries and mausoleums of Ravenna and Classe create a harmonious and poetic picture of the gospel message through the Old and New Testaments. They are still fresh and immediate in their impact. They glorify the Trinity and celebrate perfect peace between God, humans, angels, animals and nature – creator

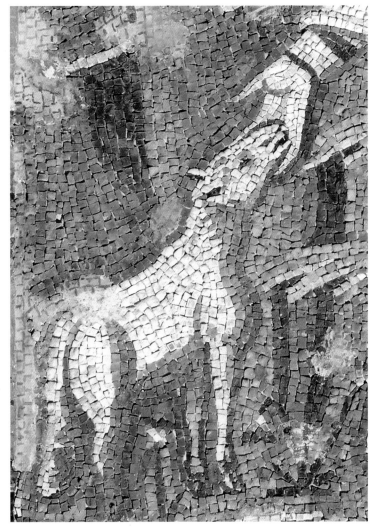

Sheep Caressed by Moses, (detail) Basilica of San Vitale, Ravenna (c.500–600).

and created in a continuous refrain of beauty and joy. Vaults are patterned with peacocks, partridges and doves; paradise is glimpsed in landscapes and garlands as another dimension beyond balustrades and altars. Emperor and empress, and their court, glitter with fine jewels and brocaded silks in the dignified style of Oriental potentates.

Mausoleo di Galla Placidia (c.425–50)

After the sunshine, your eyes take time to adjust as you enter the little mausoleum of Galla Placidia in Ravenna. The interior, built in the shape of a Latin cross, is dimly lit by small windows paned with alabaster. Everything above eye level is bathed in a deep, tranquil blue. Gradually golden stars appear – not dotted about, as in the night sky, but touching each other in one concentric circle after another until they enclose a golden cross in the centre of the dome. Squaring the outer edges are golden symbols of the four evangelists, the ox, the lion, the man, and the eagle, symbols which Christianity drew from Ezekiel's vision in the Old Testament. Below them the apostles, dressed like Roman senators, venerate the cross. At their feet pairs of doves quench their thirst at the fountain

The Good Shepherd, Mausoleo di Galla Placidia, Ravenna (c.425–50).

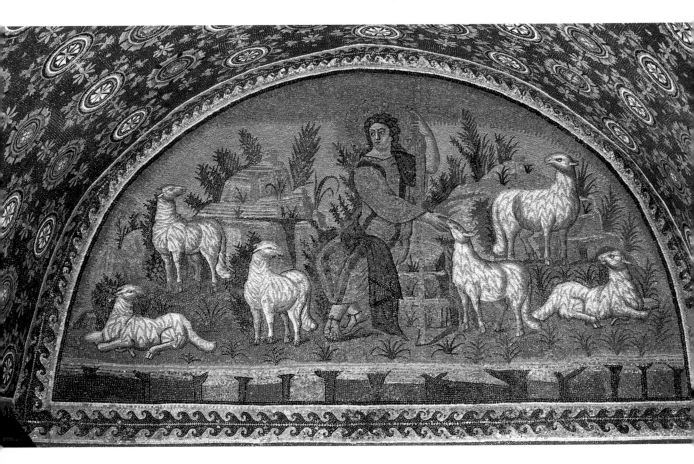

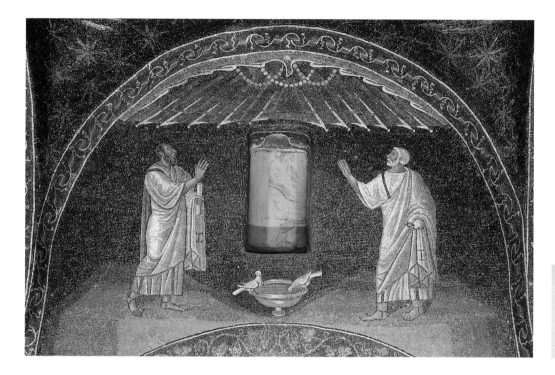

St Peter and St Paul,
Mausoleo di Galla
Placidia, Ravenna
(c.425–50).

of life. Golden vines, laden with fat grapes, wind their way around the arches, for Jesus said, 'I am the vine, you are the branches' (John 15:5).

Above the entrance the good shepherd sits on a rock in the company of six pure white sheep. They are not weighed down with wool, but are muscular with graceful, long legs and necks. As in the sculpture in the catacombs, here, in *The Good Shepherd*, Christ is personified as a calm, noble young man, clean-shaven with curly hair. He wears a golden tunic and purple mantle, and holds a golden cross. He stares out into the distance, as if lost in thought, yet is very present in the way his hand caresses a sheep. The good shepherd has been placed above the entrance to remind all who pass in and out that only through Christ can we find eternal life.

The mosaics in the Mausoleo di Galla Placidia are the oldest and most complete in Ravenna; they are the earliest major example of Christian art in Italy still in existence, and they date from the second quarter of the fifth century. The peace and serenity of the mosaics are in stark contrast to the emotional and political background in which they were formed. Soap operas pale into insignificance when Galla Placidia's tale is told. Like her father, Theodosius the Great, the Roman emperor who established Catholicism as the official religion in AD380, she was full of courage and character. By the time Alaric the Goth sacked Rome in AD410, her half-brother, Emperor Honorius, was safely ensconced in Ravenna. Eight hundred years had passed since Rome was last taken by a foreign foe and the shock was overwhelming, challenging preconceived ideas of the eternity of Roman power. The surviving pagans blamed the Christians, and Augustine, Bishop of Hippo in Numidia, wrote

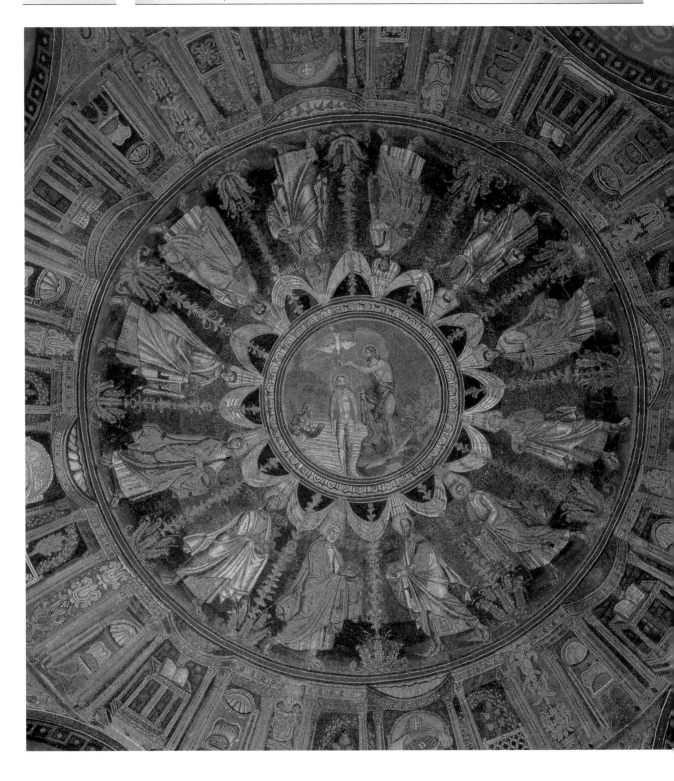

his classic book *City of God* to quash these ideas. He explained that the Roman empire was an historic phenomenon like any other state that came into being and passed away. The only permanent community was that of the church, visible and invisible: the city of God.

The widespread resettlement of barbarian peoples upset the delicate balances of order and economics, and devastated the western empire. Galla Placidia was captured and carried off from Rome to Narbonne in Southern France, and married to Alaric's successor, Ataulfo. The emperor's sister becoming queen of the barbarians sent shock waves throughout Roman society, but her experience was short lived. Ataulfo was killed and Galla Placidia, who was still a young woman, was sent back to Rome in exchange for several thousand cartloads of grain. She married a patrician Roman general and produced a son who soon inherited the throne as Valentinium III. Under Galla Placidia's regency Ravenna enjoyed twenty-five years of peace – relative peace, for the barbarian hordes that swept across Europe in droves from the east must have been a constant source of anxiety. When Galla Placidia's daughter became engaged to Attila the Hun, the gangs he sent to claim her wrought havoc on their way. The western empire finally expired in AD476 when the last Roman emperor, Augustus Romulus, was forced to abdicate.

Battistero Neoniano (c.440–50)

Surrounded by the threat of violence, Galla Placidia built for the glory of God. Battistero Neoniano, erected on the foundations of a Roman bath, served the Ravenna basilica destroyed in 1734 to make way for the present cathedral. According to custom this baptistry was built in octagonal form to symbolize the seven days of creation, plus an eighth for resurrection and new life. In *The Baptism of Christ Surrounded by the Apostles* in the crown of the dome, against a rich background of gold, Christ stands up to his waist in water. On his right a bearded man personifies the River Jordan, while on his left St John the Baptist raises a hand over Christ's head above which a dove, symbolizing the Holy Spirit, hovers. Total immersion – three times – was the normal baptismal practice. The image of Christ's baptism in this mosaic became the standard for icons painted on wood and used by the Greek, and then Russian, Orthodox churches for the next millennium.

Archiepiscopal Chapel (c.480–500)

A young warrior confronts you in the entrance hall of the Archiepiscopal Chapel. He holds an open

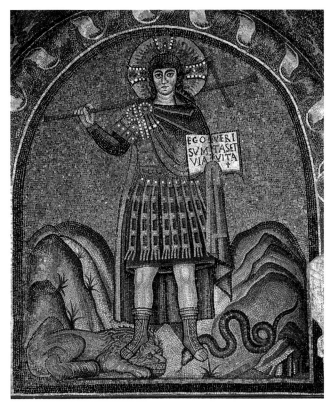

FACING PAGE:
The Baptism of Christ Surrounded by the Apostles, Battistero Neoniano, Ravenna (c.440–50).

Christ Stands on a Lion and a Serpent, Archiepiscopal Chapel, Ravenna (c.480–500).

book in his left hand on which is written, *Ego sum Via, Veritas et Vita* – 'I am the way, and the truth, and the life' (John 14:6). He balances a red martyr's cross over his shoulder, above which blazes a golden halo. He has overcome the trials of the desert, and the lion and the serpent – symbols of sin and evil – lie subdued beneath his feet. The good shepherd of the catacombs is seen in *Christ Stands on a Lion and a Serpent* (p. 19) as the Saviour of the world. His dark, clear eyes endorse the verity of his message and its meaning; he has fought the battle for humankind and invites humanity to follow his example. And they do follow him.

Basilica of San Apollinare Nuovo (c.480–500)

Up the nave of the Basilica of San Apollinare Nuovo in Ravenna twenty-two virgin saints of the Byzantine age, richly dressed and adorned with pearls and precious stones, carry laurel wreaths of victory. They move with dignity and grace towards the Madonna enthroned with her infant Jesus. On the opposite wall twenty-six martyrs, attired in white robes, walk in rhythmic procession towards Christ the redeemer who is seated on a throne, attended by four angels. They bring him the gift of their martyrdom, completely detached from the world on their pilgrimage to glory.

 Above them are the earliest-known scenes of the life of Christ in mosaic. They date back, like the warrior Christ, to the end of the fifth century when Theodoric the Ostragoth ruled Italy with a wisdom and education equivalent to that of the finest Roman emperors.

 In the thirteen scenes of Christ's miracles and parables, Jesus is again portrayed in classical style. He wears a purple tunic and pallium, or mantle, and his halo is made of cross-shaped jewels. With absolute serenity he calls St Peter and St Andrew from their fishing nets, delivers the demon-ridden man from his suffering, heals the blind and paralysed, speaks with the Samaritan woman at the well, and divides the sheep from the goats.

 The Christ of the passion and the resurrection on the opposite wall is no longer a young man. He has grown a beard and his face is full of sadness. The scenes follow Christ's passion in an urbane, restrained manner. After Pilate washes his hands, Jesus is led to Calvary, Simon carrying his cross. And the next picture shows the two Marys at the tomb, a little rotunda with fluted marble columns and a domed roof, where a seated angel hails them. No crucifixion. No blood. No drama. Yet it strikes the heart.

 All these images demonstrate the high artistic quality reached in the mosaics of Ravenna before this grand style of art was superseded by the early Gothic and Celtic concentration on small artefacts: illuminated manuscripts, carved ivories, decorated brooches and other moveable goods.

Basilica of San Apollinare (c.550)

During the reign of Emperor Justinian, who reunited the eastern and western empires before the west finally disintegrated, the basilica of San Apollinare in Classe was built, financed by a very rich Greek banker called Julian.

 On the flat plain outside the basilica, where the huge harbour has silted up, creating

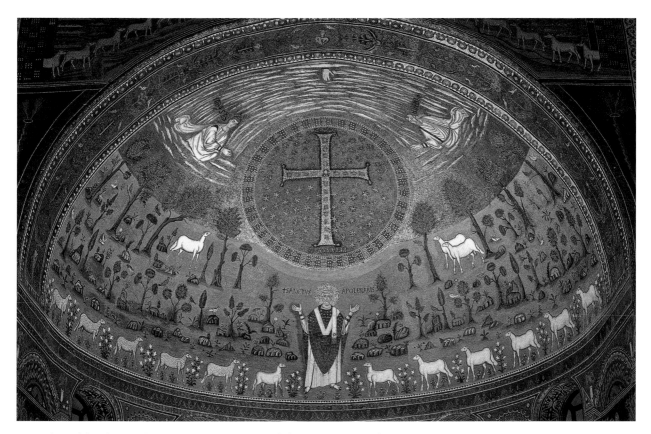

agricultural land, stands a nineteenth-century life-size bronze of Caesar Augustus. As you enter the basilica, noble Greek columns line the nave, directing your eye to the rich mosaics in the apse, showing twelve sheep grazing in a lush meadow. The well-known psalm springs to mind:

Apse mosaic, Basilica of San Apollinare, Classe (c.550).

> *The Lord is my shepherd, I shall not want;*
> *he makes me lie down in green pastures…*
> *he restores my soul (Psalm 23:1–2, 3).*

And this message revealed itself through the imagery:

> *The past can be shed like old skin;*
> *left outside where Augustus guards.*
> *There is no place for fear in the green pastures*
> *where sheep graze peacefully among the lilies*
> *beside olive, pine and date-palms;*
> *and follow their Master joyfully.*
> *There is no place for pain*

in the harmonies of green and white:
symbols of hope and purity,
where no shadows break the constancy of light.
There is no place for death
in the golden cross of the risen Christ
where archangels and saints cry:
'Jesus Christ, Son of God, Saviour'.

'I am the door,' said Jesus. And the sheep walk in a straight line to it, from the door in Bethlehem, where he was born, to the door of Jerusalem, where he died. The sheep know his voice, and follow him in clarity, simplicity and obedience, uncluttered by the noise of the world. And the serenity of Ravenna prevails.

Sicily

In Sicily, where Greeks from the mainland established cities, a few temples, empty shells long stripped of ornament, still beautify the landscape 2,500 years after they were built.

Temple of Athena – Syracuse Cathedral (480BC)

The Temple of Athena was the pride of Syracuse, built in memory of the victory over the Carthaginians at Himera. St Paul must have visited the temple during his three-day sojourn in Syracuse en route to Rome. Imagine him scrutinizing the portraits of the kings and tyrants that hung on the walls, admiring the workmanship of doors inlaid with ivory and gold, pondering over the pediment where the golden shield of Athena, goddess of justice, dazzled fisherman far out at sea. Could he have pictured the temple as a Christian church? No doubt he prayed for it. Five hundred years were to pass before the saintly Bishop Zosimus converted the temple into a church. Undaunted by the shadow of Mount Etna and periodic earthquakes, Syracuse Cathedral still stands. It is a moving experience to step inside and see the original pagan temple, embedded in the Christian walls, and realize that this has been a place of worship for 2,500 years.

In 1054 eastern and western Christendom finally split after centuries of disagreement over the three persons of the Trinity. A decade later, Count Roger de Hautville won Sicily from the Arabs, and another Norman, William, conquered England. Within thirty years the first Crusade to regain Jerusalem from the Arabs, who took it in AD638, was launched.

Harmony reigned in Sicily. Count Roger ruled efficiently. He was also wise, for he adapted willingly to the Arab, Roman and Greek traditions that existed on the island. It is not difficult to see why when sitting under an unblemished blue sky on the acropolis at Selinunte, surrounded by stone that was here 500 years before Christ on which wild

chrysanthemums, red poppies, wild pea and citronella clamber. The silence is gently stirred by the wind in the leaves, and the waves embracing the beaches. This island had been lived in and loved to the heights of civilization for more than a millennium when Roger arrived. When his son – Roger II – became king of Sicily in 1130, he was the wealthiest ruler in Europe, and his brilliant court in Palermo became the foremost centre of scholarship and art, as it had been earlier under the Arabs.

Roger II was a great builder. During his reign the monumental cathedral at Cefalu grew up against a rocky hill, its feet almost in the sea.

Palatine Chapel (1132–40)

The Palatine Chapel was inset like a jewel in the Norman palace at Palermo. Inside, magnificent mosaics testify to a culture now lost. Here, Greek, Latin and Arabic art blend

Christ Pantocrator, Cefalu Cathedral, Sicily (1131–66).

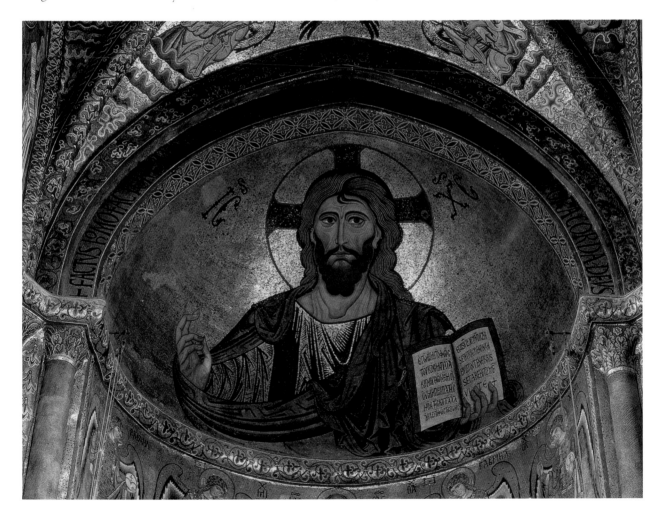

together in an extraordinary richness of decoration concentrated in a limited space. The marble floor and lower parts of the walls are inlaid with Arabic geometric patterns. The screens separating the nave from the presbytery, and the pointed arches rising to the stalactite ceiling, carved with rare virtuosity from cedars of Lebanon, could have been made for a mosque. The basilica-shaped chapel and the alternating Egyptian granite and *cipollino* marble columns from Elba that separate the nave from the aisles are thoroughly Latin, while the transept with its central dome is Greek.

Mosaics cover most of the interior. The sense of divine splendour is increased by the use of silver as well as gold *tesserae*. You could be in a mansion in heaven, watching the story of Christ from the creation unfold. And the colours are as rich and bountiful as they are in the natural world outside.

The huge Christ in the upper part of the apse behind the altar is the Byzantine *Pantocrator*. He has moved on from being the young shepherd and the God incarnate of this world to become the 'All Sovereign'. After various bouts of iconoclasm, particularly in the eighth century when art in the eastern church was banned, mosaics became increasingly mystical as they were transformed into great arrangements of large and solemn images, surpassing even those we glimpsed at Ravenna. This remote, bearded figure with long face and penetrating eyes holds a gospel in one hand and raises the other in blessing, bridging the gap between God and humanity. The book lies open at John 8:12 and the words read, 'I am the light of the world; he who follows me will not walk in darkness': the darkness of fear, of pain, of deception.

Cefalu Cathedral (1131–66)

Christ Pantocrator (p. 23) is also the focal point of the Sicolo-Norman cathedral at Cefalu. Many of the original mosaics are lost. Christ remains, in the central apse, framed by turquoise, mosaic-clad pillars, while angels and seraphim adore him from the vault and his mother intercedes from below, flanked by four archangels. Beneath them in strict Byzantine hierarchy are the apostles, and then saints; blue and gold predominate with splashes of white.

Orthodox Christians consider their icons to be sacred, and when you look at these colossal, regal figures, remote yet very present, you are drawn into a great and awesome mystery. You want to bow down and worship – not the actual image, but the one who inspired it. This is often sensed by the large groups of tourists who visit Cefalu Cathedral and sit in the pews gazing up, spellbound.

Monreale Cathedral (1174–85)

Monreale Cathedral is the swansong of Norman art in Sicily and, because of the Crusades, the final union between Greek, Latin, and Arabic influences. It was built during the reign of William II in just eleven years and became one of the architectural wonders of the late Middle Ages. Monreale combines the grandeur of Cefalu Cathedral with the magnificence of the Palatine Chapel.

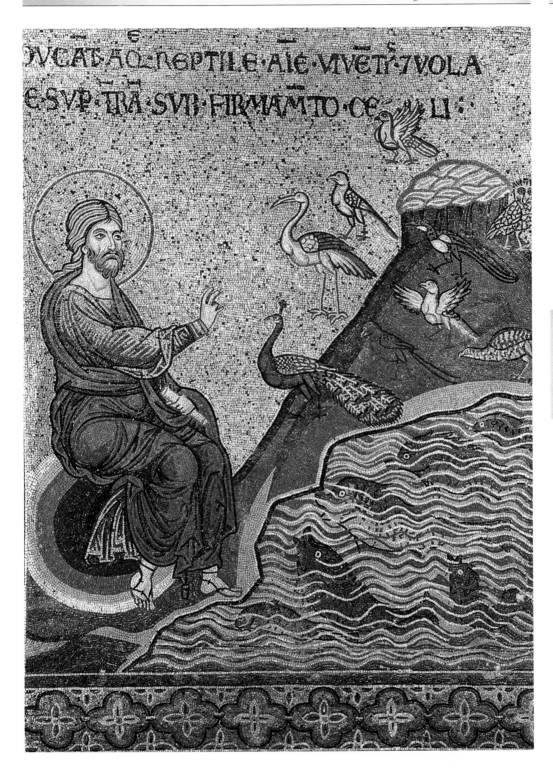

God Enlivens Water and Earth with Animals, Monreale Cathedral, Sicily (1174–85).

The bronze doors, cast in Pisa in 1186, with their scenes from scripture set into separate panels, are an intimation of what is to come. Inside, the vast basilica is alive with *tesserae* exploding with colour amid a symbolic confrontation with reality.

The complexities of the human condition reveal themselves like vivid strip cartoons on every millimetre of the upper walls, beginning with the creation and ending with the martyrdom of St Peter and St Paul. God, who creates from nothing, wears a golden robe and blue cloak. A golden halo encircles his head and he moves from mosaic to mosaic with absolute authority, calling forth light from darkness, separating land from water, filling them with lush vegetation and living creatures. Birds crowd the air, fish fill the sea, animals graze. Richly varied in shape and size, colour and hue, they flutter, wiggle and frisk, full of freedom and delight at the dawn of life, new, innocent and harmless. This is exemplified by *God Enlivens Water and Earth with Animals* (p. 25).

The ministry of Christ is re-enacted on the walls of the aisles. There is the leper covered in spots like a leopard, imploring Jesus to help him. Written in black in the golden sky above him is the biblical verse: 'If you wish to, O Lord, you can heal me.' Jairus and his family weep with joy as their Saviour restores their daughter. The eleven apostles lean forward anxiously in their boat as Peter, momentarily lacking faith, fails to walk on the water and Jesus lifts him from the deep. This is the risen Christ who radiates all love, wisdom and mercy.

In the transept, like the central bar of the cross on which he was crucified, Christ's life and death are illustrated. Opposite are incidents from the lives of St Peter and St Paul, who took Christ's message of salvation out into the world. They follow him to martyrdom and, like the symbolic sheep in Ravenna, have gone through the door that led to life.

CHAPTER 2

The Rebirth of Realism

Nobody can understand the greatness of the thirteenth century, who does
not realize that it was a great growth of new things produced by a living
thing… It was a new thrust like the titanic thrust of Gothic
engineering; and its strength was in a God who makes all things new.
G.K. Chesterton (1874–1936), *St Thomas Aquinas*

The magnificent cathedrals that crown cities throughout Europe are symbols of a living faith from a time when Europe was united under the banner of Christ. Artists and craftsmen, their practice controlled by guilds, worked together under the patronage of the church in an outpouring of artistic and spiritual energy. The Benedictine monks' centuries-long commitment to keep ancient culture and early Christian learning alive, by meticulously copying and illuminating manuscripts, had borne fruit.

St Dominic, St Francis of Assisi and St Thomas Aquinas were outstanding among a host of men and women who sought to make the whole fabric of society worthy of the redeemer. Sculpture, scholarship, and saintliness walked hand in hand.

In those days life moved at a natural pace. There was time to carve misericords on wooden pews, chisel fine figures of saints in stone, and embroider copes with gold and silver thread. And there was time to contemplate life and death – for poverty, political insecurity and violence also existed, as Christ warned they always would. But there was hope in God's sovereign power and mercy, and as the glory of the cathedrals lifted minds and hearts heavenwards, St Paul's words, 'to live is Christ, and to die is gain' (Philippians 1:21), must have continued to resonate in those lofty places.

Spiritual, philosophical and artistic ideas were spread around by the constant movement of people. Rats spread pestilence. Thousands died fighting in the crusades. In the days before morphine and other panaceas, pain was an active part of life. Christ's passion and death were real, especially after the feast of Corpus Christi, which commemorated the Lord's Supper, was incorporated into the church's liturgical calendar. The sovereign Lord of the Byzantine world became the crucified redeemer of humanity and, in the churches and cathedrals, he hung on the cross above the rood screen, touching hearts, moving people to confess sins and commit their lives to him.

As the thirteenth century unfolded, St Francis of Assisi was the main inspiration for the spiritual revival which also directly influenced artistic trends. Embracing poverty for the sake of the gospel, his example of self-giving love renewed the church and helped ordinary men and women to understand the reality of a loving God, and trust in the almighty Father who had given up his only son to save souls from selfishness that leads to sin.

In giving up everything worldly for love, Francis received everything the created world could give. The flowers and trees, the moon and stars, and the birds and animals were his friends, for they too were children of God. His *Canticle of the Sun* – a tumult of praise to God for his creation – finishes with thanks even for 'sister death'. Legions of lives were changed by his example, and so many people followed him that by the time of his death in his beloved Assisi in 1226 the Franciscan Order was 5,000 strong.

The late medieval mind-set was embodied in Alighieri's epic *Divine Comedy*. The poet goes on an adventure through the morass of human evil, through the struggle of all that separates us from God, to the beatific vision of the heavenly throne. He is escorted first, by the pre-Christ poet Virgil, through the Inferno and Purgatory, then by Beatrice, the woman he loved with knightly chivalry, to Paradise. Dante combined classical scholarship and Christianity with the contemporary political scene to present a rounded view of humanity from the depths to the heights. His poem reveals the supernatural world and people's need to find their true home there. Love is the key to life, and the soul's pilgrimage through this world is a preparation for the next.

In this cultural climate, Italian artists moved away from the Byzantine images of Christ's death on the cross which, through endless reproduction, had become cold and lifeless. Under the patronage of the Franciscans they were the first to paint the crucifixion in all its human drama. As G.K. Chesterton put it, 'the East was the land of the cross and the West was the land of the crucifix. The Greeks were being dehumanized by a radiant symbol, while the Goths were being humanized by an instrument of torture.'

Giovanni Cimabue (c.1240–c.1302)

Giovanni Cimabue was in the vanguard of a new artistic movement in Tuscany which sought to enliven Christ's passion by emphasizing his humanity. He painted *Crucifixion* for the Franciscan church of Santa Croce in Florence around 1287. As the twentieth-century art critic Battisti commented, 'He is not a sacrificial offering, but an example of a superior humanity to which many can attain with the necessary spiritual power – not an icon to be wept in front of, but an inspiring model.'

The huge *Crucifixion*, measuring 3.90 m by 4.33 m, was constructed to hang on the choir screen. What inner urging prompted Cimabue to twist the body on the wood in a way not understood in art since the days of antiquity – before Christ even lived? What agonies did he

himself experience as he emphasized the strong tension and wracking pain in Christ's curved body, and painted the head collapsed helplessly upon the shoulder as it carried every screaming nerve end until the end of time? Did tears blur his own vision as he shut those eyes for the last time? Those carpenter's eyes that gloried in the beauty of the world, and saw with penetrating vision into every human heart, those eyes that looked from that accursed place called Golgotha as he prayed, 'Father, forgive them; for they know not what they do' (Luke 23:34).

The blood drips relentlessly from the hands that open up in love. Beyond them, his mother and St John the Evangelist grieve. In his *Meditations on the Passion*, St Anselm, the Archbishop of Canterbury, reports that Mary took the veil from her face to cover her son's nakedness; and this is the first time such a delicate and diaphanous loin cloth was painted.

For 700 years people came to Santa Croce and searched in this masterpiece of Italian painting for some revelation of truth. Latterly it hung in the museum next door. Here, on 4 November 1966, another, elemental, visitor came and completely enveloped the crucifix in its chilly embrace: the raging waters of the River Arno that flooded the city and caused more damage to art treasures than occurred during the wartime days of August 1944. The mayor of Florence described the scene:

> All Florentines seemed to be... up to the waist... in sludge. It was as if they felt nothing but contempt for this boggy, stinking hell... They bent their backs laboriously and gritted their teeth, cursing and complaining. The fatally wounded *Crucifixion* by Cimabue was transported to the Limonaia [the winter lemon house in the Boboli Gardens] on an army lorry; the most proud and irreligious men interrupted their battle with the sludge and silently removed their hats.

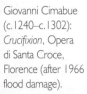

Giovanni Cimabue (c.1240–c.1302): *Crucifixion*, Opera di Santa Croce, Florence (after 1966 flood damage).

Giovanni Cimabue (c.1240–c.1302): *Crucifixion*, Opera di Santa Croce, Florence (before 1966 flood damage).

Conservators spent ten years piecing together the delicate fragments that survived, and *Crucifixion* was reinstalled in Santa Croce. The damaged areas were 'hatched in' in harmonizing tones after the whole construction had been consolidated. Later it came to the Royal Academy in London during a world tour. The picture has lost large chunks of paint, but none of its spirituality. In fact, its very vulnerability adds to its strength.

'The Way to God is the way of weakness,' wrote Henri Nouwen in his book *In the House of the Lord* at about the time of the flood.

> The great news of the gospel is precisely that God became small and vulnerable, and hence bore fruit among us... He came to us as a small child. He lived for us as a poor preacher, without any political, economic or military power. He died for us nailed on a cross as a useless criminal. It is in this extreme vulnerability that our salvation was won. The fruit of this poor and failing existence is eternal life for all who believe in him.

Duccio di Buoninsegna (c.1255–c.1318)

Italian artists were profoundly influenced by their environment. They breathed its gentle beauty into their paintings, as the land and light of Attica inspired the art of ancient Greece. Siena is surrounded by bare, low hills glinting in a golden light that permeates the paintings with a delicate veil of mysticism.

Fanned by the Franciscan and Dominican religious revival, this luminous spirituality shimmers from the paintings of Duccio di Buoninsegna, the earliest and most influential of the Sienese artists. His master was Cimabue, with whom he worked for five years painting frescoes in the Basilica of St Francis in Assisi. Like him, Duccio absorbed the austere gravity of the medieval Greek style, which he enlivened with the Gothic trends that filtered south from France.

Duccio's masterpiece was the extraordinarily ambitious *Maestà* which was carried in solemn procession from his workshop to the Duomo (cathedral) on 9 June 1311. The vast altarpiece covered the entire length of the high altar. In 1260 Mary, as Queen of Heaven, had been elected supreme protectress of Siena. In *Madonna Enthroned*, from *Maestà* (Italian for majesty) she sits enthroned with Jesus, surrounded by the royal court, facing the congregation. She is the focal point of devotion, seated on an open throne of multi-coloured marble, like the outer cladding of the cathedral, which is softened by a delicately patterned backcloth. Her robe is articulated by golden striations in iconic style. She enfolds the incarnate Lord on her lap, her long-fingered hands in gentle contact with him, and together they exist in serene stillness, looking out silently at the faithful, and dwarfing the heavenly court which, in strict hierarchical orderliness, fills every inch of the throne room without any sign of overcrowding: timeless. Holding their identifying symbols, saints of the early church stand behind four kneeling patrons who

were martyred for their faith. Angels surround the royal pair. Four lean against the throne with disarming naturalness to contemplate, like puzzled children, the mystery of the incarnation.

Duccio extended *Maestà* on the reverse by gluing and nailing poplar panels to its back. On these he painted a narrative cycle of the life of Christ and his passion for the edification of the clergy in the sanctuary, who could examine closely the pictorial stories. Tragically the huge altarpiece, which contained sixty-five separate painted elements, was cut up in the late eighteenth century and stored in terrible conditions. Many components of the predella and the crowning section were lost; some have surfaced in foreign museums, for example, *Temptation on the Mount* (Frick Collection, New York), *Calling of Peter and Andrew* (The National Gallery of Art, Washington), and *Annunciation* (The National Gallery, London). Despite their small dimensions, the scenes are depicted with incredible virtuosity, and must have inspired generations of clergymen as they prepared themselves to feed their flocks. In *Temptation on the Mount* angels, their hands covered by their robes in Byzantine manner (for even they could not touch holiness), wait in wonder as Christ commands the hideous, black, winged devil to depart. Jesus, who alone never sinned, suffered for the totality of sins — great and small — from Judas' betrayal to the sloth and self-centredness of many a respectable life. Satan continues to point down the mountain at the exquisitely articulated clumps of cities, bathed with pastel shades — spires, domes

Duccio di Buoninsegna (c.1255–c.1318): *Madonna Enthroned*, from *Maestà*.

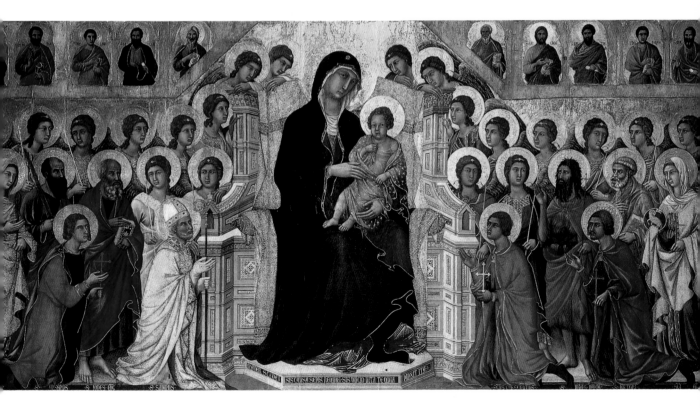

and battlements rising and falling – as he offers to give the whole world to Jesus. But Jesus stands his ground, refusing to be tempted by worldly power: "'You shall worship the Lord your God, and him only shall you serve'" (Luke 4:8).

Giotto di Bondone (c.1267–1337)

Giotto di Bondone was a man of the soil. He observed nature closely. He lived at a time when people were becoming newly aware of their individuality; when writers like his contemporary, Dante, and later, Chaucer, expressed themselves in their native tongues rather than in the universal Latin.

His early life as a shepherd coupled with his prodigious talent enabled Giotto to lead art into completely new pastures. His 'discovery' was graphically described by Lorenzo Ghiberti (sculptor of the bronze doors of the Florence Baptistry) around 1450, in his *Commentarii II*:

Giotto di Bondone (c.1267–1337): *St Francis Renouncing his Earthly Possessions*, Basilica of St Francis, Assisi.

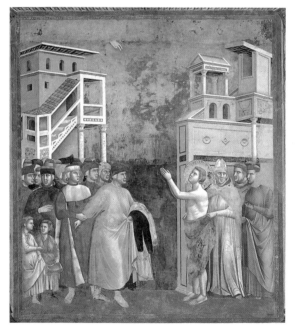

A boy was born of wonderful intellect, who happened to be drawing a sheep when Cimabue the painter passed that way along the road to Bologna, and saw the boy sitting on the ground and drawing a sheep on a stone. He was filled with admiration for the young lad, who was drawing so well. Seeing that he was naturally gifted as an artist, he asked the lad what his name was. 'My name is Giotto and my father's is Bondone and he lives in this house near at hand,' the boy said. Cimabue went with Giotto to his father (he made a very fine appearance), and asked the father to entrust him with the boy. The father was very poor. He allowed the boy to go with Cimabue, and so Giotto became his pupil.

Cimabue had breathed life into traditional Byzantine iconography. Giotto, according to Cennini in 1390, 'translated the art of painting from Greek into Latin, and made it modern'. His innovations soon made the Romanesque and Gothic styles obsolete, although Gothic developed into the International style which continued until the end of the fifteenth century. This style was delicate, other-worldly, and somewhat precious, full of patterned gold leaf and rich colours which shimmered in the candlelight.

Giotto's painting, in contrast, was very earthy. His people are solid and inhabit real space. They laugh and cry, kiss and kill. Even his animals have character. Giotto was

inspired, on an early visit to Rome, by the monumentality of classical art. He watched local artists recreating frescoes and mosaics on the walls of early Christian basilicas which were being reawakened from the ancient rubble. Art no longer only looked heavenwards but outwards, as St Francis had lived, in celebration of the created world. Soon artists were painting frescoes on church walls throughout Italy. They mixed ground pigments with water and painted onto fresh plaster. They had to work quickly, in stages, for when the plaster dried it crystallized, making the paint indelible. Like the earlier mosaicists they illustrated the Christian message, to instruct and inspire the faithful.

Giotto and the Basilica of St Francis (1290s)

Giotto's first major project was in the Basilica of St Francis in Assisi where Cimabue, Duccio and other collaborators painted scenes from the Bible on the walls of the upper church. The great architectural complex of the convent and basilica had been started within two years of the saint's death, and grew into the most important monument of Italian architecture and painting in the thirteenth and fourteenth centuries. In the late 1290s Giotto was given a free hand to paint stories from the life of St Francis along the walls beneath the biblical scenes. These frescoes were meant to be read as the exemplary fulfilment of Christ's teaching, culminating in the stigmata the saint received on Mount La Verna. Here Giotto honed his techniques; here his originality surfaced, although much has now been lost through over-restoration — and earthquakes.

In 1206 Francis Bernardone renounced all his worldly goods in front of the Bishop of Assisi. In *St Francis Renouncing his Earthly Possessions* Giotto emphasizes the complete break between father and son by leaving a gap between the protagonists. He illustrates that moment in the story when Francis, fulfilling his decision to embrace holy poverty, has flung off his clothes and is concentrating his whole being on prayer. A hand emerges from the sky in blessing, to confirm his choice. While the thoughts of Francis rise to a spiritual plane, everyone else in the picture is concentrating on the human dilemma. The bishop has had the presence of mind to cover the young hothead's nakedness with his cloak; the irate father, clutching the clothes that have been thrown at him, is restrained by more sober citizens. Francis' face has a beatific aura framed by a halo which, of course, no one else can see. All the others express anger, frustration, or wariness. Like a good crime writer Giotto keeps us in suspense as he unfolds the story. A seed has been sown but the abundant fruit, which will produce a rich harvest for Christ, is still hidden.

Francis restored the little church of San Damiano, where he first heard God calling, 'Go Francis, and restore my church, which as you see, is falling into ruin.' The words Christ spoke to the apostles seemed to be spoken to him: 'preach as you go, saying, "The kingdom of heaven is at hand." Heal the sick, raise the dead, cleanse lepers, cast out demons. You received without paying, give without pay' (Matthew 10:7–8). And he did. Within two years he had matured — carved and chiselled by the hardships and humiliations of poverty, and by the contempt of those he hoped would understand. He emerged rock-like from the transformation. The scorn of his fellow citizens changed into admiration — and then veneration.

Soon the Franciscan Order had a profound influence on social and political, as well as spiritual, matters, and the barefoot friars carried the words of Christ to the ends of the earth.

In 1210, when his little band of followers had grown somewhat in size, a more regular organization was necessary. Francis drew up a Rule for the community, based on poverty, chastity, and obedience to Christ's commands, and he travelled to Rome to receive Pope Innocent III's approval. Giotto painted the friar and his companions in their simple garb, which was based on the local peasants' brown tunics, girdled with a rope. They kneel before one of the greatest popes in history, in whose presence kings and emperors trembled. He sits on a throne, surrounded by other dignitaries, dressed in the rich apparel of his office.

Innocent III had a dream in which a poor man helped him restore the church, which had fallen into laxity and corruption. When he met Francis he immediately perceived his holiness, blessed his Rule, and gave him his protection, thus enabling Francis and his Order to survive and grow, and for revival to renew the church. Giotto sets his figures in an architectural space where rounded arches jut out above a curtained backdrop. His unprecedented three-dimensional vision anticipates later studies of perspective; yet with the virtuosity of a master he does not let the decorative effects distract the viewer from this meeting of two great men.

Giotto became a tertiary Franciscan – a lay member of the Order. Throughout his life he worked on commissions from them in Assisi, Rimini, Padua and Florence. The scenes from *Life of St Francis* were very dear to him. Those he painted in the Bardi chapel in Santa Croce, Florence, in the last years of his life are pervaded with a sense of peace. Giotto's depiction of the death of the founder of the Order to which he was dedicated is very moving. In *Death of St Francis* St Francis lies in utter serenity, waiting to join his master,

Giotto di Bondone (c.1267–1337): *Death of St Francis*, Bardi Chapel, Santa Croce, Florence.

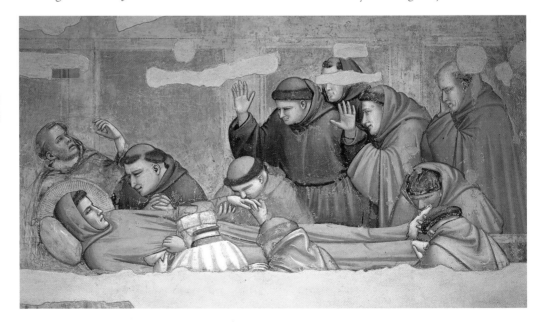

surrounded by friars who kneel and kiss his wounds, stand and pray, or sing psalms. His closest friends, Fra Leo, Fra Masseo and Fra Bernard, weep with grief. They weep for the world, for it was as if a light had dimmed. Perhaps they remembered what he said repeatedly, 'You must learn to love. For beyond the door there is nothing – except love' (Carlo Caretto, *I, Francis*).

Giotto and the Scrovegni (Arena) Chapel (1304–6)

In 1301, the year Dante was exiled from Florence for political reasons, Enrico Scrovegni began erecting the Arena Chapel in Padua, dedicated to the Virgin Mary, to expiate the sins of his father's usury. What good arose from evil!

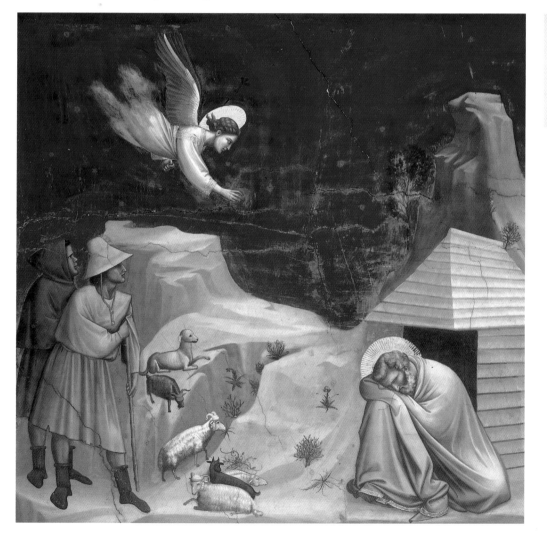

Giotto di Bondone (c.1267–1337): *The Dream of Joachim*, Scrovegni (Arena) Chapel, Padua.

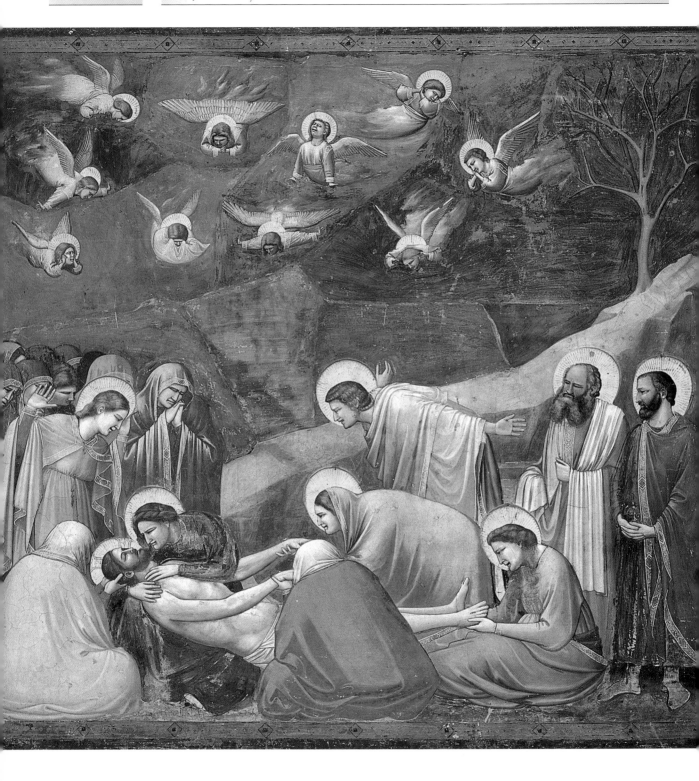

In the small area of this simple, barrel-vaulted, rectangular hall, Giotto planned and painted thirteen episodes from the life of Mary and her parents, twenty-six from the life of Christ, and fourteen panels of vices and virtues. The latter were painted in grisaille to give the impression of carved stone.

According to legend, Joachim and Anne, like Abraham and Sarah, had no children. Joachim went out to the desert to pray, living among the shepherds. One day he sacrificed a lamb on an altar to purify himself, and an angel appeared to tell him his prayer had been heard and he should go home. On the way he rested in a shepherd's hut. Again an angel appeared, this time in a dream, to tell him he would become a father. Anne also received the good news from an angel, and in due time Mary was born.

Giotto is utterly at home here. In *The Dream of Joachim* (p. 35) he paints the story with a clarity and realism unknown by his contemporaries. You feel that the sheep scrambling about on the rocks are his sheep, individually known and loved. They are not symbols of spirituality like the sheep in Ravenna; not even a messenger from God can interrupt their grazing. Fortunately a sheepdog watches them, for the two shepherds in the picture are completely entranced by the angel whose heavenly light illuminates the hills, the hut, the clothes, and even the sheep. Joachim has curled himself up and wrapped his cloak securely around him. It falls in elegant Gothic folds. Giotto creates space, physical and metaphysical, within a landscape as old as creation. The simplicity of the scene suggests that faith not ideology, common sense not confusion, tranquillity not haste, are the secrets of a happy life.

Angels praise and worship God for the birth of Christ. In the nativity scene Mary reclines on a pallet, in line with Byzantine iconography. But there the comparison ends; Giotto has modified the old patterns, twisting Mary's body forwards as she places her baby so tenderly into the manger, foreshortening the donkey in the foreground, and placing the whole scene in real space. Joseph sits, like Joachim, with his knees up. Perhaps it was a position Giotto favoured when he looked after the sheep. On the right two shepherds turn away to listen to an angel.

St Francis' love for all creatures led to a new celebration of nature in art and architecture, and his introduction of a crib into the church at Greccio has enhanced the Christmas story ever since.

In *Last Supper*, before they all sit down to eat, Jesus washes the disciples' feet. They are lost in thought, humbled by his humility. Only Judas is hidden. The natural way St Peter lifts his robe to let Jesus wash his foot is exemplary. This is Christ coming from his throne in heaven, becoming a little 'lower than the angels' (Hebrews 2:9) to be utterly human for humanity. This is the gospel message so recently followed by St Francis. Both the apostle lacing up his shoe and St John holding the jug are very realistic; their idealized stillness holds humanity and holiness in perfect balance.

In *Lamentation*, the drama of the passion reaches its climax in the lament over Christ's body. All creation mourns. The cosmos is heavy with grief. All eyes are turned on Mary who cradles her dead son in her lap, leaning her head against his. Giotto shows the whole gamut of human sorrow: the 'stiff upper lip' of Nicodemus and Joseph of Arimathea who stand upright; the unchecked tears that flow down Mary

Giotto di Bondone (c.1267–1337): *Lamentation*, Scrovegni (Arena) Chapel, Padua.

Magdalene's cheeks as she holds Christ's feet; the passionate despair of St John as he flings back his arms; and the mute, anonymous silence of the two women who sit with their backs to us.

Giotto blended the spiritual and secular values of his day in a way people could understand and marvel at. He was a humble genius who never allowed anyone to call him 'Maestro'.

In Giotto's day Europe was united spiritually, with the pope as shepherd of the flock. Politically the continent was split into a polyglot of kingdoms, principalities and city-states. Inter-city rivalry was strong, and each Italian town employed a *condottiere* to lead its army out to capture other cities or defend its own. Siena took civic responsibilities seriously under the patronage of the Virgin Mary, Queen of Heaven. (Since time immemorial the mother goddess had been the chief divinity in pagan religions and therefore it seemed natural for early Christians to venerate Mary, the mother of the incarnate Christ; a devotion which continues to this day.)

Ambrogio Lorenzetti (d.1348)

In the late 1330s Ambrogio Lorenzetti was commissioned to paint an allegory on the theme of good and bad government, on the walls of the Hall of Peace, for the Government of the Nine in the Palazzo Pubblico in Siena. In an age when right and wrong were clearly defined, in *Good and Bad Government*, Virtue and Vice are personified. On the wall behind which the town councillors sat, Justice, the Common Good, Providence, Temperance, and other virtues are enthroned. On one long wall sit Tyranny and his vicious henchmen; behind them in a large landscape is a city of fear and death, illustrating the dreadful effect they produce on humankind. On the opposite wall, the effect of good government is idealized. People feel free to move about without fear; to talk and dance and sing; to dig their land and tend their animals, at one with creation. These were the first great panoramic views of town and country to be painted since classical times, and they show how far the techniques of Italian painting had advanced in a short time. Giotto was among those who led the way into the genre of topographical painting. There is a wonderful wealth of detail arranged into a large-scale, convincing whole. You can recognize the well-governed town, for the dome and campanile of its cathedral are painted in the top-left corner of the picture. And the gentle, undulating, earthy hills could only be those outside Siena.

Contemplating these paintings must have inspired both those making the laws and those respecting them. There is no blurring of values, no mixing of motives. It is beautifully clear, looking at these frescoes, that if you follow what is honourable and true there can be happiness and harmony in the city, productive and peaceful living in the countryside.

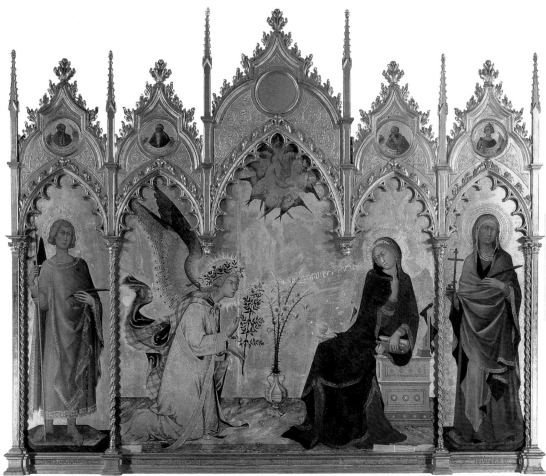

Simone Martini
(c.1284–1344):
*The Annunciation
with St Margaret
and St Asano.*

Simone Martini (c.1284–1344)

The Annunciation with St Margaret and St Asano, the central part of an altarpiece painted for Siena Cathedral in 1333 by Simone Martini, is perhaps the definitive painting on this theme. Martini worked in Avignon, where the papal throne was temporarily located from 1309 until 1370. He combined the grace and elegance of the northern Gothic court art with the spiritual aura of Siena, to make a picture that is truly international. Martini placed the delicate and decorative figures of Mary and the angel Gabriel in a golden background, and crowned them within a Gothic gilded and pinnacled frame. Above them the Holy Spirit, in the form of a dove, hovers in a circle of angels. Everything is golden for this is that pregnant prelude in history when God is about to enter the body of a woman and become man. Gabriel has just arrived, for his wings are tense and his cloak is still in flight. His brow is crowned with olive twigs, for he brings peace and goodwill to all. Mary shrinks back, clasping her cloak tightly about her, clutching her missal in her

FACING PAGE AND
BELOW:
The *Wilton Diptych*
(1395–99):
*Richard II presented
to the Virgin and
Child by his patron
Saint John the
Baptist and
St Edward and
St Edmund.*

left hand as she considers his message, and then replies, 'let it be to me according to your word' (Luke 1:38). Her 'yes' to God opened the door to our redemption.

Exactly forty years after Martini painted his *Annunciation* in the sunny Tuscan clime, the anchorite Julian of Norwich received her *Revelations of Divine Love* in a prayer cell in East Anglia. At the end of the first revelation she saw Mary:

> In my spirit I saw her as though she were physically present… God showed me something of her spiritual wisdom and honesty, and I understood her profound reverence when she saw her God and Maker; how reverently she marvelled that he should be born of his own creature, and of one so simple. This wisdom and honesty, which recognized the greatness of her creator and the smallness of her created self, moved her to say to Gabriel in her utter humility: 'Behold the handmaid of the Lord!' By this I knew for certain that in worth and grace she is above all that God made, save the blessed humanity of Christ.

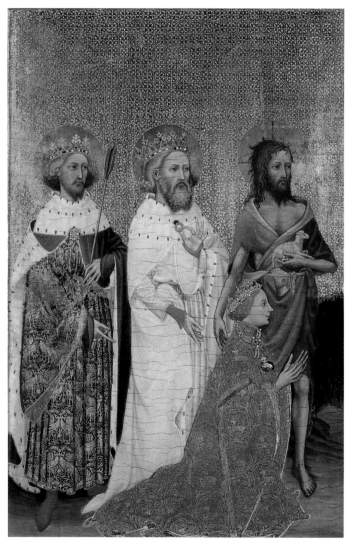

Medieval man loved and honoured Mary more than any other biblical figure. The Madonna and child had become the most painted and sculpted of religious images by the start of the fourteenth century. In church, convent and court Mary, Mother of Mercy, brought her son's mercy to the extended family. And Christ, enthroned on his mother's lap, also signified the word of God. Emperors, kings and princes, as well as their subjects, knelt before Mary; they venerated her as the mother of God and of the church, and asked her to intercede on their behalf in heaven; to be a partner in prayer.

The *Wilton Diptych* (c.1395–99)

One such king was Richard II of England. Richard loved luxury, and his court became one of the most cultured in Europe. There was

frequent contact across the English Channel; French chroniclers like Froissart visited London, and Chaucer travelled on embassies to Italy and France.

Richard employed artists, writers and craftsmen, and commissioned books and paintings that concentrated on the sacral nature of kingship. Among the luxury objects of the court were portable altarpieces used for private prayer. Few survive in England. The *Wilton Diptych* is one of the most refined and beautiful examples. It is the epitome of the knightly culture of the late Middle Ages, painted in the International Gothic style. The identity of the painter is a mystery.

When the diptych is shut the personal emblems of the king give it a secular air. Open, it shows three magi being presented by St John the Baptist to the virgin and child. The

three magi are portrayed as three English kings: Richard II, shown as the young boy he was at the time of his coronation, St Edmund, and St Edward the Confessor. St Edmund was the last king of East Anglia, martyred in AD870; St Edward was the last of the Anglo-Saxon line and the founder of Westminster Abbey; St John the Baptist was Richard's patron saint. Though richly dressed, the kings walk in a rocky wasteland on the stony path of pilgrimage. Their eyes are fixed on Jesus, who leans out of his mother's lap in the right-hand panel to bless them. Eleven angels (Richard was crowned in his eleventh year) surround the sacred pair, their arms crossed, their feathery wings folded behind them, on guard. The green sward on which they stand or kneel is strewn with roses, showing that Mary was the rose without a thorn. The richly tooled and patterned gold on the panel is further enhanced by lapis lazuli, that rare and precious blue stone that came 'ultra marine' from Afghanistan.

The virtuosity in the handling of paint and gilding, the subtlety of feeling and delicacy of taste, make the diptych a rare match for the Simone Martini masterpiece. The French elements that the Sienese painter found at Avignon linger here also, in the detail and design that sprang from illuminated manuscripts, and the perennial French chic.

Richard's first wife, Anne of Bohemia, daughter of Emperor Charles IV, died before

The Master of the
Trebon Altarpiece
(after 1390):
*Adoration of the
Child*, Ales Gallery,
Hluboká Castle,
Czech Republic.

the diptych was painted. It is probable that, in her memory, Richard wanted to use her favourite statue of the virgin and child, sculpted in Bohemia, as a model. The stance of the virgin, slightly S-shaped, with the baby counter-balancing the pose, is typical of the Beautiful Madonna style of Central Europe, although in the *Wilton Diptych* the 'S' is reversed. A similar although slightly later statue, in which Mary also holds her child's foot, is in Cracow. The carved and polychromed *Kruzlov Madonna* has wide-set, almond-shaped eyes and a round, red mouth. She is a picture of sweetness and modesty, with her golden hair tucked into her cloak, and a simple crown on her head. Maternal pride radiates from her, and both mother and baby smile as his toes are tickled – inner smiles born of inward blessedness.

In the *Wilton Diptych* thorns and nails incise Christ's halo as reminders of his passion. The angel on his right holds a white banner on which is a red cross, a symbol of his resurrection. At the top of this banner is a tiny orb. Minutely painted within this glassy sphere is a tiny, green island with trees and a white tower; in front of the island a full-masted ship sails on a silver sea.

Did Shakespeare see the diptych? In his play *Richard II* he gives John of Gaunt this famous speech:

> *This royal throne of kings, this scept'red isle...*
> *This happy breed of men, this little world,*
> *This precious stone set in the silver sea...*
> *This blessed plot, this earth, this realm, this England,*
> *This nurse, this teeming womb of royal kings,*
> *Fear'd by their breed, and famous by their birth,*
> *Renowned for their deeds as far from home,*
> *For Christian service and true chivalry... (Act 2, scene 1)*

The Master of the Trebon Altarpiece (after 1390)

The greatest artist in Prague in the last decades of the fourteenth century was the Master of the Trebon Altarpiece. This artist of unknown name painted with intense emotion, combining the local style with progressive Franco-Flemish currents. He embodied the ideas of the *devotio moderna*, the new spiritual movement spread throughout Europe mainly by the Augustinian Order, which enlivened an individual's faith with a deep personal experience. In the National Museum in Prague are fragments from an altarpiece. Christ rises out of his tomb, standing majestically and compassionately against a star-studded, red sky, while the soldiers crumple in fear. The faces are strongly modelled and the bodies solid, but the essence of Gothic art remains.

The Ales Gallery is out in the Bohemian countryside in the precincts of Hluboká Castle. This gallery is filled with early Gothic paintings and sculptures including an

enchanting *Adoration of the Child* (p. 43). After recent cleaning it became clear that this picture, painted after 1390, is also by the Master of the Trebon Altarpiece. The earthiness of Giotto combines with the supreme mysticism of Martini. Here is 'the simple humble girl, still in her youth, and little more than a child' that Julian of Norwich saw. Kneeling on a brocade cushion she worships her son and Saviour with loving simplicity. As the most important people in the picture Mary, Joseph and Jesus are several times larger than the shepherds and the animals, which are painted with great verity and affection. Even the doves on the stable roof dance with joy. This almost unknown painting epitomizes the strength and beauty of Christian art at the end of the Middle Ages.

CHAPTER 3

The Humanization of Faith

[T]hey have sailed the stormy sea of this life in great calm, with serene spirit and tranquil heart, because obedience together with faith has taken away all darkness from them. They are courageous and confident because by shedding their own will, the source of all weakness and disordered fear, they have shed weakness and fear.
Catherine of Siena (1347–80), *The Dialogue*

The cloak of the church that covered Christendom began to fray as winds of worldliness blew across Europe. Gradually the old medieval order crumbled as the idea of nationhood and the power of nations grew, and the attraction of a foreign pope waned.

In *The Decameron*, written about 1350, Boccaccio tells the story of a Florentine merchant who wants to convert his much-loved Jewish friend to Christianity. The Jew, who believed in doing things properly, went to Rome. He failed to meet the pope but had ample opportunity to see the debauchery of clerics from the highest to the lowest. He returned to Florence where his friend feared he had been put off Christianity. On the contrary, the Jew observed, if the church could continue to stand despite the degeneracy of its leaders it must be of God. The Jew proceeded to be baptized.

A new spirit of enquiry was in the air; science was replacing symbolism, authority was questioned, and the revival of classical learning placed a new attention on people and their interests. Yet the flowering of personal, spiritual experience, written about by mystics such as Julian of Norwich, Catherine of Siena and Thomas à Kempis, and illustrated by great artists, reflected an underpinning of faith.

After Giotto's innovations, nearly a century passed before Pandora's box was really opened, and out flew conceptions of space, impacts of light, examinations of volume and structure (particularly of the human body), and new techniques for handling paint – in short, what became known as the Renaissance.

Frescoes continued in popularity, and it is instructive to consider the evolution of art in Tuscany through this medium. As they were attached to the wall, frescoes, like mosaics, are still (with a few exceptions) in the convents, churches, and chapels in which they were conceived. Frescoes by Fra Angelico, Benozzo Gozzoli, Tommaso Masaccio and Piero della Francesca are of particular artistic importance.

Fra Angelico
(c.1387–1455):
The Transfiguration.

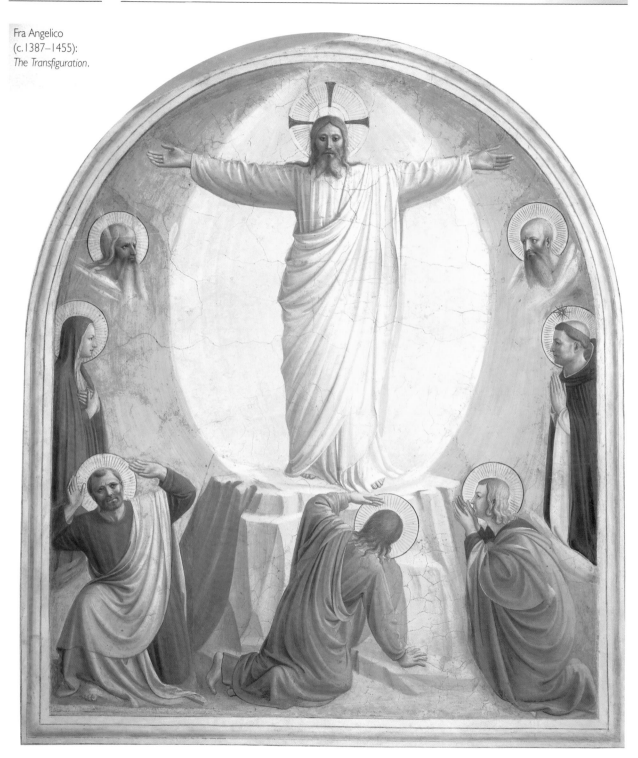

Venice

Like Florence, Venice was another city of the Renaissance. As well as being a commercial and economic hub, it was a great artistic centre.

Venice was the only Roman community unconquered by the barbarians. It was built mainly by the inhabitants of Aquileia after they fled from Attila the Hun, on a lagoon beside the sea. 'Her Serene Republic', as it was called, was one of the most glorious in history. The first duke, or doge, of the republic was elected in AD697 and there were 120 doges in direct and unbroken succession until Napoleon destroyed the republic in 1797. He then sold Venice to Austria.

Venice was rich, beautiful and exotic – a romantic city on the water untroubled by wheeled transport. Her power was great on land and sea. Her ships brought spices, silk, Greek manuscripts and rare pigments from the East. The imperial mausoleum in Constantinople, where Constantine the Great was buried in AD337, was the architectural inspiration for St Mark's Basilica in Venice 500 years later. Whenever they set off on voyages to the East, Venetian captains had to bring back some precious object or stone to contribute towards the decoration. Subsequently this splendid church, glittering like an encrusted reliquary, with its five domes in Islamic style, became the most impressive reflection of the eastern Roman empire still in daily use.

Fra Angelico (c.1387–1455)

Even though he was summoned to Rome and offered the archbishopric of Florence when it fell vacant in 1445, Fra Angelico refused the position. Just as Thomas Aquinas refused worldly power in the church to commit his life to scholarship, Fra Angelico, also a Dominican monk, concentrated his energies on the considerable talent for painting God had given him.

Giorgio Vasari, the sixteenth-century artist and art historian, wrote of him:

> Fra Angelico led a simple and devout life… He lived in purity and holiness, and befriended the poor… He worked continuously at his paintings, and he would choose only holy subjects. He would often comment that anyone practising the art of painting needed a quiet and untroubled life and that the man who occupies himself with the things of Christ should live with Christ… [he] would never take up his brushes without a prayer. Whenever he painted a crucifixion the tears would stream down his face; and it is no wonder that the faces and attitudes of his figures express the depth and sincerity of his Christian piety.

Humility, gentleness and faith pervade Fra Angelico's paintings.

Scenes from the life of Christ were painted on one wall in each of the forty monks' cells in the Convent of San Marco, where Fra Angelico lived. Dominating their austere surroundings the frescoes were designed as aids to meditation; contemplating a devotional picture kept the mystery of faith in the forefront of the monk's mind.

Fra Angelico was in charge of the project, and paintings in six cells have been credited to his hand alone. His refined use of colour, delicate draughtsmanship, and sensitive handling of the subject matter imbue these frescoes with a sense of peace.

In *The Transfiguration* (p. 46) in cell six, Christ stands majestically on a rock within a white mandorla, the almond-shaped symbol of the glory of heaven. His arms are outstretched, as on the cross, to receive all humanity, and the heads of Moses and Elijah appear, one each side, outside the mandorla. There is sorrow and joy: the sorrow of sin which disfigures humankind, for Christ had not yet risen, and the joy of the resurrection, to which Christ alludes here, through which lives are transfigured. The three apostles, St Peter, St James and St John, crouch on the ground in astonishment and awe.

Noli Me Tangere was painted in cell one. Fra Angelico places Mary Magdalene at the mouth of the empty tomb, on her knees, her hands out to clasp her Lord. But he gently forestalls her because he must first go to his Father. It is an intimate and holy scene. When Mary, the loose-living convert, had washed Christ's feet with her tears 'and wiped them with the hair of her head, and kissed his feet, and anointed them with the ointment' (Luke 7:38), much to the horror of the respectable Pharisees with whom Jesus was eating, he told them a story about forgiveness. Then he said, 'her sins, which are many, are forgiven, for she loved much' (Luke 7:47). And then he told her, 'Your faith has saved you; go in peace' (Luke 7:50).

She knew how much she was loved; and now, having defeated death, Christ was revealing himself first to her. What grace! '[T]hough your sins are like scarlet, they shall be as white as snow' (Isaiah 1:18). Fra Angelico painted the figures in an enclosed garden to which he added trees, plants and flowers, making the fresco more detailed than those in the other cells.

Although the monks have gone and San Marco is now a museum, Fra Angelico's cell murals still have much to say to an open heart and a quiet mind. Inlaid in the memory, these images can reappear at unexpected moments to stimulate prayer and praise.

Benozzo di Lese di Sandro Gozzoli (c.1421–97)

Benozzo Gozzoli learnt his trade on the walls of San Marco. Fra Angelico taught him how to combine the exquisite, ornamental, 'other-worldly' values of the International Gothic style with the plasticity of Masaccio, whom we shall meet later. Significantly, as it turned out, Gozzoli was almost solely responsible for painting *Adoration of the Magi* in cell thirty-nine and *Crucifixion* in the entrance hall outside. These rooms were kept for Cosimo de Medici, patron of the convent and effective ruler of the city, for those times

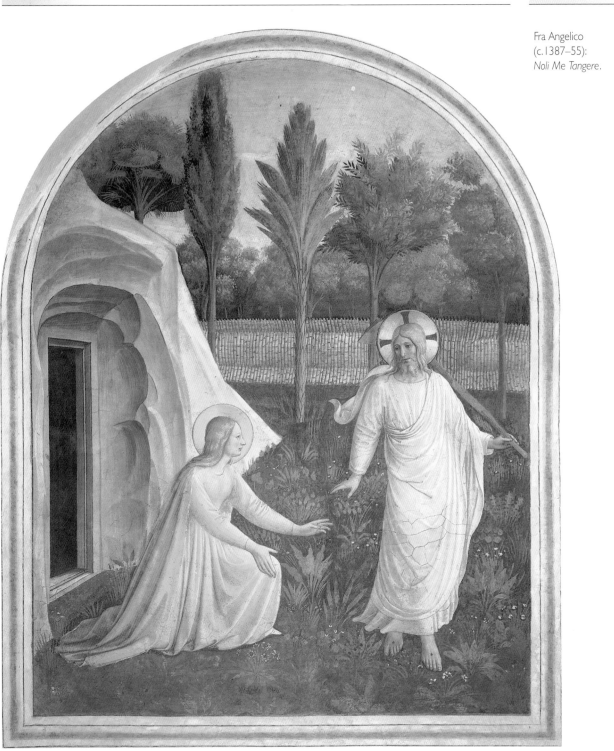

Fra Angelico
(c.1387–55):
Noli Me Tangere.

when he wanted to retreat from his pursuit of worldly power to contemplate a higher authority.

Gozzoli acquired a wider range of technical skills than an apprentice normally picked up in a typical Florentine workshop, ranging from the art of manuscript illumination to goldsmith work on Ghiberti's bronze *Doors of Paradise* for the Baptistry. All this was to his advantage when Cosimo, who knew his work in San Marco, decided to award him the contract to paint the walls in the Medici private chapel in the palace Cosimo had built as his official family residence in 1459, now the Palazzo Medici-Riccardi.

This was a coup for Gozzoli. Florence was teeming with many, more outstanding, artists and this was a prestigious commission. But Cosimo was no fool. He was only too aware, in the invigorating climate of humanist Florence, that the avant-garde artists would surely have refused his offer. He wanted his chapel to outshine the fabulous splendour of *Adoration of the Magi*, painted by Gentile da Fabriano for the Medicis' arch-enemies, the Palla Strozzi, more than forty years before for their chapel in Santa Trinita (Uffizi). Gozzoli had to look back to an earlier, more decorative style.

But whereas Fabriano crowded his conception of the event onto a panel enclosed within a Gothic gilt frame, Gozzoli had the walls of a chapel on which to expand the narrative. To set the scene he painted *Lamb of the Apocalypse* over the entrance. Inside the chapel he painted *The Journey of the Magi to Bethlehem*, showing the procession from Jerusalem to Bethlehem.

Gozzoli worked fast, with the help of at least one assistant, under the eagle eye of Cosimo de Medici's son, Piero. Alternating true fresco with dry, he was able to work with meticulous care, as if he was again illuminating a manuscript. Jewellery, rich brocades and harnesses inlaid with gold seem 'real'. And how the gold must have glittered when candles flickered.

Roads wind up the green hills of Fiesole to castles at their crests, and rivers meander through plush meadows as in a Flemish painting. It is a fairy-tale landscape where the princes are riding, not to wake up a sleeping princess, but to bow down before the King of kings.

Adorned with crowns, Gaspar, Balthazar, and Melchior represent the three ages of man. They look more like kings than members of an ancient Persian priestly caste, and ride with chivalrous splendour. Protocol is strictly observed. The kings are accompanied by noblemen who entertain themselves along the way by hunting with hawks, hounds and cheetahs. Groups of citizens follow. Here is life in all its variety and fecundity: the glitter and finery of Florence, fruits of a banking and trading town that also appreciated culture and beauty and faith. The faces all portray individual character, filled with a strong sense of community and civic pride. Each knew his role in society: 'For the body does not consist of one member but of many' (1 Corinthians 12:14). This is a long way from colourless, egalitarian conformity.

The handsome, young Gaspar is mounted on a richly caparisoned, grey horse. He looks thoughtful as he rides by in the clear, crisp light. He has time to contemplate Herod's words and to wonder with eager anticipation about Emmanuel – God with us. The three kings bring gold, frankincense, and myrrh, and these rulers of this world are about to present them to the king who has come down from heaven; gifts for the Christ

Benozzo di Lese di Sandro Gozzoli (c.1421–97): *The Journey of the Magi to Bethlehem*, Palazzo Medici-Riccardi, Florence.

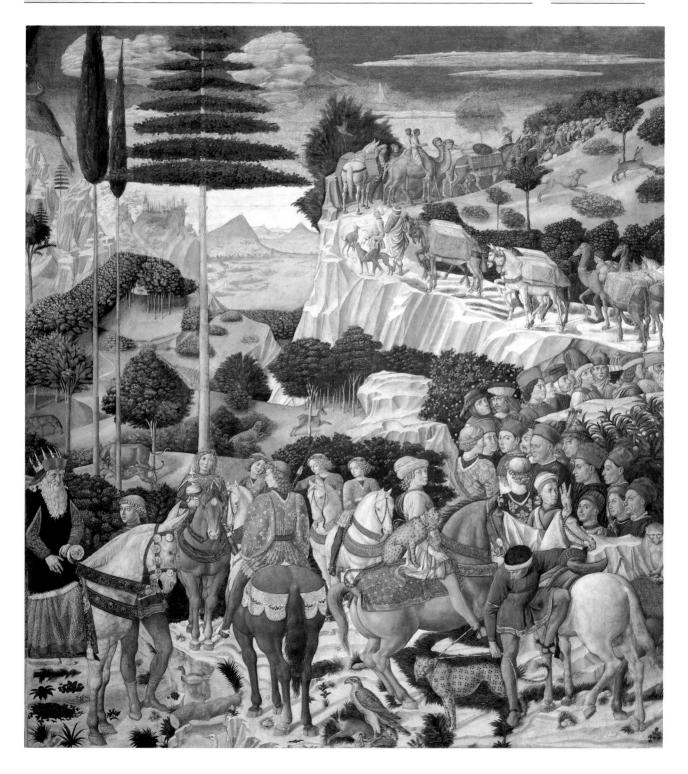

Tommaso Masaccio
(1401–28):
*The Holy Trinity with
the Virgin and St
John*, Santa Maria
Novella, Florence.

FACING PAGE:
Tommaso Masaccio
(1401–28):
*Expulsion from
Paradise*,
Brancacci Chapel,
Santa Maria del
Carmine, Florence.

child who has already received the love of Mary and the prayers of the angels. Everyone is dressed in their best clothes, but all their worldly trappings are nothing beside the baby enclosed in swaddling clothes and tucked up in a manger. In a painting on the altar Christ is adored by his mother. On the walls at each side angels assemble to sing his praises. Other angels fly down from heaven through a royal blue sky, reclining on clouds that look like magic carpets, skimming the palm, cypress, and umbrella pine trees to reach their destination and fulfil their purpose: to worship God on earth as in heaven.

Tommaso Masaccio (1401–28)

The angels in Tommaso Masaccio's paintings are more decorous. Masaccio was involved in the humanistic avant-garde led by the sculptor Donatello and the architect Brunelleschi. The latter cracked the mathematical codes of perspective through studying the ancient ruins of Rome, and went on to design the magnificent dome of the Duomo which still stands out as the landmark of Florence. Their aim was to exalt human values.

Masaccio was a genius who died at the young age of twenty-eight. His fresco *The Holy Trinity with the Virgin and St John* in the church of Santa Maria Novella was the first picture that contained, according to Vasari, 'a barrel vault drawn in perspective, and divided into squares with rosettes that diminish and are foreshortened so well, that there seems to be a hole in the wall'. Masaccio could paint backgrounds so utterly convincingly that space seems to manifest itself in three dimensions.

But Masaccio's masterpiece is *Life of St Peter*, which, together with Masolino, he was commissioned to paint on the walls of the Brancacci Chapel in Santa Maria del Carmine in 1423. The project took four years to complete. The overall programme is a *historica salutis*: an history of the salvation of mankind through Christ, mediated by the church which is represented by St Peter. The story begins with *Expulsion from Paradise*, which is the prelude to Christ's salvation. Adam and Eve have been cast out from the garden, and this naked, very human pair are hunched in pain and sorrow, creased by shame

and agony. Yet they have lost none of their dignity or beauty as they step out into the wasteland of alienation from God.

In the scenes with St Peter, the people milling about the distinctly Florentine streets are all dressed in the latest fashions, except for the poor. Some are recognizable as portraits; the blind man is the sculptor Donatello. Peter walks, lost in thought, yet the sick are healed by his shadow as he passes by. How tenuous, yet how total. A miracle of grace is coupled with the miracle of a new artistic discovery: painting shadows accurately was another breakthrough by Masaccio.

In contrast to this ephemeral quality, Masaccio gives his background landscapes an entirely new and earthy concreteness, coupled with perfect linear perspective.

In *Tribute Money*, taken from Matthew 17:24–27, the scene opens with the tax collectors' demand, continues with Christ's immediate response as he indicates to Peter where to find the necessary money, and moves on to that moment when St Peter

Tommaso Masaccio (1401–28): *Tribute Money*, Brancacci Chapel, Santa Maria del Carmine, Florence.

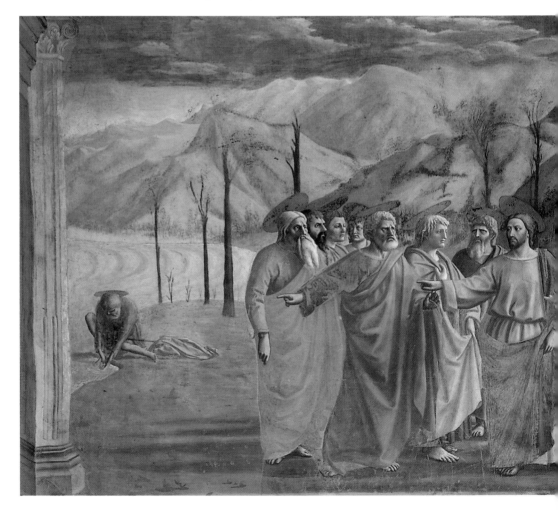

catches the fish, extracts the gold coin from the fish's mouth, and hands it to the tax men. The characters play out their roles with the power and conviction of classic theatre. There is no virtue in causing needless offence, for as Jesus demonstrates he can supply all our needs: he always wants to give what is pure and precious.

Piero della Francesca (c.1420–92)

The Piero trail leads from Florence through Tuscany. Piero della Francesca grew up in the little Tuscan town of San Sepolcro, and spent most of his working life away from the great cities. He was ignored by his contemporaries; indeed he was ignored until Vasari wrote his biography in 1550. But not even Vasari realized that, more than any other artist,

Piero della Francesca
(c.1420–92):
The Baptism of Christ.

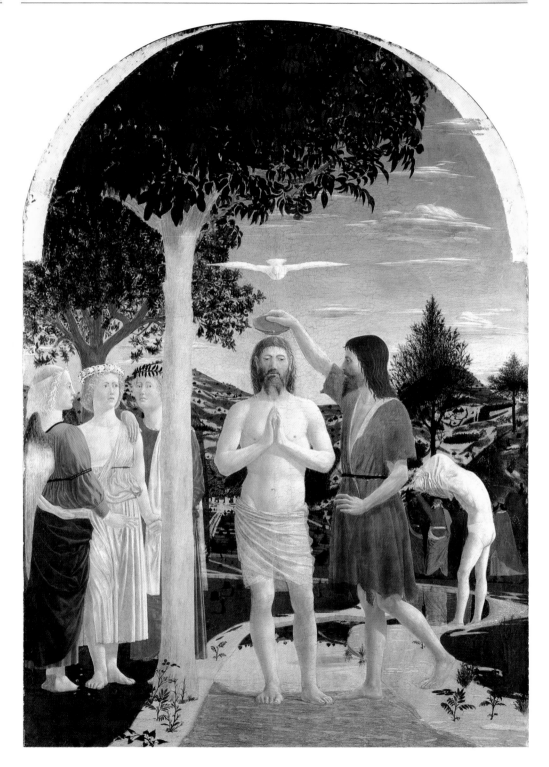

Piero was responsible for the development of Florentine Renaissance painting, and for spreading the principles of this new art throughout Italy. Piero perfected the synthesis between the Italian concentration on perspective and space and the Flemish emphasis on light and detailed realism. By the end of the fifteenth century, the Netherlandish oil painting technique, with its brightly coloured, transparent glazes and minute detail, had captivated Europe.

Piero arrived in Florence in the 1430s. By then the city was bursting with creativity. Masaccio had completed his work in the Brancacci Chapel, and Brunelleschi was finishing the Duomo dome. Piero took all this in. He also looked at Fra Angelico's masterpieces and studied Uccello's experiments with perspective. He worked with Domenico Veneziano on the frescoes for San Egidio (now sadly lost) and then returned to San Sepolcro. In 1441 he became a town councillor.

The poetic *The Baptism of Christ* was Piero's first major commission, painted in egg tempera, for the altar of a chapel dedicated to St John the Baptist in the Camaldolese Abbey. The light falls gently from above. The clear, pure light of the Holy Spirit hovers like a snow-white dove among the flat, white clouds, suspended above Christ's head, as his cousin St John baptizes him. The water trickles over Christ's pensive face. It is the face of a simple countryman standing with the grace of a sculpted Greek god, his hands united in prayer. Like the dove, Christ stands face on, his accurately foreshortened feet solid on the muddy riverbed of the Jordan. A tree, symbolic of Christ's family tree, grows beside him, rooted in Jesse, rising through David's line and sprouting delicate new leaves in anticipation of the new covenant. The three young angels, their blond hair garlanded with symbols of peace and plenty above pale, round faces, were inspired by the group of children sculpted by Luca della Robbia for the choir loft in the Duomo of Florence. There they sing their hearts out, praising God, as in Psalm 150. Here they watch silently. And the river is also mirror-still as it reflects the bright clothes of the observing priests, the young man pulling off his shirt in preparation for baptism, and the gentle curve of the hills that rise up behind San Sepolcro. Piero painted with fastidious understatement, with a reticence that is deeply reverent.

Piero's True Cross Cycle (1452–64)

Most of Piero's frescoes have perished. One cycle that remains, albeit damaged, is the *True Cross Cycle* in the main chapel of San Francesco in Arezzo, a stately basilica in a beautiful town. This story is taken from *The Golden Legend*, an history of the Saints written by the monk Jacobus de Voragine in the 1260s. A mixture of pious image and local folklore, the legends wrapped up truth in symbolism. Their popularity reflects the medieval love of miracles.

This legend, which Piero illustrated brilliantly, tells how seeds from the tree of original sin were placed in the dying Adam's mouth. The tree that grew up on Adam's grave was cut down by King Solomon and used to bridge a river. When the Queen of Sheba passed that way she learnt by a miracle that the Saviour of the world would be

Piero della Francesca (c.1420–92): *The Victory of Constantine Over Maxentius – the Battle of Milvian Bridge*, AD312 from the *True Cross Cycle*, San Francesco, Arezzo, Tuscany.

crucified on that plank of wood, and she immediately informed King Solomon, who buried it because he realized this would signal the end of the Jewish kingdom. But the plank was found, again miraculously, and became the cross on which Christ was crucified. Three hundred years later, on the eve of battle against Maxentius, the sleeping Constantine was told by an angel that he would defeat his rival if he fought in the name of Christ crucified. Obediently he carried an image of the cross into battle and was victorious. After this his mother Helena travelled to Jerusalem where she found the plank, and through its power a dead youth was brought back to life. Later the Persian king Chosroes stole the precious wood and set it up among idols, but Emperor Heraclius defeated him in battle and took the cross back to Jerusalem, carrying it humbly into the city on foot, in reverence to Christ.

This folk tale is a far cry from Piero's sober and classical painting which was enhanced by his deep knowledge of Euclid's geometry. In his frescoes he transformed the story into an epic poem. Like Masaccio's *Tribute Money*, the picture of Adam's death is a narrative in three parts. But whereas Masaccio's apostles are emotional and sometimes dramatic, Piero's figures are calm and rational. The ancient Adam sits, barely clad, surrounded by a wrinkled, frail Eve and powerfully built sons, while in the background Seth receives the seeds from the Archangel Michael. On the left, in the shadow of a huge tree, Adam is buried.

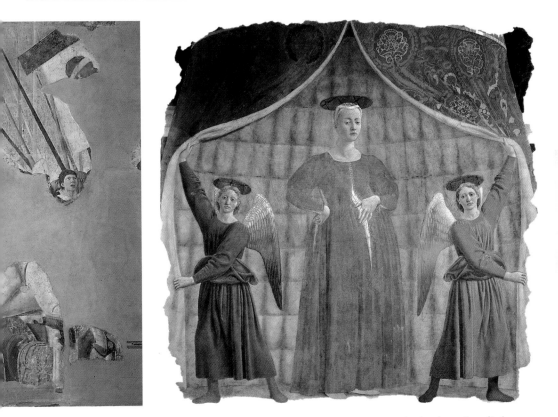

Piero della Francesca (c.1420–92): *Madonna del Parto*, Santa Maria Nomentana, Monterchi, Tuscany.

Piero portrays a new vision of man and nature, set in a magical, changing light – a bluish light that softly moulds figures into three-dimensional forms.

Piero also challenges the problems of night light, sending the angel illuminated by heaven to speak to the sleeping Constantine. This is a powerful and poignant moment; the angel was communicating with the emperor who brought Christianity out of the darkness of persecution to become the light of the empire.

Piero painted this fresco cycle at another crucial time for Christianity. In 1453 the Turks took Constantinople and the first great Christian capital fell to Islam. In *The Victory of Constantine Over Maxentius – the Battle of Milvian Bridge, AD312*, Piero gave the first Christian emperor the face of the last eastern emperor, John VIII Palaeologus. Constantine had carried a symbol of the cross, but a modern emperor could lead Christian armies into war. The life of a soldier in the Middle Ages was not incompatible with a sacred mission, and to exemplify this ideal Piero portrays his champions, not in bloody battle, but marching on nobly, inexorably, beside the river of life which twists and turns through the centuries.

Piero's Madonna del Parto (c.1455)

Piero accepted other commissions during the twelve years he took to complete the Arezzo cycle. He painted *Madonna del Parto* in the cemetery chapel at Monterchi. This Madonna,

protector of pregnant women, is heavy with child. The buttons down the centre of her dress are partially unfastened, a reminder that her body is shortly to release its precious charge, and she lays her hand protectively across the opening. Two angels, mirror images of each other, also prepare for the event as they pull back the curtains of the tabernacle.

How fitting in a chapel for the dead to paint a promise of new life. Simple and solid, leaning back on her heels to balance the weight in her womb, Mary contemplates the future, as no doubt the mourners did as they watched their loved ones buried. She is calm, a balm to troubled hearts.

The chapel had become damp and, as this threatened to damage the fresco further, conservators removed it from the wall and re-backed it. After cleaning, the colours have regained their vibrancy; in restoration, the later accretions were removed. The fresco is now enclosed by glass and displayed in a small museum in the village.

Piero's Resurrection *(c.1458)*

Perhaps Piero's most famous work is *Resurrection* which he painted for his home town. With a name like San Sepolcro (holy sepulchre) it was perhaps unsurprising that the town's emblem was the resurrection. The glorious message of Christ's victory over death figured on the city's flags and fluttered from banners held high by its citizens.

Piero painted *Resurrection* for the town hall. He used the sacred images of previous centuries (he was probably inspired by the fourteenth-century polyptych in the cathedral), but transformed them into a new language. Piero framed his composition with two fake marble columns, and divided it into two perspective points. The lower part, where he placed his sleeping guards, has a very low vanishing point. Instead of being on the level of the figures' eyes, as Alberti in his theoretical writings had suggested, Piero projected the point onto the guards' feet, thus foreshortening them. As a result, the guards seem imposing in their monumentality. In contrast, Christ is not seen from below but frontally, and in the centre of the picture, as in *The Baptism of Christ*. He has the same face but older and, instead of lowering his eyes to receive the Spirit within himself, his countenance compels you to believe that, through defeating death, he gives eternal life. One solid foot rests on the vanquished tomb; one hand clasps the banner of victory. 'Thus it is written, "The first man Adam became a living being"; the last Adam became a life-giving spirit' (1 Corinthians 15:45).

Behind Christ the landscape is already responding, for in traditional fashion Piero painted one half in the dead of winter and the other bearing the green mantle of spring to represent the old and new covenants with God.

Piero's Christ epitomizes the ideal human being, whole in mind, body and soul, a man full of wisdom, compassion, honour and strength. What an example and inspiration this painting must have been and still is – and not only for the citizens of San Sepolcro.

Piero della Francesca (c.1420–92): *Resurrection,* San Sepolcro, Tuscany.

Giovanni Bellini (c.1430–1516)

Giovanni Bellini was the brightest member of a family of brilliant artists. Influenced by imported Byzantine and Flemish paintings, Bellini guided Venetian art along a different road to that the Florentines trod. There was less emphasis on drawing, and form tended to be defined by colour rather than by line. As a maritime power Venice had a big ship-building industry. The canvas cloth used for making sails was easily available, and increasingly artists used this material as a support. Compared with a finely prepared wooden panel, canvas has a coarse texture which suits freer brush strokes. Canvas was also considerably cheaper than panel, so it was possible to cover large areas of wall with it. A suitable alternative to fresco in a damp city was thus provided.

Giovanni Bellini
(c.1430–1516):
Pietà.

During his sixty-year-long career Bellini managed to keep abreast of new developments while conserving his links with tradition. One recurring theme in his work is *Passion Portrait* of Byzantine origin which was introduced into the West via Venice. These pictures helped the Christian empathize with Christ the martyr, the innocent victim; to look at Christ's pain can also help to ease our own. A fine example is Bellini's *Pietà*. The dead Christ, with head bowed and the hands that healed and blessed now lying helpless, is propped up in his sarcophagus by two angels. After all the suffering he has undergone, which culminated in the crucifixion, he is now utterly devoid of human contact – alone, dead. This is the last view of Christ's body before the resurrection, an excruciatingly poignant and poetic moment as the day fades and the light is gone.

In *The Agony in the Garden* (p. 64), Bellini places his figures out of sight of the city in a landscape which would have been familiar to his contemporaries – a country full of footpaths. He brings the scene into the present via the stone pre-dieu, which was the usual place for private prayer, to remind us that Christ's passion is re-enacted daily through our sins. His friends were unable to keep awake and support him as he prayed, '"Father, if thou art willing, remove this cup from me; nevertheless not my will, but thine, be done." And there appeared to him an angel from heaven, strengthening him' (Luke 22:42–43).

But whereas in *Pietà*, the sun was setting on death, here Bellini paints the sun rising pinkly on the horizon. 'Weeping may tarry for the night, but joy comes with the morning' (Psalm 30:5).

On his brother Gentile's death in 1506, Bellini inherited his father Jacopo's celebrated sketchbooks. There was one condition attached. He must finish Gentile's large canvas painting *The Sermon of St Mark in Alexandria* commissioned by the Scuola Grande di San Marco two years earlier. The style of architecture which encloses this composition on three sides is Oriental. Gentile had accompanied a diplomatic mission to the east in 1479. He painted a celebrated portrait of the sultan, *Sultan Mehmet II*, and possibly journeyed from Constantinople to Jerusalem on a pilgrimage. The painting focuses on the crowd gathered around the rostrum where St Mark the Evangelist stands. St Mark is preaching to sixteenth-century people in contemporary dress, but they are as varied as the multitude on the Day of Pentecost.

Giovanni Bellini
(c.1430–1516):
*The Agony in the
Garden.*

St Mark was not the original patron saint of Venice, but when the Venetians annexed him in AD827 his emblem, the winged lion, became so synonymous with the city it was hard to believe he had not been born there. St Mark's Gospel stresses the regal status of Christ, the lion of the tribe of Judah. The lion of St Mark, arrogant and alert, perfectly symbolized the policy of a great commercial empire. Wherever Venice imposed herself, the winged lion of St Mark was seen with a paw resting on a book open at a page on which was written, *Pax tibi Marce evangelista meus* ('Peace be with you Mark my evangelist'). This

was the greeting the saint reputedly received from an angel when he was shipwrecked on a desolate island in the lagoon on his way to preach in Aquileia. Although Venice is no longer a republic the Venetian lion, chiselled out of a slab of marble, still haunts old victories, and still guards the gate in far-off cities like Famagusta.

Legend reports that St Mark was martyred and buried at Alexandria in Egypt in a church near the eastern harbour. One day in AD827 two Venetian sea captains decided to steal his remains and take them to Venice, a Christian city. They persuaded the guardian of St Mark's tomb to exchange the saint's remains for another's, and then they placed the sacred relics in a basket beneath cabbages and pork, which they knew the Muslims would not investigate. But as they set sail the evangelist himself nearly betrayed them. As they removed his remains from the tomb a sweet smell pervaded the town. The inhabitants were accustomed to this fragrance every year when St Mark was reputedly 'stirring'. People ran to the tomb but were deceived by the substituted bones. Thus the Venetians successfully rescued the saint from a Muslim country and carried him over the sea to Venice, where he was immediately adopted. The devotion to relics was an ancient one. The body of a holy person was precious for it was a contact with the supernatural, and relics were placed on the altar to make it a sacred place for the Lord's Supper.

Andrea Mantegna
(c.1431–1506)

Giovanni Bellini's sister Nicolosia married Andrea Mantegna. Mantegna had studied classical art and its influence was always present in his painting. The relationship between the two brothers-in-law can be measured in their paintings of the agony in the

garden executed in the 1460s. They are both now in London's
National Gallery.

In *The Agony in the Garden* Mantegna's fascination with stone
transforms his rendering of this troubled scene into a symbolic

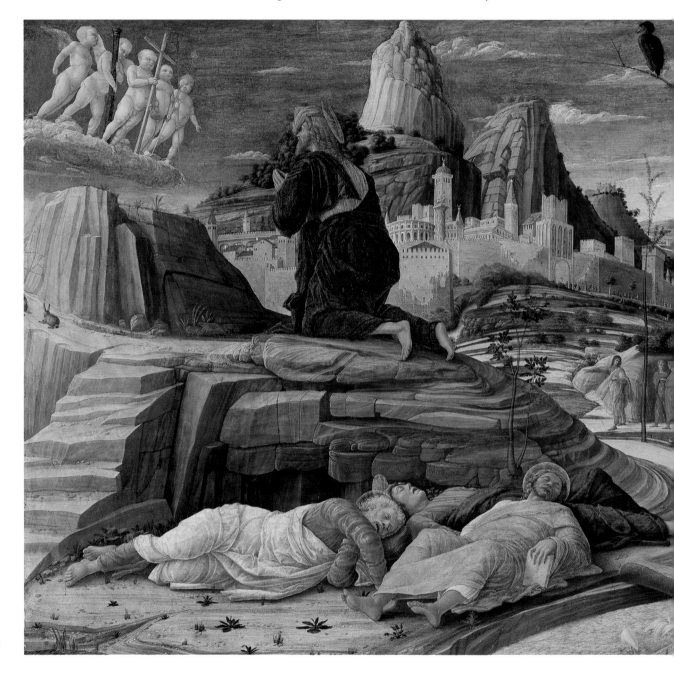

meditation on 'The Lord is my rock, and my fortress, and my deliverer, my God, my rock, in whom I take refuge' (Psalm 18:2). An imaginary ancient Jerusalem rises up from a rocky scarp. Stone steps lead up to the stone altar of sacrifice before which Christ kneels and prays at this his final hour of freedom, the stepping-stone between the Last Supper and the crucifixion.

There is a primitive harshness about the scene. Christ's fears are made visible as he surveys the instruments of his passion, which are displayed by five angels who are naked like the athletic babes of ancient art. The Old Testament decreed, 'you shall give life for life, eye for eye' (Exodus 21:23–24). Now Christ is being asked by his Father, in this bitter moment, to be the final sacrifice for the sins of the world. A vulture waits silently for its prey, and the apostles are heavily asleep. Again Christ is abandoned.

Andrea Mantegna (c.1431–1506): *The Agony in the Garden.*

Vittore Carpaccio (c.1460–c.1525)

Vittore Carpaccio was a born storyteller – in paint. He illustrated stories from *The Golden Legend* with precision and wit, combining reality and fantasy in perfect balance. Animals and architecture add weight to his compositions. Half a century after the Dalmatians founded the Scuola di San Giorgio degli Schiavoni in 1451, Carpaccio was commissioned to paint highlights from the lives of the three Dalmatian patron saints, Jerome, Tryphon, and George. His evocative paintings still line the walls of the little Scuola. St George looks like one of Malory's Knights of the Round Table out on an adventure. He leans forward on his prancing horse and aims his lance straight through the dragon's head on a field littered with half-eaten people, while the princess watches with relief.

Animals are prominent in these pictures. They enter the story of good and evil although their role is not always clear. In *St Jerome and Lion in the Monastery* (p. 68), the monks flee in terror from the lion. They do not realize that St Jerome has extracted a thorn from the lion's paw and the beast has become his friend, even though he vaguely gestures towards the animal. The monks look very agitated as they run for their lives. The one closest to St Jerome looks back at him reproachfully. After all it was not that long since Christians had been thrown to the lions. And St Peter had warned Christians to be careful, for their enemy 'the devil prowls around like a roaring lion, seeking some one to devour' (1 Peter 5:8). Meanwhile the birds on the grass do not move. A squirrel and even a timid deer in the background continue grazing. They are not afraid of St Jerome, who was an impressive but cantankerous classical scholar.

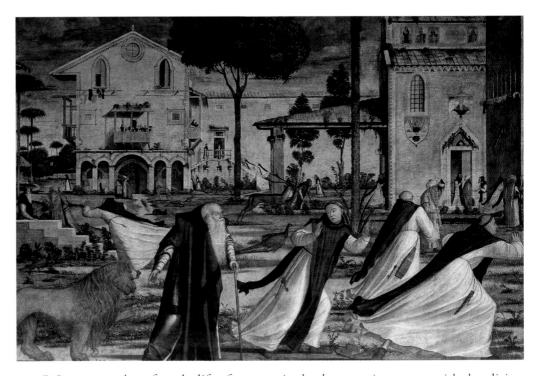

Vittore Carpaccio
(c.1460–1525):
*St Jerome and Lion
in the Monastery*,
Scuola di San
Giorgio degli
Schiavoni, Venice.

St Jerome may have found a life of penance in the desert easier to cope with than living with people. But he left the desert in AD380 and moved to Constantinople where he began translating the Psalms into his native Latin. After a spell in Rome as secretary to the pope he went to Bethlehem where he spent the rest of his life translating the Bible into Latin. As one of the four fathers of the church, St Jerome was a popular subject for artists. He was usually painted as a hermit in the desert or as a scholar in his study. Only Carpaccio painted him in this amusing way. But perhaps a lion should have the last word in Venice.

CHAPTER 4

The Flemish Altarpiece

*Christ will come to you and show you his comfort if you will prepare
for him a worthy house in your heart. All his loveliness and his glory he
keeps for the house of the soul, and there it is that he takes his pleasure.
Many are the times he comes to the man who lives the inward life, and
to him he grants sweet conversation, glad comfort, great peace and
amazing friendship.*
Thomas à Kempis (c.1380–1471), *The Imitation of Christ*, Book 2:1

Art in the north grew out of a different root from that in Italy. As the Roman empire declined, the restless and warlike tribes of the north – Goths, Saxons, Vandals, Danes and Vikings – were more interested in raping and pillaging than in absorbing Hellenistic cultural traditions. But gradually, as the light of Christianity dispersed the Dark Ages, northern Europe produced its own masterpieces of architecture, sculpture, and painting. In contrast to the classical clarity of Italy, the idiom of the north was tortuous, spiky, and expressive. As frescoes were poorly suited to the northern climate, sculpture and stained glass windows were the chief visual means of arousing faith in Romanesque, and then Gothic, cathedrals and churches.

During the fourteenth and fifteenth centuries a widespread devotional movement occurred throughout Europe, and books such as *The Imitation of Christ* by Thomas à Kempis were a helpful guide to living the Christian life. This *devotio moderna* enabled the church to survive its own follies and protected it against the pagan elements of the Renaissance.

The Renaissance had implications beyond the revival of classical learning. Art, letters, philosophy, science, and religion all received a breath of fresh air. Life was changed by new discoveries such as Copernican astronomy, voyages of exploration, the printing press, and gunpowder. Trade and commerce expanded with new methods and markets, and the restrictive practices in the guilds of the Middle Ages gave way slowly to individual initiative. This transition from medieval to modern Europe occurred gradually over the course of two centuries. However 1453, the year the Turks took Constantinople, is often seen as the turning point when Greek scholars fled west and so stimulated the rebirth of culture.

The religious revival had a stabilizing influence on all strata of society, particularly in

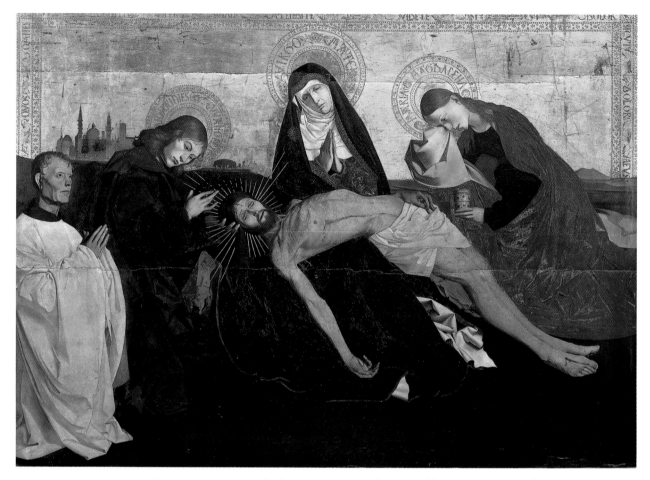

The *Villeneuve Pietà*
(c.1460).

the Low Countries and the Rhineland where small communities of lay people lived according to the rule of a religious Order. Books of Hours were produced to enable educated people to pray at home as well as in church. These books contained shortened versions of the offices, prayers, and Bible readings for the canonical, monastic hours of the day, and they were often exquisitely illustrated with illuminated miniatures. They were influential in the development of altarpieces.

As the devout walked deeper into their interior lives, and as they went on pilgrimages of faith, many experienced visions and prophecies. These pictures from another realm – joyful visions of Mary, painful pictures of the passion – were shared with artists who transformed them into paintings, often for altarpieces.

Altarpieces did not exist in the early church. The altar was free-standing and the celebrant stood behind it facing the congregation. By the ninth century reliquaries were placed on the altar as devotion to saints and reverence of their remains grew – particularly when miracles occurred in their presence. As pilgrimages grew more popular these shrines were

removed to a more suitable position in the church, and their place taken by a tabernacle where the host (consecrated communion wafer) was kept, under a crucifix. Gradually an image of the saint to whom the church was dedicated was placed on the altar, either alone or venerating Christ or Mary. Smaller scenes illustrating the life of the saint were painted below, on the predella. Eventually these altarpieces, which focused on the beginning and end of the life of Christ, became the focal point of the church.

Works of art were often commissioned as a sign of piety, for here were flesh and blood people in the painted presence of their patron saint, leading the way in a daily mass to worship God, and praying to Mary and all the saints in preparation for their own future bliss. Belief in the 'communion of saints' is part of the Church of England creed as well as Roman Catholic practice; part of the seamless rhythm of existence that extends beyond death. But the example of Christ and the saints had to be followed to obtain life in the hereafter. Again pictures were a visual reminder.

The *Villeneuve Pietà* (c.1460)

The *Villeneuve Pietà*, painted for the Charterhouse of Val-de-Benediction by an unknown artist, is a masterpiece that encapsulates the profundity, dignity, and internationalism of the *devotio moderna* movement. Even though an all-gold background had long been obsolete in paintings, here it serves to emphasize the austere tragedy of the event as the dark, mournful figures of St John, Mary mother of Jesus, and Mary Magdalene are silhouetted against its lustre. The pale, angular figure of the dead Christ, lifeless upon his mother's lap, lies below the low horizon, earthed in death, while the kneeling priest on the left of the picture reminds us, centuries later, of how a mortal human being can share in the timeless grief of the crucified Lord.

Hubert (d.1426) and Jan van Eyck (c.1390–1441)

One of the greatest of these altarpieces in size and impact, in artistic virtuosity and spiritual depth, is *The Adoration of the Lamb*, from the Ghent Altarpiece, painted by the brothers Hubert and Jan van Eyck for the church of St John the Baptist in Ghent (which later became St Bavo Cathedral).

After Hubert van Eyck's death *The Adoration of the Lamb* was eventually completed by his younger brother Jan, who was kept busy as court painter to Philip the Good, Duke of Burgundy. Like Peter Paul Rubens two centuries later, Jan van Eyck served his master as a confidential envoy and the duke obviously thought highly of him for he became godfather to one of Jan's sons.

The Burgundian lands stretched from the Alps to the North Sea. The larger Flemish

towns were centres of world trade; merchants as well as noble families were extremely wealthy. Everything was sumptuous, as can be seen in illuminated books and paintings, from the furnishing of interiors to the precious stones and brocaded fabrics. Philip the Good was a great patron of the arts, and traces of his picturesque court still remain in Bruges and Dijon.

Like all altarpieces *The Adoration of the Lamb* was closed on working days. Shut, it measures 4 m by 3 m. The colours on the outside panels are somewhat muted. Van Eyck painted the light that streamed into the Vijd Chapel (named after Joos and Isabella Vijd who commissioned the altarpiece) from the right in his painting so that it was in complete harmony with its setting. (Unfortunately, for security reasons, the altarpiece was recently moved into the specially reinforced and windowless baptismal chapel at the back of the cathedral, but at least it is still there.) The donors look very devout as they kneel in prayer. Between them, painted in grisaille to look like sculptures, St John the Baptist holds his lamb and St John the Evangelist clasps a snake-filled chalice. According to legend a pagan priest at the Temple of Artemis in Ephesus challenged St John to drink from a poisoned cup, which he did without ill effect.

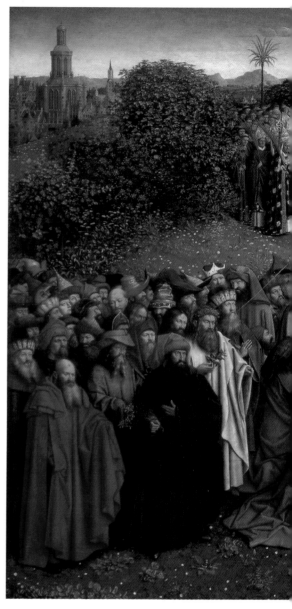

The central panel contains the annunciation witnessed by the prophets Zechariah and Micah and the pagan sibyls of Eritrea and Cumae who had all foretold the coming of Christ.

When the wings are opened the altarpiece doubles in width to reveal a paradisic splendour on twelve separate panels. Splendid indeed at the time, for Van Eyck had perfected the technique of painting in oil which was still in its infancy. He applied glaze after glaze of pigment (coloured plants and minerals ground to powder and dissolved in linseed oil), building up a sense of reality in meticulous detail.

St John the Evangelist received his Revelation on the island of Patmos:

and lo, on Mount Zion stood the Lamb, and with him a hundred and forty-four thousand... it is these who follow the Lamb wherever he goes; these have been redeemed from mankind as first fruits for God and the Lamb, and in their mouth no lie was found, for they are spotless (Revelation 14:1, 4–5).

Jan van Eyck (c.1390–1441): *The Adoration of the Lamb,* lower half of central panel, Ghent Altarpiece, St Bavo Cathedral, Ghent.

The lamb has been slaughtered and the blood flows from its breast into a chalice on the altar on which he stands, for he lives. Written on the altar frontal are the words spoken at the Lord's Supper, 'Behold the lamb of God who takes away the sins of the world.' At the bottom of the hill a fountain spouts water into a basin, octagonal like the early baptistries, and thence into a stream that flows down, out of the picture onto the real altar where the mass is celebrated. The allusions are many, from Moses striking the rock in the desert, to Jesus explaining to the Samaritan woman who had drawn water for him at Jacob's well at Sychar, 'Every one who drinks of this water will thirst again… the water that I shall give him will become in him a spring of water welling up to eternal life' (John 4:13, 14).

The lamb is surrounded by winged angels, some of whom carry the instruments of his passion as in Mantegna's *The Agony in the Garden*. The altar is placed in a lush meadow which swells with ranks of the redeemed. The skyline above is pierced with Gothic visions of the celestial Jerusalem. Behind kneeling prophets stand noble characters from the Old Testament and classical times who have been saved by their righteous lives. Among them, dressed in white and crowned with a laurel wreath, is the Latin poet Virgil who foretold the dawning of a new golden age through the birth of a child. Virgil was Dante's guide on his journey through Hell and Purgatory in *Divine Comedy*. There he could go no further. Here he is received in Paradise and Dante's words echo round the scene, '"Glory be to the Father, and to the Son, and to the Holy Ghost," all Paradise began, so that the sweet song held me wrapt; what I saw seemed to me a smile of the Universe, so that my rapture entered both by hearing and by sight' (*Divine Comedy*, 'Paradiso', Canto XXVII).

Behind St Paul and St Barnabas and the apostles are grouped popes, bishops, deacons (including St Stephen the first martyr), and prominent non-clerical Christians, some 'confessors' (those who endured persecution for their faith), holy women, virgins, and martyrs who lived in people's hearts through their tales in *The Golden Legend*. Like the holy women in the Ravenna mosaics, they carry palm leaves of victory and their heads are crowned with wreaths.

More of the chosen are drawn towards the lamb in the panels extending out on either side. On the right the holy hermits are led by St Anthony of the Desert with Mary Magdalene behind. Like the holy pilgrims in the adjacent panel led by the giant St Christopher, patron saint of travellers, these men and women had led lives 'in' but not 'of' the world. They inhabit an unspoilt country full of rocks, caves, and greenery. Palm trees remind you of their sojourns in the desert or of pilgrimages to Jerusalem.

On the left side, however, are those who have fought the good fight for truth very much 'in' the world: the just judges who led unpolluted lives, and the Knights of Christ, their armour shining in glory. Just as St George and St Michael fought evil by force of arms, knights went to war to fight the enemies of Christ – infidels or heretics – in order to unite the warring worlds of God and men. Courage and compassion were inherent in the ethics of chivalry until the fifteenth century, when the machinations of diplomacy took over.

Above the lamb three panels dominate the polyptych. Here in Byzantine style is the Deesis: life-size figures of Mary and St John the Baptist intercede with the Almighty, enthroned between them, on behalf of sinners. This feature was normally found in paintings of the last judgment as well as in countless icons. The Almighty, like the Pantocrator, raises his hand in blessing, and as in the mosaics in Monreale, where God and Christ are identical, this serene ruler set within a golden Byzantine canopy could be both God Almighty and Christ the King.

Luminous on the white chalk ground that had been polished smooth as ivory, the pure colours mix harmoniously throughout the twelve oak panels, and blend them together as young saints sing and make music. Every millimetre of these panels is alive with textured detail, from the jewels in the headbands to the tiles on the floor, and every tiny detail is significant.

In complete contrast to the other ten panels, Adam and Eve, Hebrew for 'earth' and 'life', stand naked and alone. They are not hunched and anguished like Masaccio's Adam and Eve in *Expulsion from Paradise* in the Brancacci Chapel, but are static and serene, absorbed in their inner life like all the rest of Van Eyck's figures. Traditionally the forbidden fruit which Eve ate in the Garden of Eden was an apple. Here she holds an etrog, an Oriental citrus fruit used in the Jewish Feast of Tabernacles.

The Adoration of the Lamb, unique in its conception and theological insight, had a profound influence on artists in the Low Countries. The Flemish Primitive School developed from it. Historically, the polyptych reveals much of the Burgundian culture. Artistically it incorporates many painting genres, from portraiture, landscape, and still life to the study of perspective and *trompe-l'oeil*.

Rogier van der Weyden (c.1399–1464)

While Van Eyck was the master of fact in the revelation of faith among the Flemish Primitives, Rogier van der Weyden was the master of feeling. *The Adoration of the Lamb* was designed to be read, whereas Van der Weyden's altarpieces were to be contemplated. Like many other northern artists, Rogier travelled to Italy for artistic and spiritual inspiration. En route to Rome for the 1450 jubilee pilgrimage, he stayed in Florence where he was commissioned by the Medici to paint an *Entombment* and a *Madonna and Child with Four Saints*. Van der Weyden was much affected by the simplicity and monumentality of Fra Angelico's frescoes in San Marco, and he must have been involved in the *devotio moderna*, for he understood exactly the type of painting that was needed for personal prayer and meditation.

A small *Pietà* (p. 76) in Brussels typifies his ability to combine realism and deep emotion with simplicity. The dead Christ has been taken down from the cross, and is surrounded by the three people who loved him most. His mother holds his slim, lifeless body in her arms, and presses her cheek against his to catch the last vestiges

Rogier van der
Weyden
(c.1399–1464):
Pietà.

of warmth before his body stiffens. Simeon had prophesied to Mary, when she presented her baby Jesus in the temple, that '(… a sword will pierce through your own soul also), that thoughts out of many hearts may be revealed' (Luke 2:35). St John the Evangelist helps and comforts her while Mary Magdalene kneels at Christ's feet. Van der Weyden has placed these two as if to protect the central couple from the outside world. It is dusk, and the sun is setting behind the bare hill. It is an end, but also a beginning. As the light fades and hope dies, the three figures are united in a grief that seems, slowly and painfully, to drain them of life too – of the life they knew.

Van der Weyden painted a skull in the foreground beneath the cross; traditionally the first Adam was buried on Calvary, which means 'the place of the skull', and as Christ's blood fell over Adam's grave the first sinner could be redeemed.

Hugo van der Goes (c.1440–82)

Only Hugo van der Goes approached Rogier van der Weyden in emotional intensity. Van der Goes became a master in the Ghent Guild of Artists in 1467, and was much employed in the early years of his career on commissions for civic ceremonies, mainly in Bruges. His masterpiece was the Portinari Altarpiece, a huge triptych nearly 3 m by 7 m when open. It was commissioned by Tommaso Portinari, an agent of the Medici bank in Bruges, for the church of San Egidio in Santa Maria Nuova, a hospital founded by his ancestor in 1286. San Egidio was the church where Piero della Francesca had painted frescoes during his stay in Florence nearly fifty years earlier. Both church and hospital function still.

Hugo van der Goes (c.1440–82): *Christ Child Adored by Angels*, central panel, Portinari Altarpiece.

The triptych caused a huge stir in Florence for the Florentines were not used to such detailed realism. The grisaille figures of Mary and the angel Gabriel on the outer doors could almost have been turned an instant before into stone. Inside, in *Christ Child Adored by Angels* (p. 77), the stage is set for a religious drama with the actors artfully arranged in a *tableau vivant*. Holding centre stage Mary kneels in adoration of her babe who lies defenceless on the ground. The scene conjures up the medieval meditation, 'The mother also knelt to adore him and to render thanks to God saying: "I thank you, most holy Father, that you gave me your Son and I adore you, the eternal God, and you, son of the living God, my Son"' (*Meditations on the Life of Christ*).

They are surrounded by angels whose priestly robes could have been worn in a medieval mystery play. Joseph leans beside a massive column of a ruined palace on which David's harp is carved. Remembering God's command to Moses to 'put off your shoes from your feet, for the place on which you are standing is holy ground' (Exodus 3:5), one wooden patten lies discarded beside him. Rustic shepherds kneel in wonder, jostling to get a better view. They look like real shepherds, who have just arrived from the hills, with their humble peasant faces and crude gestures. Italian artists imitated this idea; indeed Ghirlandaio used the same men as models in his *Adoration of the Child* which still hangs in Santa Trinita.

Portinari and his sons are painted in the place of honour on the left wing, his wife and daughter on the right. All are overshadowed by their patron saints who loom, several sizes larger, behind them. Van der Goes was more concerned with a hierarchical scale than with classical rules of order or perspective; he interrelated the physical and the spiritual, the realistic and the symbolic, with great psychological effect. Figures shrink and grow, depending on their spiritual importance; all express their inner feelings.

In contrast to the lean, grey Flemish December viewed in the background, two vases in the centre of the composition are full of summer flowers, out of the seasonal rhythm for a singular reason. This exquisite little still life, placed on its own plane of reality, would have looked as though it stood on the altar itself, as people came up for the blessed sacrament. As San Egidio was a hospital church the Spanish drug jar, decorated with the grapes of the passion, would have been a familiar sight, that type being in common use. With the sheaf of wheat, the allusions to the Lord's Supper would have been as clear as those in Van Eyck's *The Adoration of the Lamb*.

Ever since God delivered the Israelites from the angel of death and enabled Moses to lead God's people out of slavery in Egypt, the annual festival of the Passover has been a special part of Jewish religious observances. And it was at this festival, when thousands of sacrificial animals were slaughtered at the temple, that Jesus allowed his life to be taken to become the ultimate sacrifice for the sins of the world. As he celebrated his Last Supper with his friends:

Jesus took bread, and blessed, and broke it, and gave it to the disciples and said, 'Take, eat; this is my body.' And he took a cup, and when he had given thanks he gave it to them, saying, 'Drink of it, all of you; for this is my blood of the covenant, which is poured out for many for the forgiveness of sins' (Matthew 26:26–28).

For Catholics, the real presence of Christ is in the Lord's Supper, and renewal occurs each time they take the bread. The church believes everyone is a child of God and redemption is for all mankind. How sad Jesus must be that so many do not acknowledge his sacrifice for them, or want to receive his transforming love. This is why he was sad in Jerusalem, 'How often would I have gathered your children together as a hen gathers her brood under her wings, and you would not!' (Matthew 23:37).

Van der Goes had a passion for flowers. During the last years of his short life, he lived in a monastery, which he entered in 1475, and would have been familiar with the herb garden and the herbal remedies the monks made up to heal people. Perhaps the herbs gave him, too, blessed relief from the bouts of depression he suffered. In the tranquillity of the monastery garden, he spent many hours studying the plants that grew there, minutely examining each leaf and petal. In the Portinari Altarpiece the lilies and irises for passion, the violets for humility, the columbines for the Holy Spirit, and the three red carnations in memory of the nails that bound Christ to the cross are startlingly accurate. Flowers had been extensively painted in Books of Hours and they continued to play a symbolic role in artistic dramas. Van der Goes's botanical studies anticipated those of the botanists.

Hans Memling (c.1435–94)

Hans Memling was Rogier van der Weyden's prize pupil. He was born near Frankfurt, and en route to Brussels he stopped off in Cologne, where he saw Stephan Lochner's paintings with their refined International Gothic style and varied use of colour. After Van der Weyden's death in 1464, Memling moved to Bruges where he set up a successful workshop. A port, Bruges was the meeting place of Europe, basking in the lush climate of the Burgundian court and international trade. This civilized, wealthy city – where Edward IV's sister Margaret of York married Charles the Bold in 1468, where Caxton learnt the art of typography and printed the first book in English, where the tall belfry has been a symbol of civic pride for 700 years – was a perfect place for a gifted artist to flourish. There was much demand for works of art from dukes, diplomats, courtiers, and clergymen – and branch managers of the Medici bank.

Tommaso Portinari, who commissioned Hugo van der Goes' altarpiece, was preceded by Angelo Tani at the Medici bank. The monastery chapel of Fiesole, outside Florence, had been built with Medici money, and Piero de Medici reserved the rights of patronage over all the side chapels for the families who ran the various branches of his bank. Angelo Tani had been given a chapel dedicated to St Michael and, while in Bruges, he commissioned Memling to paint a triptych, *The Last Judgment* (pp. 80–81). Memling's triptych is similar to the one Rogier van der Weyden created for the Hotel Dieu in Beaune, except that he reverted to an earlier tradition of depicting St Michael weighing souls. When the prophet Daniel interpreted the writing on the wall at King Belshazzar's feast, he read, 'you have been

weighed in the balances and found wanting' (Daniel 5:27). In other words, the soul of the just person has more substance and weight than that of the unrighteous person.

In the central panel of Memling's triptych, Christ sits on a rainbow throne in heaven crowned with a lily and a sword. He is surrounded by the apostles, and by his mother and St John the Baptist, who intercede. Beneath Christ's feet angels blow the Last Trumpet, and below them St Michael stands in a vast green meadow which recedes to a bright horizon. His fifteenth-century armour glints in the light and reflects the panoramic scene in minute detail. (Van Eyck's glazing technique had been meticulously mastered by Memling.)

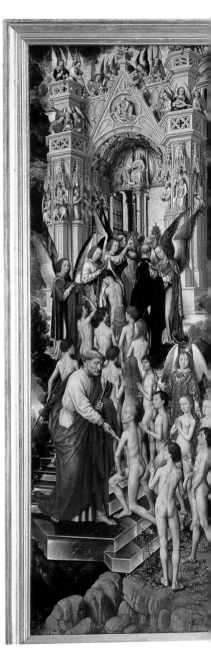

Hans Memling
(c.1435–94):
The Last Judgment.

Most powerful of the archangels, St Michael is Christ's lieutenant who battles with Satan over every human soul. He guards the guardian angels and God's people. In his hand the scales tip in favour of the righteous man who kneels in prayer. Like everyone else he is as naked in death as at birth. This side of the picture promises peace, for the redeemed are protected from evil, and they wait patiently for St Peter to welcome them at the crystal staircase and lead them into heaven. St Michael points his staff at the condemned soul who writhes in fear. Around him people shake and shiver as, mocked by demons, they contemplate their fate. They are damned to hellfire – separated for ever from the way, the truth and the life which they had rejected on earth. Dante's descriptions of Hell, Purgatory and Paradise in his *Divine Comedy* influenced artists for two centuries. Right and wrong were black and white in the Middle Ages.

Fate brought Memling's *The Last Judgment* to Poland. The galleon on which the triptych was to be carried to Pisa was captured in 1473 in a sea battle off the English coast by Paul Benecke, a captain fighting for the German Hanseatic League against the English. He took the ship to Gdansk and gave the triptych to St Mary's Church where, despite endless vicissitudes, it remained until its removal to the city museum after the Second World War.

When martial law was imposed on the Polish people after Solidarity was crushed in 1981, life was very hard and fear lurked round every corner. Paintings like *The Last Judgment* fed the soul like manna in the

desert. It was bitterly cold. Mercy, justice, and truth – how easily values are blurred by comfortable materialism. In Poland they were written on the faces of the people as they queued patiently for hours to buy bread or rationed meat, denying themselves the privileges of party membership: 'he who loses his life for my sake will find it' (Matthew 10:39).

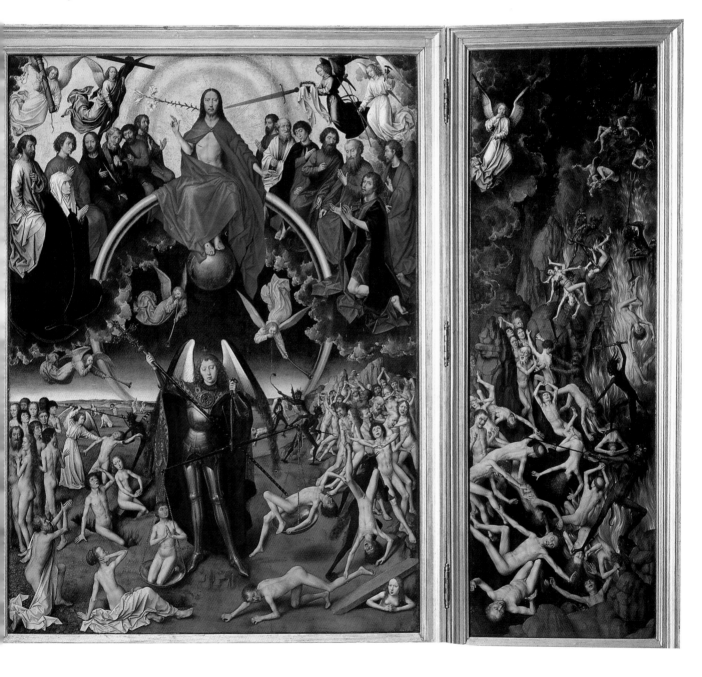

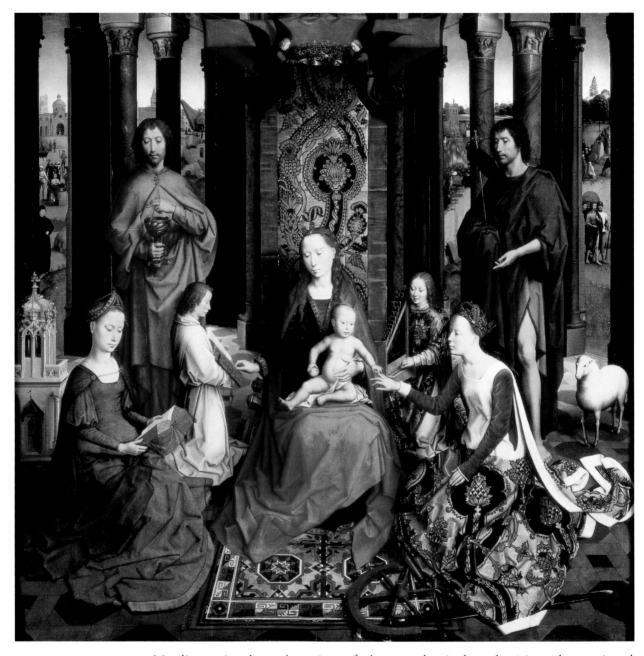

Hans Memling
(c.1435–94):
*The Mystic Marriage
of St Catherine*,
central panel.

Memling painted another view of the apocalyptic last days in a large winged altarpiece, *The Mystic Marriage of St Catherine* dedicated to St John the Baptist and St John the Evangelist, the patron saints of the hospital in Bruges. This was commissioned for the chapel by the four Augustinian brothers and sisters who ran the hospital. Mary mother of Jesus, patroness of many cities including Bruges, was painted frequently by

Memling. Here she sits with the baby Jesus amid rich brocades and an Oriental rug, with St Catherine and St Barbara and the two St Johns.

St Catherine with the wheel and sword (symbols of her martyrdom) and St Barbara with a tower (she was imprisoned for life by her father after becoming a Christian) were invoked as patrons by those in danger of sudden death, a fear prevalent in most hospitals in those days. The saints were, no doubt, also good role models for the Augustinian sisters who served the sick. Through the arches behind Mary's canopied throne, and in the side panels, Memling illustrated the life and death of St John the Baptist and St John the Evangelist. He managed to condense the descriptions from Revelation 4–12 ingeniously into the left-hand panel in the most elaborate representation of the apocalypse ever seen in a panel painting. St John the Evangelist sits on Patmos watching the vision unfold around him. Christ is enthroned above, and the four horsemen of the apocalypse ride across the water. Stars fall, fire is cast into the sea, people hide in caves, and locusts dart about in the shape of horses with men's faces and scorpions' tails. In the sky the mighty angel, backed by a rainbow, holds up a scroll in his hand, which no one was found worthy to read; and the apocalyptic woman, the church, is clothed with the sun, the moon at her feet and twelve stars at her head; beside her is the red dragon with seven heads and ten horns. Each generation seeks meaning in these symbols.

The chapel has become the Memling Museum and several of the paintings on show were originally commissioned by the hospital. Among them is an exquisite little reliquary of St Ursula, on which Memling painted this popular saint's adventures.

Memling's characters live a life of tranquillity and piety in a dreamy, static world where no dirt or pain intrude.

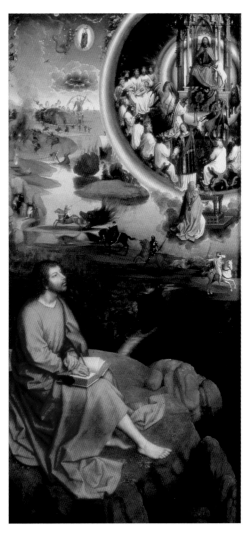

Hans Memling (c.1435–94): *The Mystic Marriage of St Catherine*, left-hand panel.

Hieronymus Bosch (c.1450–1516)

In the Musée Royale des Beaux-Arts in Brussels, a picture gallery full of treasures, there is a painting by Hieronymus Bosch, *Christ on the Cross* (p. 84), from about 1485. The colours give a mirage effect, taking the subject a step or two away from the world we live

in. Instead of building up coloured glazes on a white ground like Van Eyck, Bosch created his celebrated 'flashes of white' by using light glazes and modelling with strokes of white. Instead of defeat there is expectancy in the air, emphasized by the breeze rippling Christ's loin cloth. Instead of despair, Hope lifts her head in the tranquil landscape in the background, where a windmill perches on a grassy sand dune, a town sits prosperously on the horizon, and a few figures wend their way along the curving sandy paths near trees in full leaf.

Christ hangs on a tall cross. He is smaller than the other actors in this drama, and bows his head in a gesture of compassion towards the unknown donor, who is fully integrated into the picture he commissioned. St Peter, his patron saint, holds the key to heaven and looks across to St John who intercedes with Mary beside him. Jesus said from the cross to his mother, 'Woman, behold, your son!' (John 19:26). Then he said to his dearest friend St John, who was standing beside her, 'Behold, your mother!' (John 19:27). And from that moment Mary, the mother of the Saviour of the world, became the mother of all mankind. The donor, clad in black, looks pensive. His face is white, his eyes stare into the distance, and the corners of his mouth turn down. In fact, he is probably deep in contemplation, for an important role of a painted image is to enable us to see beyond the physical picture to the inner reality.

Hieronymus Bosch (c.1450–1516): *Christ on the Cross.*

CHAPTER 5

Before the Body Was Broken

*A new commandment I give to you, that you love one another; even as
I have loved you, that you also love one another. By this all men will
know that you are my disciples, if you have love for one another.*
John 13:34–35

Germany always kept close ties with Italy, especially in the fifteenth century when German merchants had factories there, students travelled south to study law and medicine, and wandering scholars moved back and forth across the Alps.

The Renaissance gained ground swiftly in Germany, for the soil was fertilized by a high standard of education; scholarship as well as religion was propagated in schools set up by Christian communities. Pupils from such schools went on to the new universities which were springing up like mushrooms all over Central Europe, from Heidelberg to Vienna, from Prague to Cracow.

Family religion of a simple kind was practised. And, despite the ongoing problem of peasant unrest, the Renaissance stimulated the piety for which Germany was famous. By the Middle Ages, pilgrimages, vividly described by Chaucer in *The Canterbury Tales*, had become big business. Instead of travelling to the Holy Land, to those places hallowed by the incarnate God, most Europeans visited their local shrines. These excursions symbolized the journey of life, and helped to deepen faith and foster understanding of holiness and wholeness. Devotion to Mary was popular and intense. Her shrines, like that at the miraculous church, Schöne Maria, in Regensburg, attracted crowds of fervent pilgrims.

This pilgrimage church, built after the Jews were expelled from the city, was one of many centres where 'speaking in tongues' occurred. Spiritual manifestations were widespread and ranged from the mass visions of whole communities to St Teresa of Avila's strict enclosure.

There had been murmurings of revolt against the church and its practices throughout the fifteenth century, initiated by John Wycliffe in England and continued by Jan Huss in Bohemia. There were also many stalwart Catholics who disapproved of the practice of indulgences. Indulgences were believed to speed up your time in purgatory, for they were founded on the theory that good works led to salvation. They were granted for worshipping at particular pilgrimage places, for the construction of altarpieces or chapels,

or for money. A lot of money was needed to rebuild St Peter's in Rome, and for other projects like Cardinal Albrecht of Brandenburg's lofty plans for Halle, and many poor and gullible people parted with hard-earned cash out of fear of hell.

Germany, with its traditional hostility between the emperor and the pope, was the natural setting for the Protestant revolt. Political and economic considerations merged with a desire to return to a simpler faith. Henry VIII had confiscated church property in England, and other rulers had similar ambitions.

Martin Luther initiated the revolt. Luther was an ordained member of the Reformed Augustinian monastery in Erfurt, and a doctor of theology at Wittenberg University, who translated the Bible into German. A neurotic genius, obsessed with the problem of sin, he grappled with the theological question, 'Am I saved?' until he came to the conclusion that we are only justified through faith, as St Paul had written to the Romans. Good works — going on pilgrimages to shrines, buying indulgences, or even commissioning altarpieces — did not reconcile you to God. Only by believing and receiving Christ into our hearts and committing our lives to him can we be saved.

Luther's morbid sense of human depravity and alienation from God led him to reject the Roman Catholic Church's teaching on salvation, reason, and free will expounded by Thomas Aquinas. The church held that 'Grace comes to perfect Nature not to destroy it,' and that salvation was found in the community of the faithful, that is in the church and her sacraments.

Luther did not set out to cause a schism in the church. Nor did he have many sleepless nights when the split occurred, though he might have done when his doctrine of 'princely government' encouraged his patrons to put down the Peasants' Revolt without mercy. Luther quarrelled with Erasmus because he thought the humanist scholar, who wanted to reconcile the new humanism with the old religion, was not radical enough. Erasmus translated the New Testament from Greek, and edited several works of the Church Fathers. He revealed the practical simplicity of the Christian faith, based on the life and teaching of Christ, which had become bogged down in the ceremonials and dogmas of the church. He hoped the Renaissance spirit of enlightenment might bring about reform for he was convinced that if the church split, civilization would collapse.

Unlike more radical reformers such as John Calvin and his followers in Geneva and Scotland, Luther, an enthusiastic musician, did not believe that patronage of Christian art was status-seeking or sinful, that the altar should be stripped bare to become the place of Christ's sacrifice, or that intercession through Mary and the saints was wrong. He was ambivalent about sacred art, tolerating it as long as it did not distract from the word of God. Many images like *Schöne Maria* remained in churches that became Protestant, and altarpieces, particularly those illustrating the Last Supper, continued to be commissioned.

But Luther's stand had unleashed mindless violence and Protestantism became destructive. Works of beauty in even the humblest parish church, from carved images to reredoses and font covers, were smashed. Pilgrims who formerly venerated images of Mary or the saints now destroyed them.

Stephan Lochner (active 1442; d.1451)

Despite the innovations of the brothers Van Eyck, tradition held sway in the arts and so the Gothic style continued in Germany during the fifteenth century. Stephan Lochner, working in Cologne, was imbued with that medieval mysticism that made him a northern Fra Angelico.

His *Madonna in the Rose Garden* from 1440 is more concerned with 'other-worldliness' than with the Italian Renaissance fascination for humanism and perspective, and Lochner shows more affinity to the *Wilton Diptych* than to *The Adoration of the Lamb*. Yet his Madonna sits enthroned on a grassy bank, surrounded by more space than the cramped figures in the diptych. Behind Mary is a backcloth of gold supported by two angels where roses entwine a trellis. Above, God the Father blesses from yet another kingdom of light. The northern realism pioneered by Van Eyck is apparent in the jewels, the angels' instruments, and the flowers growing on the bank and up the trellis.

The enclosed garden in which the Madonna and child sit, separated from the world, was a popular image, taken from the Song of Solomon: 'A garden locked is my sister, my bride, a garden locked, a fountain sealed' (Song of Solomon 4:12). The sealed garden was a reference to Mary's virginity and a call to purity, for Jesus said, 'Blessed are the pure in heart, for they shall see God' (Matthew 5:8). The faces of Lochner's little angels mirror the spirit of simple devotion and childlike faith.

Stephan Lochner (active 1442; d.1451): Madonna in the Rose Garden.

Michael Pacher (c.1435–98)

In the last decades of the fifteenth century, German artists developed their own type of altarpiece in the High Gothic style. There had been a long tradition of carving in Germany, especially in the mountain regions where country people spent winter evenings working with wood and chisel to produce crucifixes, Christmas cribs and so forth for their homes and churches. Long after France and Flanders had turned to painting, carved and gilded altarpieces were still produced by German masters.

One of these was Michael Pacher, who broke new ground yet retained a sense of mysticism in his pre-Reformation art. In those days minds and hearts were willing to be drawn from earthly preoccupations to contemplate heavenly glories.

Pacher spent most of his life living and working in the south Tyrol, but he travelled to Italy where he observed Giotto's earthy frescoes in Padua, and Mantegna's discoveries in the art of perspective in Mantua.

His altarpiece for the pilgrimage church dedicated to St Wolfgang (bishop of Regensburg in the tenth century), at St Wolfgang am Abersee near Salzburg in Austria, was commissioned by the abbot of the Benedictine monastery at Mondsee in 1471. The contract stipulated that the focal point of the work – *Coronation of the Virgin* – should be composed 'as exquisitely and as well as his skills permit'. As Pacher was proficient in both

Michael Pacher
(c.1435–98):
St Wolfgang
Altarpiece,
St Wolfgang am
Abersee, nr
Salzburg.

painting and sculpture he could carry out the whole project in his own workshop. The altarpiece took a decade to complete and is his only work to remain, undamaged, in its intended place. In keeping with medieval tradition – winged altarpieces were designed to be miniature replicas of the house of God – Pacher designed his in the shape of a monstrance – a vessel of gold and silver in which the consecrated host is exposed to the congregation for veneration.

In the mounting above the main corpus, exquisitely sculpted tracery shoots up to form seven delicate turrets. In their centre Christ hangs on the cross, above a border of gilt limewood filigree. The predella, which forms the base, portrays the western church fathers: St Gregory the Great and St Jerome, St Augustine and St Ambrose (the bishop of Milan who converted Augustine). This is how the St Wolfgang Altarpiece looked on weekdays when the two sets of moveable wings, which comprised the substantial central

portion of the altarpiece, were closed to show episodes of St Wolfgang's life. In one quaint scene the saint, with an earnest expression and his mitre askew, is hammering a brick into the wall he is building while wearing white gloves! His assistant is mixing cement, and in the Abersee beside them ducks watch with amazement. The tools of their trade are painted in great detail. This is a house that was not built in vain, for beneath St Wolfgang's rich badges of office is a humble man of deep faith being obedient to his calling.

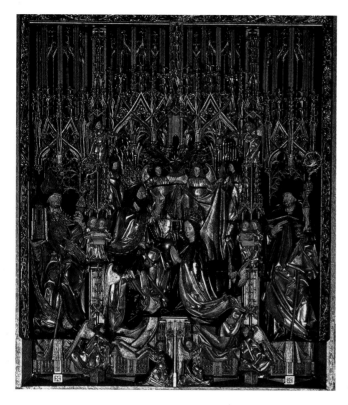

Michael Pacher (c.1435–98): *Coronation of the Virgin*, St Wolfgang Altarpiece, St Wolfgang am Abersee, nr Salzburg.

When the panels are opened they reveal the life of Christ in four dual themes (pp. 90–91). His baptism and his temptation by the devil emphasize the gap between heaven and earth; the miracles he performed during the marriage at Cana, and the feeding of the five thousand refer to the bread and wine of the Lord's Supper; the scenes of his stoning and driving the moneychangers from the temple mark the division between the Old and New Testaments – Christ was driven from the temple but he purifies the church; and his forgiveness of the adulteress and raising of Lazarus reveal his ability to redeem humanity from sin and death.

Pacher attempted to integrate the lessons he learned in Italy into the painted panels of this altarpiece, but somehow they remain very German and Gothic, full of twists and turns. The architectural features are prominent – in fact the sky is scarcely glimpsed – but unlike the feeling of space Mantegna achieves these pictures seem cramped. You could have stepped into a fairy-tale world, into one of Grimm's stories. Castles totter on ragged rocks, faces are craggy, devils have horns, figures contort themselves into strange shapes, and haloes as hard as plates somehow stay attached. This down-to-earth, rather awkward style, in which every part of the panel is treated with equal care, is typical of German painting. Pacher paints vulnerable, expressive faces. These are real, not ideal, people and Christ understands their weaknesses and wants them to receive his love. His face is gentle and kind as he moves about this colourful medieval world. He listens and suffers patiently with an inner strength that moves mountains.

When the doors of the predella as well as the doors of the altarpiece are opened, the former revealing *Visitation* and *Flight into Egypt*, two magnificent sculpted scenes appear. In the predella is a beautiful Madonna and her infant being adored by the three kings; above is the *coup de grâce* which everyone looked forward to seeing on the most important feast days: *Coronation of the Virgin*. It is as exquisite as the contract stipulated. In the golden

glow of Gothic folds, Christ as king sits enthroned, his cloak held up by winged pages, while other angels in the nooks and crannies of Gothic decoration sing hymns and sound trumpets. One royal hand holds a cross-crowned golden orb; the other gives a Byzantine blessing to Mary his mother. Through her earthly obscurity and total obedience, Mary was given the grace to become the church's mother. The golden crown upon her head proclaims her queenliness, yet she kneels meekly in prayer, her virginal hair cascading down over her shoulders as she receives the benediction from God to become supreme intercessor. Her pure, young face turns outwards, towards those who seek her help, with a look full of compassion and humility, for 'henceforth all generations will call me blessed' (Luke 1:48).

What a solace such altarpieces must have been. The daily grind was unremitting for simple people. Death was never far away from anyone. The opportunity was there to seek shelter in the church and to pray, in the magical glow of many candles, to a gilded statue of the mother and child; to stand in the presence of God and pray for mercy; to be in awe of the great mystery of faith. And it is still so.

Veit Stoss (c.1447–1533)

Ever since the Middle Ages a guard has watched over Cracow, the former capital of Poland, from a little room at the top of one of the two towers in St Mary's Parish Church in the heart of the old city. On the hour, every hour, the guard bugles part of the 'Hymn to the Virgin', thanking her for her protection. In the middle of the soul-tearing sound he stops abruptly for a moment – in memory, according to legend, of the bugler who was pierced in the heart by an arrow while warning the city of the approaching Tartars who attacked on Easter Day in 1241.

There is never a strong light within St Mary's Church, even on a bright day. All day long, as in churches throughout Poland, people come like little children to leave their heavy burdens at the foot of the cross, to be nurtured and renewed. Clearly humility opens the door for peace. Weary peasants wearing old coats with woollen scarves wound round their heads kneel on the cold stone floor; young priests clad in black cassocks sit and contemplate their Lord; tourists come to see the famous gilded St Mary's Altarpiece (p. 94) carved by Veit Stoss in the 1480s, and stay to pray.

High above on the rood beam the crucified Christ opens wide his arms beneath a heavenly vault where gold stars twinkle on azure blue. From a distance the altarpiece resembles an enamelled gold brooch, its exquisite tracery blending with the pattern of the three Gothic windows behind it.

The theme of the altarpiece is the dormition of Mary, 'dormition' meaning 'death'. And how frail and vulnerable Mary looks. For centuries she had sought to teach tough and ruthless Christian men the virtues of compassion and tenderness from her earthly dwelling place in churches.

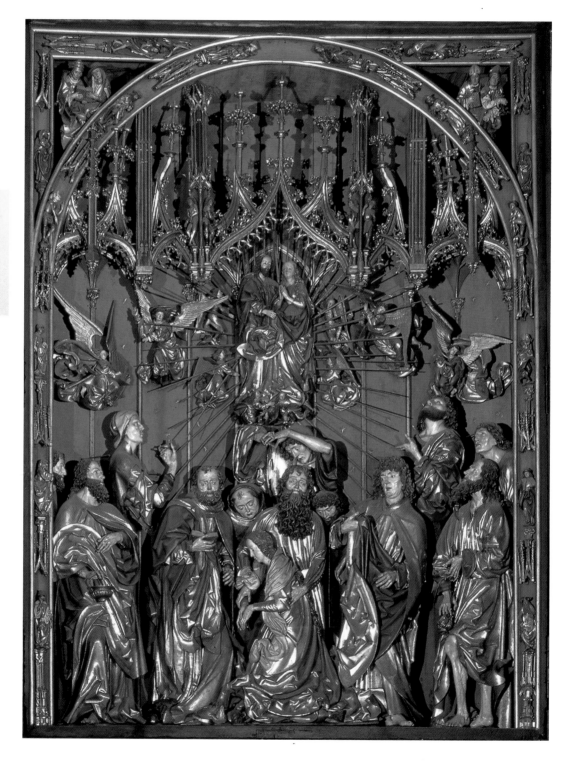

Veit Stoss
(c.1447–1533):
central panel,
St Mary's
Altarpiece, St
Mary's Church,
Cracow.

In the early Middle Ages the death of Mary was symbolized by images of Christ carrying his mother's soul to heaven. Later, as in *Assumption of the Virgin* by Tilman Riemenschneider in Wurzburg, her body rises gracefully upwards. Stoss linked his portrayal of the dormition with this image of the assumption. Kneeling, head slightly bowed, hands dropping at the wrists, her body supported by one apostle while another reads from the liturgy, this small and fragile woman draws her last breath. It is a poignant moment. The splendid group of apostles who surround her lend the earthly weight of an historical event to the scene. Five figures are fully portrayed, larger than life, carved out of the trunks of old lime trees. They look as if they might step out of the altarpiece at any moment, for Stoss has carved them with great psychological insight and anatomical accuracy. The polychromed faces express all the pain and shock of bereavement, and the drama of the moment is further enhanced by the folds of their cloaks, which seem to be swept up by a sudden wind, in the 'late Gothic swirl'.

This very human central scene, arranged along the horizontal, opens up vertically into the divine. Mary rises to heaven where she is crowned in the company of the patron saints of Poland: St Adalbert, who was killed trying to convert the Lithuanians, and St Stanislaus, who was murdered in the Pauline church a century before Thomas à Becket and for similar reasons.

The frame is filled with figures of prophets. The predella depicts the tree of Jesse, Joseph's royal line. Both emphasize the continuity of the Old and New Testaments. The life of Jesus is carved in bas-relief on the wings, illuminating the mysteries of the rosary, which are meditations on episodes of the life and death of Mary.

The altarpiece is enormous – nearly 13 m high and 11 m wide when open. No wonder it took Stoss more than a decade to complete, even with the team he employed to assist him. Stoss gave up citizenship of Nuremburg in 1477, and came to live in Cracow after being chosen by Elizabeth of Austria, wife of the Polish King Casimir IV, to create the altarpiece for the town's citizens. There were funds to pay for it as the Jubilee year had fallen in 1475; to pacify the gentry, who were fed up with the huge sums flowing to Rome through tithes and indulgences, the pope allowed some of this money to be spent on a major endowment in Poland.

There was a lively intellectual movement in Cracow. King Casimir's tolerance was well known and many philosophers and artists, including Erasmus of Rotterdam and Albrecht Dürer's brother Hans, stayed at court. Popular devotional movements were also active. All this influenced Stoss to produce a masterpiece of decorum and clarity, in which all the elements conformed to the main purpose of the altar: to peacefully and prayerfully influence the mind and heart. And, rather than contrasting with the architecture of the church, it became the keystone, with its regal colours of gold and blue. No wonder that a century later, Vasari described Stoss as the *miracolo di legno* for he was a true genius with a chisel.

Incredibly, considering the tragic history of Poland, the altarpiece has remained in St Mary's Church for more than 500 years, continuing, through the different periods and fashions of history, to stimulate prayer and peace.

Matthias Grünewald (c.1475–1528)

In contrast to the dignity of Stoss' masterpiece and the tranquillity of the Flemish altarpieces designed for hospital churches, Matthias Grünewald's Isenheim Altarpiece, completed in 1515, showed how horrific pain and suffering could be. It was among the last to be produced in Germany, and its violence and ugliness were prophetic of the divisions in the church that would be unleashed by the Reformation.

Grünewald's great polyptych was completed for the high altar of the hospital chapel of St Anthony's Monastery at Isenheim in Alsace. It is unique in the history of religious painting. There are no holds barred. Grünewald moved into new areas of the tragic, the macabre and the spiritual – as if he was unleashing the devil himself. He was not interested in the beauty of the human figure or its environment. He read St Bridget of Sweden's extensive *Revelations* about the life of Christ, which describes in every gory detail the suffering of the Son of man. Grünewald combined the mysticism of the Middle Ages with the techniques of the Renaissance to reproduce this disturbing vision.

The altarpiece is made up, in German fashion, of several hinged panels, each 3.8 m by 3.3 m. They have now been detached and are displayed in the thirteenth-century chapel of the former Dominican convent in Colmar, Alsace, once an historic centre of German piety. The outer pair, when closed, expose the famous *The Crucifixion*, depicting that moment Christ said, '"It is finished"; and he bowed his head and gave up his spirit' (John 19:30). It is horrific. Christ's body is torn and lacerated, every nerve taut as it is stretched on the wood. Even the wood is strained and bends under its appalling weight – for Christ is carrying the sins of the whole world. The crown of thorns is monstrous. The fingers writhe in agony. The feet are battered out of shape. The surrounding figures are also wracked in grief and pain: Mary Magdalene sways in empathetic frenzy, while Mary the mother is spent. The presence of St John the Baptist, who was beheaded early in Christ's ministry, adds to the sense of timelessness. The black sky and the endless green deep in the background increase the dramatic sense of fear. In the predella below, Christ's body has been taken down from the cross and the faces of his three mourners are grotesque with sorrow. Perhaps Grünewald wanted to help the terminally ill patients understand that the agony assailing them was part of the divine plan, that the battle between God and the unseen prince of darkness, who rules this world temporarily, was won on the cross. Maybe he thought the poor patients carried such impossible burdens that they could understand this ugliness more readily than Memling's idealized view of suffering.

'[T]he wages of sin is death,' St Paul wrote to the Romans. Many people considered sickness a sign of sin in the sixteenth century, and no doubt patients in hospitals were lectured along these lines. However, St Paul goes on to say, 'but the free gift of God is eternal life in Christ Jesus our Lord' (Romans 6:23).

This wonderful promise was illustrated to the sick when the outer panels were folded back to reveal highly charged, unworldly scenes from the Christian story, culminating in *Resurrection*. It is overwhelming. On the left is a feverish *Annunciation*. In the large central panel the Madonna holds her newly bathed Jesus against a landscape impregnated with the

Matthias Grünewald
(c.1475–1528):
The Crucifixion, central
panel, Isenheim Altarpiece.

spirit of God. Jesus is playing with some coral beads. This is a common theme in paintings, for coral symbolized Christ's sacrificial blood and so was a protection against evil. And Jesus needs defending here. Behind the cellist angel who serenades him, lurking among the other musicians in an ornate late-Gothic sanctuary, is a dark green, feathered monster, a manifestation of evil. It was mainly German artists who painted demons. Sin has to be recognized, confronted and dealt with in order to live in reality. The patron saint of the hospital is by no means exempt from this battle with the wicked and ugly side of life. In *Temptation of St Anthony* this protector against skin diseases lies defenceless on the ground surrounded by malevolent manifestations of the inmates of hell. He is in a land of hideous vegetation, unlikely mountain ranges, and diseased monsters, which conjure up Max Ernst's surreal visions painted during the Second World War. In his deepest agony, St Anthony was strengthened by Christ's redeeming love.

The contrasting, peaceful aspect of such enhanced spiritual reality is apparent in Grünewald's *Meeting with St Paul* (the hermit). Here the noble abbot St Anthony and the ascetic hermit represent the whole range of monastic life. Their conversation is carried out in a fantastic yet peaceful landscape, where nearly all the plants are medicinal. Hermits went

Matthias Grünewald (c.1475–1528): *Temptation of St Anthony*, Isenheim Altarpiece.

into the desert, like Jesus did at the beginning of his ministry, to struggle against evil and come closer to God. And the closer the union with Christ, the greater the reality of evil.

St Paul reminded the Romans that:

> we rejoice in our sufferings, knowing that suffering produces endurance, and endurance produces character, and character produces hope, and hope does not disappoint us, because God's love has been poured into our hearts through the Holy Spirit which has been given to us (Romans 5:3–5).

Christ's defeat of sin and death resulted in the resurrection, and this event illuminates the right-hand panel. After his death and burial, on the third day,

> Mary Magdalene and the other Mary went to see the sepulchre. And behold, there was a great earthquake; for an angel of the Lord descended from heaven and came and rolled back the stone, and sat upon it. His appearance was like lightning, and his raiment white as snow. And for fear of him the guards trembled and became like dead men. But the angel said to the women, 'Do not be afraid; for I know that you seek Jesus who was crucified. He is not here; for he has risen…' [They] ran to tell his disciples. And behold, Jesus met them and said, 'Hail!' (Matthew 28:1–6, 8–9).

Grünewald, like Piero della Francesca, paints Christ as he rises from the tomb, with the soldiers on the ground below. But there the similarity ends. The strength of Piero's *Resurrection* is in the quiet majesty of his perfected human being in a harmonious setting. Grünewald, with the excess and intensity of his German temperament, pulls out all the stops. Christ, his body as white as snow, is flying out of his tomb, his crimson and blue robes billowing out like a parachute. It is night. Stars

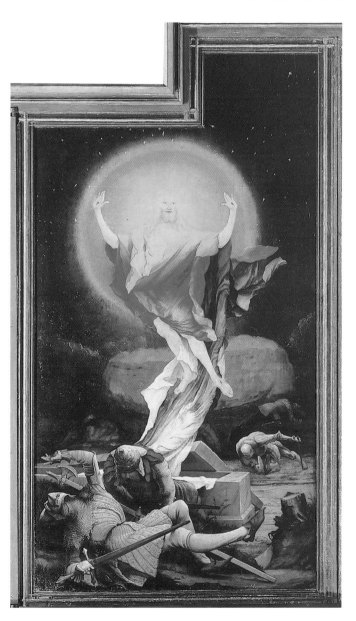

Matthias Grünewald (c.1475–1528): *Resurrection*, right-hand panel, Isenheim Altarpiece.

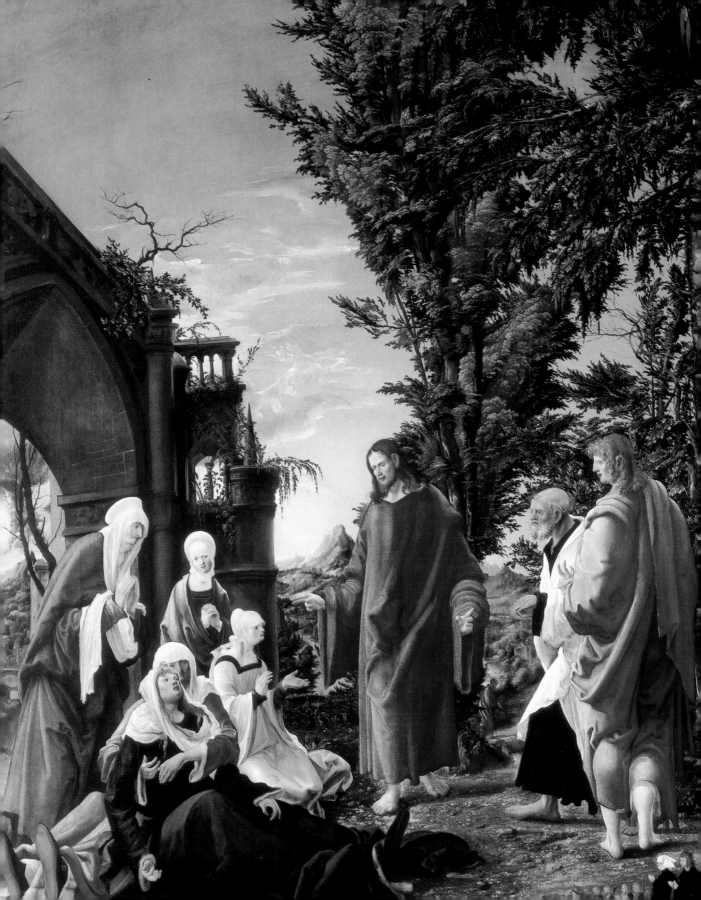

twinkle in the dark sky. The guards look terrified and as stiff as corpses. The marks of Christ's passion glint in the strange light that emanates from the triple-coloured circle behind him – the light of his lordship, his contact with heaven. The image is powerful, but no consolation for those living in good health and comfort. For the poor dying men, who suffered their last days in the squalor and stench of their mortality, it may well have drawn their hearts towards peace and hope.

Albrecht Altdorfer (c.1480–1538)

Conflict, cruelty, and religious fervour are the heaving undercurrents of Albrecht Altdorfer's magnificently potent painting *Christ Taking Leave of his Mother*; it was painted in 1520, three years after Martin Luther nailed his famous ninety-five theses to the door of the castle church at Wittenberg, setting the match to the tinderbox of turmoil. The narrative subject of this painting is derived from devotional literature of the Middle Ages, and from the popular 'miracle plays'. These religious theatrical performances, which originated in the eighth century, were presented in church during the mass. They brought the sermon to life as people relived the stories in dialogue. By the Middle Ages they had grown into separate functions arranged by the guilds, and had become quite sophisticated, with various booths for heaven and hell, and several stages. These dramatic representations of the Christmas and Easter stories were re-enacted at the appropriate times in the church's calendar and lasted for several days. The passion play, which is still acted every decade in the village of Oberammergau in Bavaria, in fulfilment of a vow made in 1634 after deliverance from plague, derives from this ancient custom.

Albrecht Altdorfer (c.1480–1538): Christ Taking Leave of his Mother.

Like his contemporary, Albrecht Dürer, Altdorfer, an active council member in his home town of Regensburg, was patronized by Emperor Maximilian I. He must have seen the passion play performed in nearby Augsburg, as its continuous scenes of lamentation are akin to that of his painting. Also, the women in *Christ Taking Leave of his Mother* can be identified from the cast list as Maria Cleophas, Maria Salome, Mary Magdalene on her knees, and Maria Jacobi clasping the prostrate mother.

However, unlike Dürer, Altdorfer was unmoved by the problems of form, perspective, or proportion. He painted these women in a higgledy-piggledy, down-to-earth group, typical of the developing humanist trend in Germany where artists largely catered for a bourgeois taste. Even Dürer, who had been to Italy and painted the magnificent *Feast of the Rosary* for the German church in Venice, decided to portray the leading figures in his *Virgin and Child and St Anne* as a German mother, child, and grandmother.

In Altdorfer's painting, human grief is exaggerated by the elongated bodies, big feet, drooping drapery, expressive actors' hands, and rustic faces. Christ stands in the centre of

the stage blessing his mother. He is mediating between the women, who cannot cope with his forthcoming ordeal, and his disciples, St Peter and St John, who have, at least outwardly, accepted the fact. The figures intertwine with the landscape which reflects the mood: the jagged branch of a dead tree piercing the sky is an omen of agony, and the tall, lush trees foretelling the new covenant burgeon, elemental forces joining in the chorus of the sacred story. Altdorfer, who created distances that are felt rather than seen, belonged to a small group of artists called the Danube School who were interested in landscape, both for its own sake and to set the emotional tone of a narrative scene. The donors at the very bottom right of the picture are even smaller than the Lilliputians beside Gulliver.

Albrecht Dürer (1471–1528): *Four Horsemen of the Apocalypse.*

Albrecht Dürer (1471–1528)

Albrecht Dürer reflected the spirit of the age through the medium of etching. His woodcuts and engravings stand supreme, and they wielded enormous influence

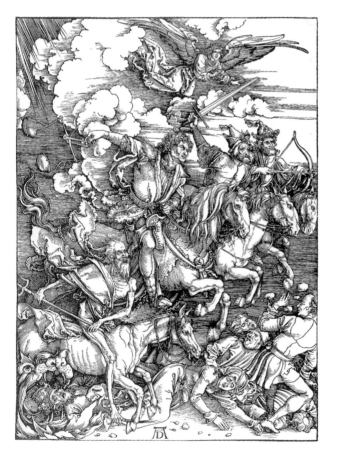

everywhere, from the moment they first rolled off the printer's press. Dürer was a child prodigy. His father was a distinguished master goldsmith who encouraged his son's talent from an early age. After travelling to Italy and Switzerland (Basle was a great centre of the book trade and printing), Dürer returned to Nuremberg where he remained for the rest of his life. His first success came with the publication in 1498 of his *Apocalypse* woodcuts, fifteen illustrations based on St John's Revelation, which he published with German and Latin texts. Their depiction of an apocalypse that was both destructive and redemptive provided a universal metaphor for the expression of all future eschatology. They were repeatedly copied throughout the sixteenth century, for in them Dürer captured the general unease that hovered over Europe, when many people feared the prophecies of St John might happen in their own lifetime.

Whereas Memling's four horsemen in his version of this picture are decorative and decorous, Dürer's, in his *Four Horsemen of the Apocalypse*, are ragged, almost barbaric, as they ride their shaggy ponies roughshod over the people, swinging their weapons of retribution. St Michael fights psychotic monsters in his war against heaven's rebel angels in *St Michael Fights Fallen Angels*. There is nothing chivalric or posed

in the way he lances his foe with an implacable determination to defeat evil. The contrast between the overcrowded slice of sky, in which the action takes place, and the serene and sleepy landscape below evokes St Paul's exhortation in Ephesians 6:12: 'we are not contending against flesh and blood, but... against the powers, against the world rulers of this present darkness, against the spiritual hosts of wickedness in the heavenly places'.

Dürer was to expand this theme later on in *The Knight, Death and the Devil*, which he based on *A Manual of the Christian Knight* by Erasmus of Rotterdam. Here, the scholar describes a Christian faith as 'so virile, clear, serene and strong that the dangers and temptations of the world simply ceased to be real'.

Although Dürer remained loyal to the Catholic Church, he was much affected by the spiritual conflicts of the Reformation. He intended to leave an altarpiece to his beloved city, but in the event only painted the wings showing *Four Apostles*. Somehow, by the 1520s, his intended subject, a *Sacred Conversation*, no longer seemed suitable in a Lutheran society.

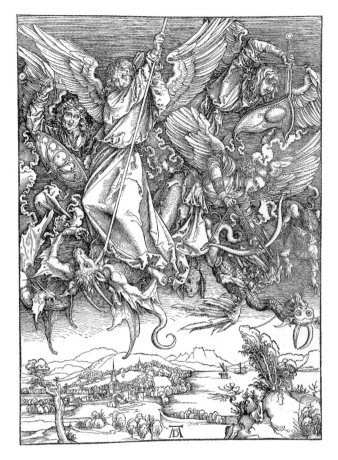

Albrecht Dürer
(1471–1528):
*St Michael Fights
Fallen Angels.*

CHAPTER 6

The Summit Unsurpassed

Then let me see you everywhere I go.
If merely mortal beauty makes me burn,
How much more strongly I shall shine and glow
When to your fiery love at last I turn.
Dear God, I call and plead with you alone,
For only you can help my blinding pain;
You only have the power to sustain
My courage. I am helpless on my own.
Michelangelo (1475–1564), 'Sonnet LXXII'

Sandro Botticelli
(c.1446–1510):
Mystic Nativity.

Savonarola became Prior of San Marco in Florence in 1491. This was where the gentle Fra Angelico had painted his frescoes fifty years earlier. After the flight of Piero de Medici in 1494, this charismatic Dominican, in an attempt to clean up Florence's moral climate, called its citizens to rededicate their lives to God. He influenced the setting up of a popular republic in the form of a Grand Council. In the council building was a marble tablet on which was written, 'This Council is from God.' Savonarola's impassioned preaching converted many, including artists and scholars. Desperate measures were needed; drastic action was taken. In a ceremonial 'burning of the vanities' (which replaced the pre-Lent carnival) irreligious art was consigned to the flames. However Savonarola himself was burnt a few years later, despite staying faithful to Catholic teaching, after he denounced Pope Alexander VI – one of the worst popes ever – as unfit to hold office. A full-size bronze statue of Savonarola in the basilica of San Marco bears witness to the spiritual intensity of this powerful man of God.

Upheaval was in the air. As Savonarola had prophesied, the French invaded Italy. The half-millennium was nigh. Natural disasters occurred, bringing floods and devastation in their wake. Some of these were recorded by Leonardo da Vinci in his extraordinary *Deluge* series of drawings which he produced while staying in the Vatican. His drawings show storms gathering momentum, throwing up mountains, towns, trees, and, finally, the sea itself.

However, instead of experiencing the end of the world, the new century realized the perfect fusion of Renaissance thought with Christian feeling, of physical beauty with

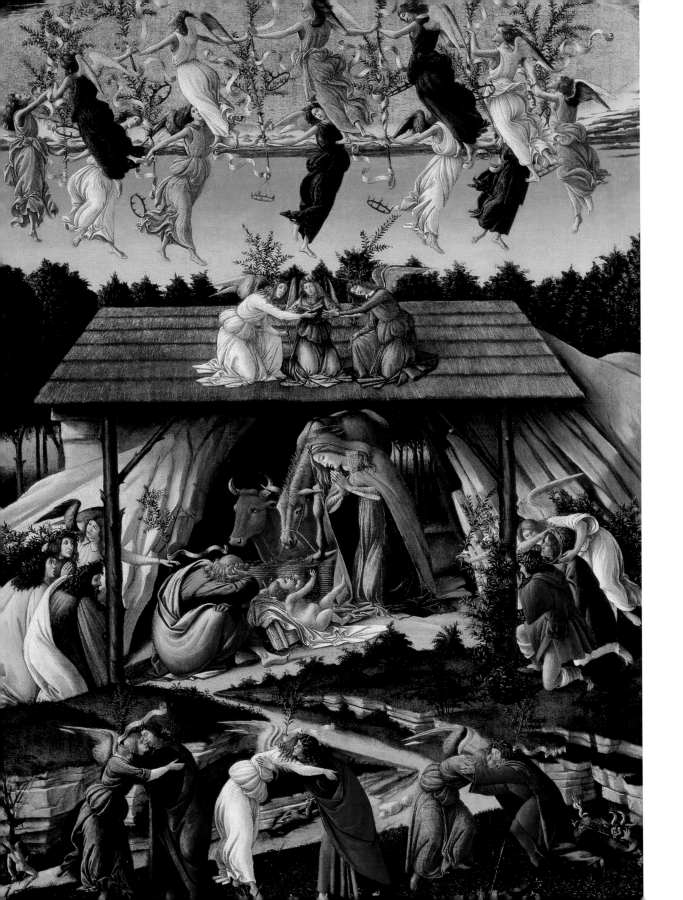

spiritual tensions in the work of three artistic geniuses: Leonardo da Vinci, Raphael, and Michelangelo. All were employed by popes. Indeed popes had been enlightened supporters throughout the Renaissance since Martin V had consolidated the papacy in Rome in 1420. Pope Nicholas V founded the Vatican library and filled it with manuscripts from monasteries all over Europe, and those salvaged from the destruction of Constantinople. He also encouraged writers, scholars, and artists like Fra Angelico. Sixtus IV built the Sistine Chapel; Julius II commissioned Michelangelo to paint its ceiling, and Raphael to decorate the papal state apartments. Leo X ordered the Raphael tapestry cartoons for the Sistine Chapel.

It looked as if the new humanism could flourish in harmony with Catholic orthodoxy, even though there was a difference between the old humanism – the world of Aquinas and St Francis, with its concern for people as children of God – and the new world, which was there to be enjoyed. Neo-platonist philosophers considered artists to be above ordinary mortals, and they were hailed by the people when they achieved something perfect with their hands. But though the great Italian artists were heirs to the classical heritage, they were also members of the Catholic Church, surrounded by all the evidence of faith with its mystical and devotional piety.

Sandro Botticelli (c.1446–1510)

Many artists consigned their pagan paintings (sought-after at that time for adorning Florentine palaces) to Savonarola's bonfire, and became *piagnoni* – members of his sect. According to Vasari, Sandro Botticelli was no exception. Botticelli painted *Mystic Nativity* (p. 105) for his own private devotions. But this was no ordinary nativity scene, nor was it similar to his many religious paintings that graced Tuscan churches. Influenced, no doubt, by Savonarola's apocalyptic sermons, Botticelli turned to St John's prophecies in Revelation for his inspiration. He also returned to the archaic Gothic style of painting, looking back to that 'Age of Faith', when symbol, not science, inspired the Christian. In hierarchical fashion, the most important figures are the largest. If Mary stood up in the stable, where she kneels before an enormous infant Jesus, she would hit her head. Joseph is curled up like one of Giotto's figures. Above the stable roof, angels hold hands and dance around the golden entrance to heaven. Scrolls flutter among them proclaiming 'Glory to God in the Highest, and on earth peace, goodwill towards men.' On Palm Sunday in 1495 Savonarola had organized a large procession through Florence in which children carried olive branches and wore wreaths in their hair, and here they abound.

Angels and men draw closer together and, as they embrace, little demons scuttle into dark holes in the ground. The Greek inscription at the top of the picture reads, 'I Sandro made this picture at the conclusion of the year 1500 in the troubles of Italy in the half time after the time according to the eleventh chapter of John in the second woe of the apocalypse during the loosing of the devil for three and a half years then he will be

chained in the twelfth chapter and we shall see [him burying himself] as in this picture.' Many people feared the second coming of Christ would happen in the millennium and a half, as they had thought at the end of the first millennium.

Leonardo da Vinci (1452–1519)

Painter, sculptor, architect, engineer, musician, mathematician, geologist, anatomist, natural historian – Leonardo da Vinci explored the visible world even more thoroughly than his predecessors. He greatly admired Giotto's work and considered him to be the first artist to turn 'straight from nature to art'.

Leonardo was a pupil of Verrocchio in Florence, along with Ghirlandaio, Perugino, and Botticelli. By the age of twenty he had become an independent artist, after being enrolled in the Florentine guild of St Luke. He was the first to probe the mysteries of the growing child in the womb, and he filled acres of sketch books with scientific drawings. Leonardo was left handed and wrote from right to left; his notes can only be read in a mirror. Perhaps he was playing safe for he anticipated Copernicus by writing, 'the sun does not move', and noted other things that, in his day, would have been considered heretical.

Leonardo felt that nature was the true mistress of design. Whatever he planned – church or cannon, something static or dynamic – he always strove to follow creation's principles. He mentally connected the dome of the cranium with the temple of a church, the ventricles of the heart with the interior of a colonnaded building, the anatomy of a bird's wing with his designs to achieve manpowered flight. An insatiable curiosity kept Leonardo endlessly searching for answers to the questions that rattled inside his ever-inventive mind and, like a leaf caught in the wind, he rarely found time to finish any project.

Despite the enormous range of Leonardo's intellect, he was primarily an artist. He wrote, 'He who scorns painting, loves neither philosophy nor nature.' He was one of the first artists to observe how objects in the distance appear blue, due to the earth's atmosphere acting as a filter, preventing many of the light rays from reaching our eyes. He noticed how colours are subdued in reduced light, resulting in an emphasis of the three-dimensional form. His blurred outlines and mellow colours merge into soft shadows as in the Mona Lisa's smile, producing a mysterious, evocative mood. The Italians call this *sfumato*.

Leonardo's The Virgin of the Rocks (c.1483–86 and c.1506–8)

This mood pervades his *The Virgin of the Rocks* (p. 108). Two versions of this subject exist (in The National Gallery in London and in the Louvre in Paris), and both were painted after Leonardo moved to the Duke of Milan's court in 1481. In the Paris version, from

around 1483–86, which was probably done first, the 'prettiness' of the Early Renaissance is apparent, while the London version has more unity of colour and shading, and a more reflective mood, which dates it nearer to 1506–8.

Professor Helmut Ruhemann had been invited to The National Gallery in London by its director in the 1930s. He cleaned *The Virgin of the Rocks*, and the subtle tones and colours were revealed. There is the Son of God with his mother, his cousin and an angel – not in a stable but in a natural grotto, surrounded by earth, water, and meticulously observed growing things. An awesome aura pervades this tiny, chubby, naked babe who blesses his cousin with God-like authority while St John kneels in homage, and Mary unites them in her love.

Ruhemann concentrated his pupils on their work by captivating them with erudite anecdotes. He questioned whether Leonardo, who rarely completed anything, could produce two almost identical paintings. The faces in the Paris version lack the spiritual weight of those in London. Why would Leonardo place the angel's pointing hand where it interrupts Mary's protective one? Such inconsistencies led Ruhemann, who started his career as an artist, to believe the 'earlier' Louvre version to be a studio copy, contrary to academic opinion. He waited patiently for it to be cleaned so that a proper comparison could be made, but it is still obscured by dirty varnish.

Leonardo's Last Supper (1495–97)

Though sorely damaged, Leonardo's mural, *Last Supper*, painted for the Dominicans of Santa Maria delle Grazie in Milan, is considered his masterpiece. (A contemporary copy, which hangs in Magdalen College Chapel, Oxford, was a useful aid to conservators in its recent extensive restoration.)

Leonardo must have enjoyed grappling with the problem of perspective: how to make the monks, eating in the refectory far below the painting, feel that Christ and the

apostles were there beside them. He brought them so close, made the figures so lifelike, that the monks must have felt they were part of the drama; the table seems to expand to welcome them. The light adds solidity and roundness to the group, and picks out the details of dishes on the table with uncanny realism.

Leonardo captures the atmosphere of tension as the apostles respond to Christ's comment, "'Truly, I say to you, one of you will betray me.' And they were very sorrowful, and began to say to him, one after another, 'Is it I, Lord?'" (Matthew 26:21–22). Traditionally the apostles sit in a tidy row, with Judas by himself. Like Giotto, Leonardo went back to the Bible and tried to recreate the scene. St John goes on to describe in his gospel, 'One of his disciples, whom Jesus loved, was lying close to the breast of Jesus; so Simon Peter beckoned to him and said, "Tell us who it is of whom he speaks"' (John 13:23–24).

The excitement is barely suppressed. Christ has spoken the tragic words, and his friends all react in different ways. St Peter, ever impetuous, rushes to St John on Jesus' right and, as he whispers in his ear, he seems to push Judas forward. The apostles are grouped in threes and each group inter-relates with gestures and movements to produce a perfect fusion of realism and design. Judas is grouped with St Peter and St John, providing a contrast between the most faithful and the least, yet he is alone, his face half-turned and in shadow – the embodiment of treachery and inhumanity. In the midst of all this activity, Jesus sits rock-like. Leonardo deliberately left Christ's head unfinished. As Vasari commented, 'For this he was unwilling to look for any human model, nor did he dare suppose that his imagination could conceive the beauty and divine grace that

Leonardo da Vinci (1452–1519): *Last Supper* (before restoration), Santa Maria delle Grazie, Milan.

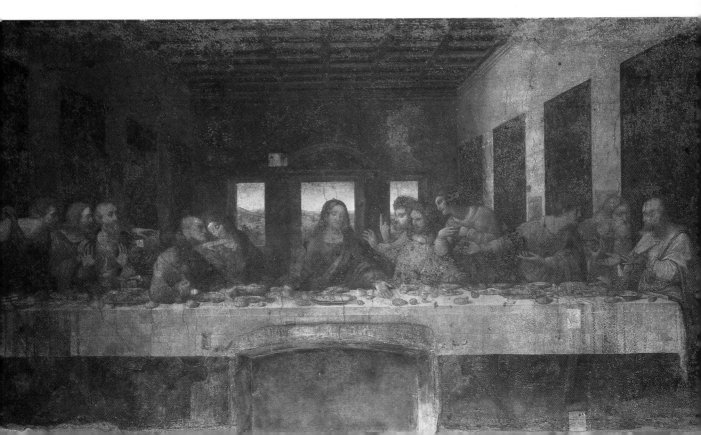

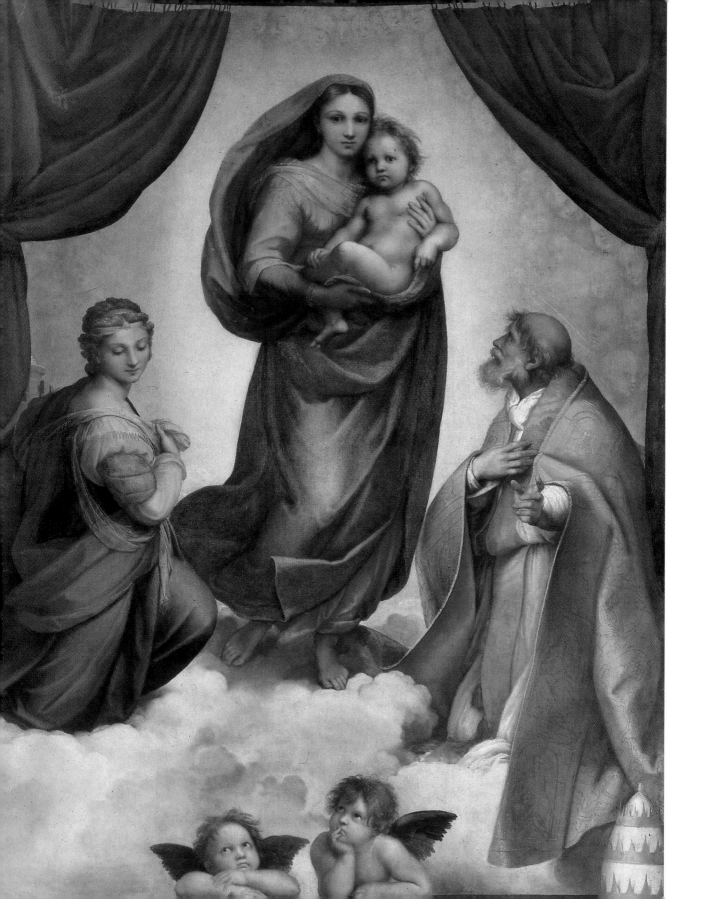

properly belonged to the incarnate Deity.' Yet the face he sketched bears a surprising similarity to that on the Turin shroud. The Dominican prior, perhaps conscious of Leonardo's tendency, would nag him to get on with the job. He became so frustrated, seeing the artist spending half a day apparently doing nothing, that he summoned the Duke of Milan to prod him. According to Vasari, Leonardo explained to the Duke that 'men of genius sometimes accomplish most when they work the least; for', he added, 'they are thinking out inventions and forming in their minds the perfect ideas which they subsequently express and reproduce with their hands'. Aristotle had separated the 'liberal arts' like philosophy, from the manual (menial) jobs. By placing art on scientific foundations, Leonardo transformed it to an honoured and gentlemanly pursuit. The *Last Supper*, perfect in composition and draughtsmanship, deep in psychological insight and imagination, is one of the great miracles of art.

Raphael (1483–1520)

While Leonardo explored truth in creation, Raffaello Sanzio, called Raphael, searched for beauty. He had a good start, being born in a pretty house in Urbino where his father was court painter to the Duke. Like Ferrara and Mantua, and other small Renaissance courts in northern Italy, Urbino was a civilized and beautiful town. Federigo Montefeltro, Duke of Urbino was highly intelligent and educated, a passionate book collector, and the greatest general of his day, well able to defend his domain from local incursions. The palace he had built is serene and timeless, the proportions so perfect that you seem to float through the rooms, and the Duke's humane, engaging personality still pervades the place. Once, when asked by his librarian what was necessary to rule a kingdom he replied, 'to be human'. Good manners were an important part of this, and young men came to his court, as to others, to finish their education: in short, to learn how to behave as true gentlemen. Castiglione later wrote his influential book *The Courtier* at Urbino, which Emperor Charles V reputedly kept by his bedside. This was the environment in which Raphael grew up. He trained with Perugino, but transformed the suave purity of his master into fullness of life. He went to Florence where he met Leonardo and Michelangelo. Undaunted by their brilliance, he wanted to learn and worked hard. His sweetness of character was attractive to patrons. Raphael's *Madonna and Child*, painted in different ways for a variety of commissions, reached a seemingly effortless standard of perfection that matched Pheidas and Praxiteles. But, whereas the ancient Greek sculptors had developed their ideal beauty from nature, Raphael idealized classical sculptures. His vision of the Madonna became the pattern that was followed by generations of artists — but never as successfully. His apparent simplicity was the fruit of deep thought — and, no doubt, prayer, careful planning, and immense artistic wisdom. *The Sistine Madonna*, painted at the end of his life for Pope Julius II, is an example of one of his paintings that is still venerated, in this case, by the citizens of Dresden.

Raphael
(1483–1520):
The Sistine Madonna.

Raphael's cartoons (1515–16)

In 1508 Raphael was taken to Rome by Bramante, the architect entrusted with the construction of the new St Peter's, who also came from Urbino. Bramante introduced Raphael to Julius II. The pope realized, after seeing one drawing, that Raphael was a great artist, and thereafter kept him busy painting frescoes in the Vatican.

In 1515, while Grünewald was painting the Isenheim Altarpiece, Raphael was commissioned by Leo X, the Medici pope who succeeded Julius II, to design cartoons for a series of tapestries illustrating the acts of St Peter and St Paul. These were to hang in the Sistine Chapel on important occasions. The subject was an appropriate one for the papal chapel, as these two saints were the twin founders of the Christian church. Raphael's cartoons were taken to the Brussels workshop of Pieter van Aelst where weavers stitched ten tapestries which still survive in the Vatican.

But Raphael's cartoons experienced a chequered history. One was acquired by Cardinal Grimani in 1521, and became the inspiration for many copies in different media. Seven more cartoons were bought in 1623 by Charles I, then Prince of Wales, on the advice of Rubens, for the Mortlake Tapestry Factory where an unknown number of sets was woven.

Cartoons were not thought to be works of art in themselves. This was not surprising when you consider the indignities they suffered. They were cut into vertical strips and shared out among individual weavers, who placed the strips under the warp threads on the looms. As the weavers worked on the back, cartoons were designed in reverse. The Raphael cartoons were reassembled at the end of the sixteenth century. This was no mean feat; the bigger ones are nearly 6 m long and consist of over 200 pieces of handmade linen-rag paper.

After the execution of Charles I in 1649, the cartoons were kept in wooden boxes in the Whitehall Banqueting Hall. They escaped the sale of Charles I's great art collection by Cromwell, and were still in the royal collection when Charles II ascended the throne of England. By then their artistic merit was generally appreciated. They were restored and displayed in a gallery designed for them by Sir Christopher Wren at Hampton Court. Then, in 1865, they were loaned to the Victoria and Albert Museum by Queen Victoria (acting on her late husband's wishes) and they have been there ever since.

It is a measure of Raphael's genius – indeed of the summit of civilization to which he aspired – that in a different climate and a different age these cartoons have lost nothing of their spiritual or artistic impact. The seven water-based paintings are among the greatest art treasures in Britain, for in them beauty and truth co-exist in perfect harmony and, as the Romantic poet John Keats commented, 'Beauty is truth, truth beauty.'

Raphael painted Jesus Christ with humility and profound faith. Both in his *Miraculous Draught of Fishes* and *Christ's Charge to Peter* Christ emanates an aura of serenity and wisdom, in contrast to the taut activity of the apostles. Their frail humanity is clothed in

handsome nobility – a reflection of the inner strength their faith developed. Both in the boat, where fish squirm, and beside the water, where sheep graze, their whole being is concentrated on Christ.

These two cartoons set the tone for the other five, taken from the Acts of the Apostles. In *The Death of Ananias*, the culprit collapses in violent death after being rebuked by St Peter for his deceitfulness. It is a penetrating lesson for the other converts who react with horror and disquiet. Meanwhile, two apostles continue to share the communal purse with the poor.

In Cyprus the proconsul, Sergius Paulus, kept himself amused in the far-flung

Raphael
(1483–1520):
*Miraculous Draught
of Fishes.*

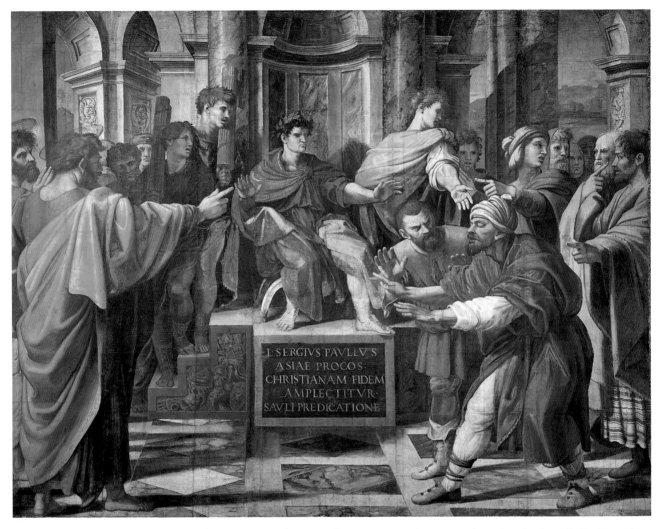

L·SERGIVS·PAVLLVS
ASIAE·PROCOS:
CHRISTIANAM·FIDEM
AMPLECTITVR·
SAVLI·PREDICATIONE

Raphael
(1483–1520):
*The Conversion of
the Proconsul.*

province, listening to the Jewish magician Elymas. When St Paul and St Barnabas arrived on their first journey to Cyprus, Elymas tried to prevent them expounding Christ's gospel of salvation to the Roman ruler. Again, in *The Conversion of the Proconsul*, Raphael illustrates the climax of the situation in a dramatic way. Although the proconsul sits on a greatly raised throne it is St Paul, standing larger than life, his arm sweeping out from the elegant folds of his mantle, who controls the situation. Simultaneously, two miracles occur: the deceiver Elymas is blinded, and the sophisticated Roman can see the truth. As a result of his conversion, Cyprus became the first province to be ruled by a Christian.

Michelangelo Buonarroti (1475–1564)

It seemed that nothing was impossible for these artistic geniuses – Leonardo, Raphael, and Michelangelo – in a revolutionary age, when humanity was striving to reach its full potential. But by 1520 both Leonardo and Raphael were dead. Only Michelangelo – sculptor, painter, architect, poet, and Florentine – survived, standing like a colossus throughout the Reformation, like his massive statue of David. This he carved out of a huge lump of marble, 4.3 m tall, that another sculptor had disfigured and then abandoned. In ancient Greece, the nude was a symbol of heroism; Michelangelo's *David* combines the ideal image of humanity with the Renaissance sense of intellectual endeavour. David holds a sling in his hand, an acknowledgment of the supremacy of intelligence over brute force, and a symbol of liberty. His face expresses the fierce assurance of youth that justice, and therefore truth, will prevail whatever the odds, and that he will protect his people. 'And David put his hand in his bag and took out a stone, and slung it, and struck the Philistine on his forehead… and killed him' (1 Samuel 17:49, 50). *David* was originally meant to stand outside the Duomo. However, in a council meeting in January 1504, only a small minority, including Botticelli, favoured that site. Leonardo, always a rival of Michelangelo, suggested the marble would survive better in the loggia – where of course, it would not be fully visible. It was finally decided to place *David* outside the Palazzo della Signoria (the town hall), as the sculpture had been commissioned by the republic. And there this classical transmogrification of the Old Testament Jewish hero, who defeated Goliath and saved his nation, remained until 1873 – a potent symbol of Florentine pride, freedom, and faith.

In 1488 Michelangelo was apprenticed to Domenico Ghirlandaio, the most flourishing artist in the city. Ghirlandaio's *Adoration of the Child* in Santa Trinita is beautiful and spiritual, precisely painted, and full of detail. It is a reminder of where Michelangelo began and, after studying Giotto, Masaccio, Donatello, and ancient classical sculptors, what a steep and stony path he climbed up the mountain of Olympus. Here he remained, on the sublime summit of the Renaissance, for thirty years, striving to release his inner vision from stone and paint. As he said, 'Good painting is nothing but a copy of the perfection of God and a recollection of His painting.' Yet, although the public's vast esteem raised him to the status of a demi-god, this melancholic genius found himself increasingly alone.

Michelangelo Buonarroti (1475–1564): *David.*

Michelangelo and the Sistine Chapel ceiling (1508–12)

Michelangelo worked for seven popes. For four long years he climbed up scaffolding, which he had designed, and painted the ceiling of the Sistine Chapel for Julius II. With superhuman exertion, and despite constant pain, he revealed the mystery of the creation and fall with forceful simplicity.

Unlike Leonardo, Michelangelo spent no time studying the beauties of nature. Since his early days examining cadavers, the human body and its spiritual qualities alone captivated him. He painted 300 figures on the Sistine Chapel ceiling, creating a pictorial poem about creation, that gift from God which so preoccupied the minds of Renaissance man. With incredible energy God the Father, swirling about in the cosmos, separates light from darkness. He creates the sun and the moon with commanding gestures before whirling off into the enormity of space to create the planets. And then 'the Spirit of God was moving over the face

Michelangelo Buonarroti (1475–1564): *Creation of Adam*, Sistine Chapel ceiling, Vatican, Rome.

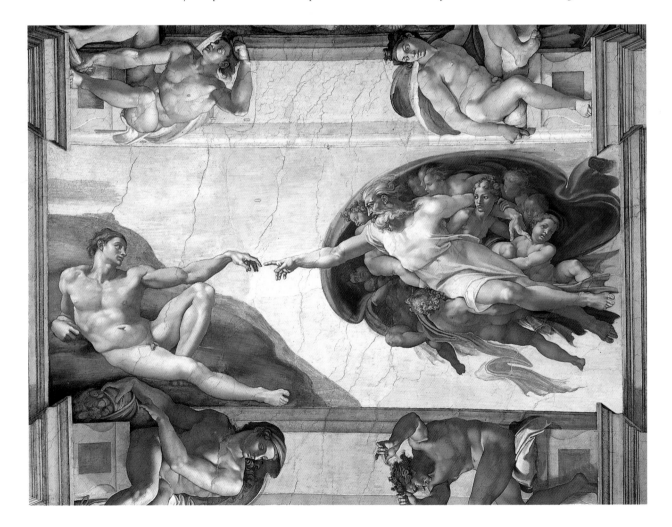

of the waters' (Genesis 1:2) dividing them from the earth. He flies through the air, a miracle of foreshortening, blessing the world with a gesture of peace and revelatory love. 'And God saw everything that he had made, and behold, it was very good' (Genesis 1:31).

Then God creates man, not in a paradisical garden, a place of beauty and plenty for him to enjoy, but on a slab of stone. In *Creation of Adam*, Adam, in the full beauty of his manhood, reclines like a river-god, his hand reaching out to his creator. The mystery which surrounds the transcendent God, long white beard and hair streaming behind him, is enshrined in the mantle which enfolds him, and the angelic creatures within it. And the love of God the Father is revealed as one arm protects woman, while the other stretches out to Adam. They do not touch, for God is unknowable, but the divine spark has been ignited and a human soul created, in God's own image. Michelangelo states the inescapable fact that men and women were made for God and can only find true fulfilment in him. 'And this is eternal life, that they know thee the only true God' (John 17:3).

The drama continues as God creates Eve. He draws her not from Adam's head, where he can rule her, or from his heel, where he can put her down, but from his rib, where he can love her from his heart. Then sin enters. The serpent, curled python-like around the tree in the middle of the garden, beguiles them to taste the only fruit that God had told them not to eat. They are deceived by Satan's lies, and through their disobedience, they fall from grace and are expelled from paradise.

The story moves on, away from the altar, the holy place, as humans move away from God. There is the sacrifice of Cain and Abel; the flood, in which groups of dying men are overwhelmed with fear, or trying vainly to help their neighbours outside the impassive ark; the drunkenness of Noah. In the manner of Byzantine iconography, Michelangelo painted

Michelangelo Buonarroti (1475–1564): *The Flood*, Sistine Chapel ceiling, Vatican, Rome.

the sequence in reverse order. But, whereas Byzantine art seemed to exist in a different realm, here time and space are one – ordered and harmonious, but very much in our world. When you enter the chapel you are very much 'in the flesh', and as you walk towards the altar, as if on an earthly pilgrimage, faith expands until you see God separating light from darkness. Then truth is revealed. To underline the sequence of history, Michelangelo paints Zechariah, the Palm Sunday prophet, over the entrance; Jonah, a vast symbol of resurrection (as in the catacombs), above the altar; and human atlantes, holding medallions in which stories from the Books of Kings are drawn. Beyond them are the ancestors of Christ, and the prophets and sibyls who foretold his coming.

Pope Julius II entered the chapel on All Saints' Day in 1512 to sing mass. And, as the people poured in to see the finished ceiling, Michelangelo was hailed as 'the greatest living artist'. Time has not diminished his greatness, since Michelangelo, with his inspired insight, belongs to every age. His human beings seem to express the essence of the divine, and his image of God the creator is so compelling that, despite his very human physical strength, he is still a symbol of the supernatural.

Michelangelo's Last Judgment (1534–41)

Michelangelo
Buonarroti
(1475–1564):
Last Judgment,
Sistine Chapel,
Vatican, Rome.

In a tricky political situation Pope Clement VII, another Medici, allied the papacy with France against the imperial forces. In retaliation Emperor Charles V, who was later to demolish St Bavo Cathedral in Ghent to make way for a citadel, sacked Rome in 1527. In his absence, his German troops, brain-washed by the Protestant propaganda that Rome was the 'whore of Babylon' and the pope the Anti-Christ, wreaked havoc for nine months. Three thousand Roman citizens were slaughtered, countless works of art destroyed, and a large part of Medieval Europe's historical records lost.

A quarter of a century after painting the ceiling of the Sistine Chapel, Michelangelo returned there to paint *Last Judgment* on the main wall behind the altar, for Clement's successor Paul III. It took him seven years. Having painted the beginning of the history of humanity, he now portrayed the end, his imagination, no doubt, filled with the terror and violence of the Reformation and the sacking of Rome. Again, human beings tell the story of humanity without distractions, the outward and visible sign of Michelangelo's own inward and physical energy. By then he was influenced by Vittoria Colonna, who wrote,

> Christ comes twice… The first time he only shows his great kindness, his
> clemency and his pity… The second time he comes armed and shows his
> justice, his majesty, his grandeur and his almighty power, and there is no longer
> any time for pity or room for pardon (Robert Coughlan, *Michelangelo*).

Christ sits in glory, an all-conquering athlete with the face of Apollo. His stern countenance turns with terrible concentration towards the damned, and he raises his hand to curse them. Beside him Mary, mother of the church, shrinks inside her cloak as she feels again that sense of terrible desolation caused by man's separation from God. Around Christ, in circles of

pulsating humanity, are the saints who have overcome: St Lawrence with his rack; St Bartholomew holding his flayed skin (a self-portrait of Michelangelo); St Catherine with half a wheel; St Peter who holds out his hand to his Lord; and a host of others who embrace and rejoice in their salvation. Beneath Christ's feet seven angels play the Last Trumpet, among them St Michael with his book, in which are written the names of the elect. The seven deadly sins, in the form of devils, try to intercept and drag to hell the souls flying up to heaven, but the souls are helped by the redeemed. Meanwhile Charon, with leonine face, makes a frenzied attack on the souls which devils are hauling into his boat. Michelangelo illustrated Dante's description from Canto III of 'Inferno' from *Divine Comedy*:

> *The demon Charon, with eyes red of burning coal,*
> *beckons to them and gathers them all in,*
> *smiting with the oar any that linger.*

Michelangelo portrayed all the emotions that human beings can experience in this massive, overwhelming fresco, emotions he probably experienced as he considered his own death and judgment. As he wrote to Vasari ('Sonnet LXXIII'):

> *Already now my life has run its course,*
> *And like a fragile boat on a rough sea,*
> *I reach the place which everyone must cross.*

The pope is said to have fallen to his knees during the unveiling ceremony, and begged to be saved from judgment.

Vasari testified to Michelangelo's faith:

> Being a devout Christian, Michelangelo loved reading the Holy Scriptures, and he held in great veneration the works written by Fra Girolamo Savonarola, whom he had heard preaching from the pulpit. He greatly loved human beauty for its use in art; only by copying the human form, and by selecting from what was beautiful the most beautiful, could he achieve perfection. This conviction he held without any lascivious or disgraceful thoughts, as is proved by his very austere way of life.

CHAPTER 7

Inner Fervour

*It was during mass on the feast of St Paul, when Jesus Christ deigned
to appear before me complete in his very holy human incarnation,
indescribably beautiful and majestic as he is depicted in paintings of him
resurrected... I never saw this vision with the eyes of my body or any
other, only with the eyes of my soul... Sometimes I thought that what I
could see was nothing more than a painting; but on many occasions it
was obviously Jesus Christ himself; much depended on how clearly he
wanted to reveal himself to me.*

St Teresa of Avila (1515–82), *The Life of St Teresa of Avila*

While Germany was the natural setting for the Protestant revolt, Spain was the obvious catalyst for the Counter-Reformation, with its intense loyalty to the Catholic Church honed by a long struggle against the Islamic Moors. Ignatius Loyola, unlike the miner's son Luther, was a grandee and a soldier. He was wounded at the seige of Pamplona in 1521 and, during a long convalescence, he experienced a conversion similar to Luther's, emerging on fire for God and the Catholic Church. Like St Francis, he gathered together a band of followers – the Jesuits – inspired with his own vision, and in 1540 this Society of Jesus was approved by Paul III (the pope who commissioned Michelangelo's *Last Judgment* for the Sistine Chapel).

Ignatius Loyola was a mystic, a visionary, and an ecstatic, but he also had a soldier's training. These experiences came together in his *Spiritual Exercises*, published in 1548, a manual of discipline in the devotional life which was geared to prepare clergy and laity for the militant transmission of the faith. It became the most important book of the Counter-Reformation.

Through Loyola and the Jesuits, a new spirit suffused the Roman Catholic Church – its new title after the Reformation – giving it vitality and vigour, winning back much that it had lost, and providing a dynamic reply to Protestantism in religion, literature, and art.

Whereas Protestants focused on the oral tradition of sermons and reading, *Spiritual Exercises* emphasized the importance of visualizing, as intensely as possible, the passion of Christ and the sufferings of the saints. Art, therefore, continued in the service of the church, but with a new visionary intensity. By the end of the seventeenth century, the

Baroque style, led by Bernini, had merged painting, sculpture, and architecture into a vivid, energetic whole.

Inevitably, both Catholics and Protestants emphasized those features of Christian practice which their opponents rejected. At the Council of Trent (which convened periodically for twenty years in the mid-sixteenth century) the traditions of the church were declared to have the same authority as the Bible. And, as the Protestants rejected everything that could not be justified by the Bible, Catholicism laid more stress on those elements of doctrine and liturgy that had developed since biblical times. These included the glory of the church with its pomp and pageantry; the centrality of the mass; devotion to Mary; the impact of miracles; and the sufferings of the saints. As practices developed, attitudes hardened and divisions widened.

Titian (c.1490–1576)

In painting, Titian, an equally long-living contemporary of Michelangelo, ruled supreme among Venetian artists. His first major religious work, *The Assumption of the Virgin*, was commissioned by the Franciscans to hang above the high altar of Santa Maria Gloriosa dei Frari, a huge church now filled with many important paintings. As so often happens with innovative work, the initial reception to this painting was tepid. There, in a canvas over 7 m high, is a beautiful young woman, the mother of God, the second, sinless, Eve, rising on angel-filled clouds to heaven where God the Father waits to receive her. Their feet firmly earthed below, the apostles are grouped together round her tomb, looking up in astonishment and awe. Here, indeed, are three planes of reality held together by superb design and vibrant colour. Titian was painting this triumphantly prophetic prelude to Counter-Reformation imagery when Luther nailed his famous ninety-five theses to the door of the castle church at Wittenberg.

Titian (c.1490–1576): *The Assumption of the Virgin*, Santa Maria Gloriosa dei Frari, Venice.

Tintoretto (1518–94)

In the year Titian completed *The Assumption of the Virgin*, Jacopo Robusti – called Tintoretto because he was the son of a cloth dyer which, in Italian, is *tintore* – was born in Venice. Unlike Titian and his contemporaries, who produced paintings of great beauty, refinement, and colour, Tintoretto, in the religious revival of the Counter-Reformation, wasted little time on secular subjects. He was a fervent Catholic who spent his life interpreting, rather than merely illustrating, biblical themes on large canvasses for Venetian churches. He absorbed ideas that flowed from the Council of Trent, particularly the need to shun luxury and opulence. Consequently he portrayed the disciples as humble, poor and undistinguished, and stressed the simplicity and poverty implicit in the gospels. To increase the tension and drama of an event, he emphasized forms, and heightened the

contrast between light and shade, an effect known as chiaroscuro. He also used audacious foreshortening and somewhat precipitous perspective, and painted with loose brush strokes. Vasari was puzzled by his lack of 'finish' and grumbled about his so-called careless brushwork and eccentric taste – a criticism that has dogged artists ever since.

In *Baptism of Christ* (c.1580), which still hangs in the Church of San Silvestro in Venice, the Holy Spirit, in the form of a dove, hovers in a cloud burst of light that beams down through the water that St John the Baptist pours over Christ's head. The light falls on to his body and flickers on the water of life that cascades down the rock on which St John stands. The picture vibrates with humility and holiness. And the symphony of light and dark, good and evil, right and wrong is prevalent here, as it is in many of Tintoretto's paintings.

The battle between light and dark takes on cosmic proportions in *The Last Supper*

Tintoretto (1518–94): *The Crucifixion of Christ*, Scuola Grande di San Rocco, Venice.

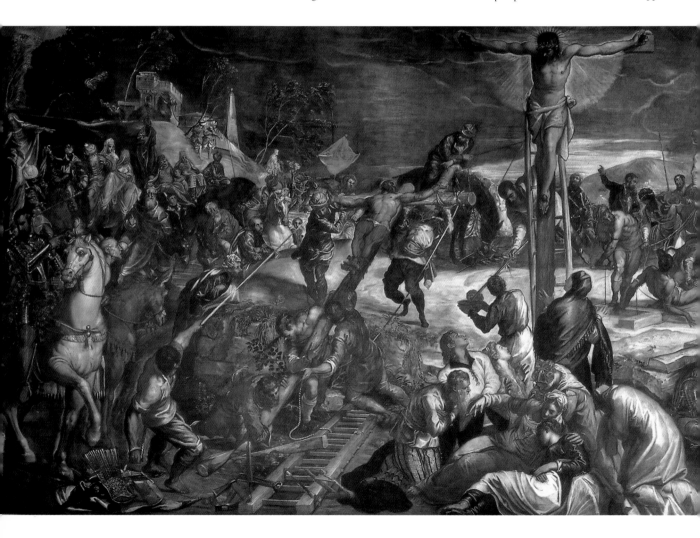

(c.1590–94), in San Giorgio Maggiore. Angels fly into the upper room where Jesus, in an aura of light, breaks bread and gives it to St John, while the other apostles, servants, and Jesus' mother look on. And we can look across the distance of time and meditate anew on Christ's incredible love.

Tintoretto and the Scuola Grande di San Rocco (1564–88)

In 1564 Tintoretto embarked on the Venetian equivalent of the Sistine Chapel project. He was appointed official artist to the Scuola Grande di San Rocco and, over the next twenty-five years, painted episodes from the Old and New Testaments on practically every inch of ceiling and wall of their grand building.

The Scuole in Venice were lay brotherhoods under the patronage of a saint protector, striving towards penitence and devotion. They were set up to help the poor and the sick, to protect the interests of individual professions, or to help the needy members of foreign communities in their city. The guild dedicated to St Roch (San Rocco) was officially recognized in 1478. Roch was a French nobleman, born in 1295, who left all his riches to go to Italy to help those stricken with plague. He died young and was immediately called upon as a protector against the pestilence which raged all over Europe. His body was brought to Venice in 1485 and laid to rest in the church of the Scuola dedicated to him, and he was proclaimed co-patron of the city. His church became a place of pilgrimage for the doge and nobility as well as ordinary pilgrims, and it still is to this day.

For nearly two decades the Brothers had deliberated

about exchanging the temporary decorations used for feast days, which had become somewhat tatty, for permanent paintings. They decided to start with the ceiling of the Sala dell'Albergo, the meeting hall of the confraternity on the first floor. Tintoretto won the commission by presenting a finished oval canvas representing *Glorification of St Roch* instead of the sketch asked for by the governors. But Tintoretto was less concerned with the life of the saint than with the deeper meaning of the Bible. He then proceeded to paint important moments in the passion of Christ, culminating in *The Crucifixion of Christ*, (pp. 124–25) on the walls of the Sala.

The dramatic staging of *Christ before Pilate* is highly original. Tall and thin, and wrapped in a long, seamless mantle, Jesus stands on a step facing Pilate. The two protagonists are raised above the crowd, and the sense of majesty is echoed in the splendid architecture that spans the picture, bathed in light and shadow. Tintoretto often put classical architectural settings in his compositions, taken, probably, from Serlio's architectural treatises. Below them, an old secretary notes down every word. Pilate did not understand why the Jews wanted him to release a known criminal rather than Jesus, whom he considered innocent of wrong doing. His wife had suffered a nightmare about Jesus and had begged him, 'Have nothing to do with that righteous man' (Matthew 27:19). But when he saw a riot was about to begin, and it was therefore useless to make a stand for justice, 'he took water and washed his hands before the crowd, saying, "I am innocent of this man's blood; see to it yourselves"' (Matthew 27:24).

And they did. After *Crowning of Thorns* the next painting is *Christ Ascends to Calvary*. The road rises at an acute angle and Christ, led by a rope round his neck, staggers under the weight of the cross. The blood drips from his forehead as the crown of thorns pierces his brow. Clouds darken angrily. In the foreground, in shadow, the two thieves follow, carrying their own crosses.

The passion reaches its climax in *The Crucifixion of Christ*, which spans one wall (5.36 m by 12.24 m). Completed in 1566, it is Tintoretto's masterpiece. Crammed full of closely observed human action, this painting is one of the most profoundly moving of all crucifixions. It received immediate acclaim and continued to influence painters like Rubens and Van Dyck in the following century. Jesus hangs on the cross, head bowed, in the centre of the picture, surrounded by an aura of light which is echoed in the silver edges of the blackened clouds. Like the bright morning star, his light radiates down to the well-placed figures that balance the huge canvas: the repentant thief on his right who looks towards him as his own cross is lifted up; the proud thief who turns away from the light as his feet are being nailed to a wooden beam; the group of women weeping in the foreground with St John, who raises his head to hear Christ's request to look after his mother; the soldiers who secrete themselves away to cast lots for Christ's seamless tunic, as prophesied in Psalm 22:18: 'they divide my garments among them, and for my raiment they cast lots'; and Tintoretto himself in a purple robe, representing all humanity, as he leans forward to witness the Saviour of the world dying. And Jesus, knowing that everything he had come to earth to do had been accomplished, said, 'I thirst.' In this tragic, bitter,

terrible moment he is separated from his Father, from a life-giving relationship with a living God. He is devoid of the love that transformed his followers into saints, like St Peter and St Paul – or St Roch. He thirsted, as all humanity thirsts, for meaning, hope and faith in a fragmented world. As St Augustine of Hippo expressed it, 'My soul is restless until it rests in Thee.' And a sponge was saturated with vinegar, put on a reed, and lifted up for him to drink. 'And Jesus cried again with a loud voice and yielded up his spirit. And behold, the curtain of the temple was torn in two, from top to bottom' (Matthew 27:50–51).

This aspect of God's mercy is reflected in the upper hall next door, where Tintoretto painted scenes from the Old Testament on the ceiling. When Moses led God's chosen people out of slavery into the desert they grumbled whenever things went wrong. Yet, although they did not trust in God's mercy, he did not forget them. When they were hungry he sent manna down from heaven and they ate their fill for as long as they needed it. In *The Fall of Manna* (p. 127) Tintoretto painted the clouds that separate us from God parting to reveal his awesome presence, while the people run about collecting what look like small communion wafers, for he feeds us through the body of his son. The improvised canopy alludes to the curtain in the temple and the tablecloth of the Last Supper.

Tintoretto's masterly brush work seems to speed up the action and lend drama to his painting, *Moses Drawing Water from the Rock*. Moses represents Christ, and the water gushing out of the rock symbolizes God's abundant grace. *The Brazen Serpent* reminds us of God's promised salvation, healing, and redemption, for when Moses lifted up the bronze serpent on a pole, everyone who was bitten by a snake and looked up at this symbol survived. Both paintings also referred to the charity of the Brothers in the Scuola who looked after the sick and hungry.

El Greco (1541–1614)

El Greco
(1541–1614):
Resurrection.

Domenikos Theotokopoulos, called El Greco, also worked briefly in Venice. He was born in Crete where he painted icons before moving to Italy. In Venice he was inspired by Tintoretto; in Rome he discovered Michelangelo and became involved in the controversy over the nude figures in Michelangelo's *Last Judgment*, offering to overpaint what some considered indecent in a chapel. With these disparate influences he moved mysteriously to Spain, where he spent the rest of his life developing an original, eloquent, and spiritual style of painting.

El Greco put Loyola's *Spiritual Exercises* into paint with ecstatic passion. He discovered a new rhythm of flames – the flames of the Holy Spirit – and a new world of weightlessness. Clouds, bodies, draperies, trees, and rocks all seem caught up in these unearthly, flickering rhythms. Whereas Grünewald's world is hard, cruel, and merciless, El Greco's is ghostly, radiant, and soaring. His paintings are essays in upward movement and inner light.

El Greco had stumbled on a new facet of Christian art. He invented a new language to interpret heaven. For two centuries the spirit of the Renaissance had struggled to understand the technical problems of structure, volume, space, and solidity. El Greco turned his back on all that. Denying the weight of the world he became master of the unworldly.

In the great picture *Burial of Count Orgaz* (c.1586), El Greco depicts the descent from heaven of St Stephen and St Augustine. The saints miraculously lift Count Orgaz's body into a crowded heaven consisting of an amazing organization of flame-like forms. The very clouds are on fire, despite their cold colours, and the clothing captures the rhythm of the flames.

El Greco painted this enormous canvas (it is 5 m by nearly 4 m) in nine months. The count had died in 1323 and, according to legend, being a very charitable man, the two great saints had carried him to his tomb in San Tome in Orgaz (part of Toledo), where he was a benefactor. In his will he left a charge on the town as a bequest to the priest. Needless to say the townspeople eventually decided to stop paying, and in 1570 the incumbent priest sued them and won his case. Ten years later the Archbishop commissioned this huge painting and sent the people of Orgaz the bill.

El Greco's *Resurrection* is another fine example of visionary painting, with its great vertical sweep. Christ rises gently to heaven, holding his banner of victory in one hand, and raising his other hand in blessing. Like Piero della Francesca's Christ, his eyes engage you, but instead of rising from an empty tomb, he ascends from a group of men who react violently. El Greco seems to have reinvented the scene by combining two incidents. The group of men represents the soldiers who came to the garden of Gethsemane looking for Jesus to arrest him. St John describes how, 'When he said to them, "I am

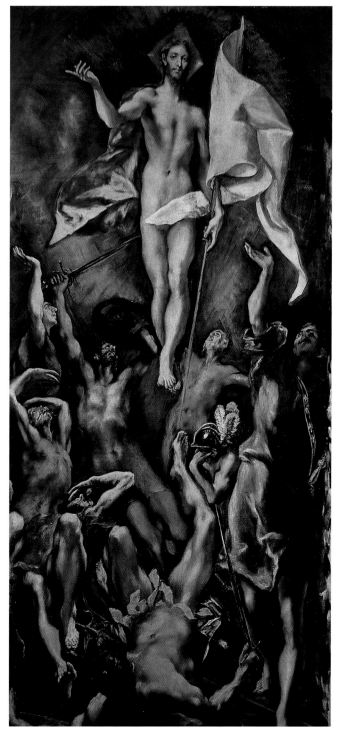

he," they drew back and fell to the ground' (John 18:6). In the Old Testament God promised Moses that 'I am who I am' would deliver his people from their slavery in Egypt. 'I am' was God who was too awesome and mysterious to be named. And here was God made man, overcoming death and going back to his Father in heaven. No wonder men reacted in fear and anguish. The exception is the man on the right of the picture, perhaps St John himself, who recognizes his Lord and salutes his victory.

Penitent Magdalene is of a typically Counter-Reformation subject which El Greco transformed into a timeless *vanitas*. The Magdalene sits upon a rock, with a book and

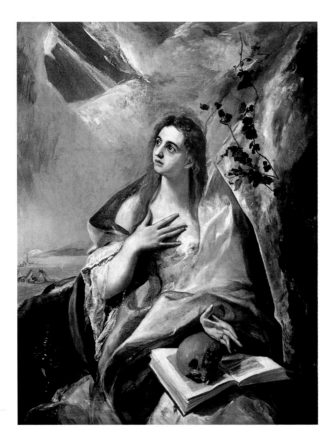

El Greco (1541–1614): *Penitent Magdalene.*

a skull upon her knee, contemplating the fleetingness of worldly existence and the inevitability of death. El Greco composed her scanty robes as a pictorial symphony of mauve, white, and azure blue, harmonizing with the sea beyond which the sun sets on the vanity of life. As she grieves over the loss of Jesus while the waves splash continually against the shore, her pale Spanish face looks up to the skies where the clouds have opened to reveal his light. Time has been superseded by eternity.

The depth and simplicity of this extremely moving portrayal of the sinner whom Jesus loved evokes St Paul's words to the struggling young church at Corinth: 'For the word of the cross is folly to those who are perishing, but to us who are being saved it is the power of God…

God chose what is foolish in the world to shame the wise, God chose what is weak in the world to shame the strong' (1 Corinthians 1:18, 27).

El Greco's *Christ Driving the Traders from the Temple* is painted with an acute understanding of the Bible. As the prophet Zechariah had announced nearly 500 years before, the Messiah would ride into Jerusalem on a young, unbroken ass. Jesus fulfilled that prophecy. As he rode humbly into the city, the people recognized him and shouted, 'Hosanna to the Son of David! Blessed is he who comes in the name of the Lord!' (Matthew 21:9). Meanwhile, as pilgrims poured into the holy city for the Passover,

imperial reinforcements marched east in case of trouble at the religious festival. The temple, believed by the Jews to be God's dwelling place on earth, which only 'pure' Jews were fit to enter, was the focal point. The blind, the lame, and certainly all Gentiles were excluded from God's presence.

Jesus also entered the temple. He 'drove out all who sold and bought in the temple, and he overturned the tables of the money-changers and the seats of those who sold pigeons. He said to them, "It is written, 'My house shall be called a house of prayer'; but you make it a den of robbers'" (Matthew 21:12–13). As he rails against the ideology that

El Greco (1541–1614): *Christ Driving the Traders from the Temple.*

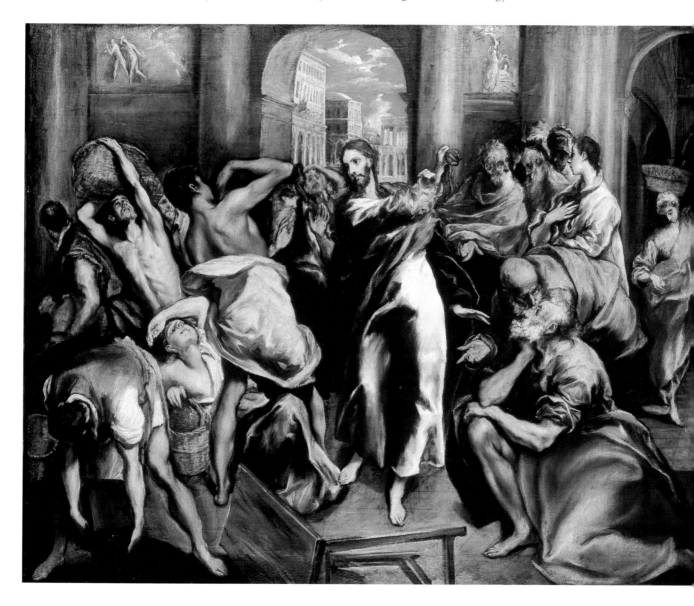

blinded them from God's ways, as he sweeps through the temple, Jesus arcs his arm back and forth like a scythe cutting grass, his eyes blazing with righteous indignation. Even the lemon and purple colours are strident. Through the arch behind him, the clouds echo his anger. The *Expulsion from Paradise* and *Sacrifice of Isaac* are carved in stone on either side of the entrance. Jesus had come to end the religious exclusiveness of the Jews, to be the final sacrifice for all mankind, and to fulfil God's promise to Isaiah: 'my house shall be called a house of prayer for all peoples' (Isaiah 56:7). And he healed all the blind and the lame who came to him in the temple.

Michelangelo Merisi da Caravaggio (1571–1610)

Whereas Tintoretto and El Greco were inspired from the depths of their all-embracing faith in Jesus Christ, Jacopo Merisi, called Caravaggio, was hardly a pillar of the church. He was an *enfant terrible* of his time – a restless, self-destructive character with a hot temper and aggressive nature which led him into constant trouble. Yet he read the Bible endlessly and wanted to 'see' the holy events before his eyes, not in classical beauty but in the light and shade of human weakness. Tintoretto and El Greco were original but Caravaggio changed the course of art for all time. He took painting into the real world – not the classical world of perfect humanity, or the Counter-Reformation world of visions, but the world we live in, the world we look at. He observed every detail of humanity – good and evil – with passion and understanding.

Caravaggio came from Lombardy in the north of Italy, where direct observation from nature was a local artistic characteristic. From the beginning he studied the relationship between objects and light – natural and artificial – and learnt how to use colour to build up form and substance. Like everyone else, he studied the works of Raphael and Michelangelo.

When he was twenty years old, Caravaggio went to Rome. Life was not easy and he worked for Cavalier d'Arpino painting, mainly, flowers and fruit. The way he saw and painted the surface textures of figs, grapes, and leaves was almost miraculous; his technique was certainly the most advanced of his age. Whereas Hugo van der Goes merely gave a still life prominence in his pictures, Caravaggio made a still life a painting in its own right for, as he once explained to a patron, it took as much workmanship to paint flowers as figures. Painters of the Utrecht School in Rome were inspired by them and took still life painting back to Holland, where it developed as a new genre.

While Michelangelo ignored nature, Caravaggio ignored niceties. He looked at incidents from a different viewpoint, going straight to the very human heart of the matter. For example, he painted Martha not with Mary her sister but with Mary Magdalene. Instead of feeling sorry for herself, busy in the kitchen, while her sister sits at the feet of Jesus, here she is telling the other Mary that she should not spend so much time and

money on the vanities of the world. He paints the sequence of this story in another picture, *Mary Magdalene*. Mary sits in a chair crying, her chestnut hair streaming down her back. On the floor beside her Caravaggio painted her pearls and gold jewellery lying discarded beside a carafe of oil. This intimate interior scene was another idea picked up by Caravaggio's northern followers. The quiet grace and exquisite detail prefigures the spirit of Vermeer, who worked half a century later.

Caravaggio and San Luigi dei Francesi (1599–1600)

Caravaggio worked initially for private patrons. His first church commission was for three pictures for the lateral walls of San Luigi dei Francesi, in the chapel belonging to the deceased French monsignor, Matteo Contarelli, who had left instructions for the chapel to be illustrated with the life of his namesake. This was the opportunity for Caravaggio to really expand. He had never put more than three figures in any one painting before. Now he put seven in *Calling of St Matthew* (p. 134) and thirteen in *Martyrdom of St Matthew*.

Bellori, the seventeenth-century art historian, claimed that Caravaggio 'knew no master but the model'. Instead of the inhabitants of Mount Olympus he brought ordinary people off the street to sit for him. This was another revolutionary step, and the reason that several of his down-to-earth paintings were rejected by those who commissioned them. Indeed, his painting, *St Matthew Writing His Gospel*, had to be reworked before the French church authorities accepted it. They were the artistic equivalent of the evocative sermons and teachings of St Philip Neri, who identified with the poor and humble people who followed him round the back streets of Rome when Caravaggio lived there.

The power of Caravaggio hits you when you enter San Luigi dei Francesi and are confronted by these paintings. They must have had an even greater impact in his own day, when they were new. No wonder his work was copied so much, even during his short life. They are extremely unusual. Looking at *Calling of St Matthew*, you could be transported back to that moment in history when Jesus went to find St Matthew and call him to be his disciple. The colours are rich and mellow. St Matthew sits at a table among four acquaintances. Time hovers between past and present; Caravaggio's contemporary dress adds to the immediacy, while Christ is timeless. He continues to call us. He stands here in shadow hidden from worldliness, his hand outstretched commandingly, in contrast to St Peter's hesitant stance beside him. Like Michelangelo's God on the Sistine Chapel vault, reaching out to the first man, Christ wants to communicate – to pour out his Spirit and enliven humanity for a new and everlasting role. The light floods in behind him, catching the expressions on the five faces.

As St Matthew looks up questioningly he points to himself. Is it I? The tension of Leonardo's *Last Supper* is evoked, when the apostles were forced to consider their own actions, to point the finger at themselves instead of at others.

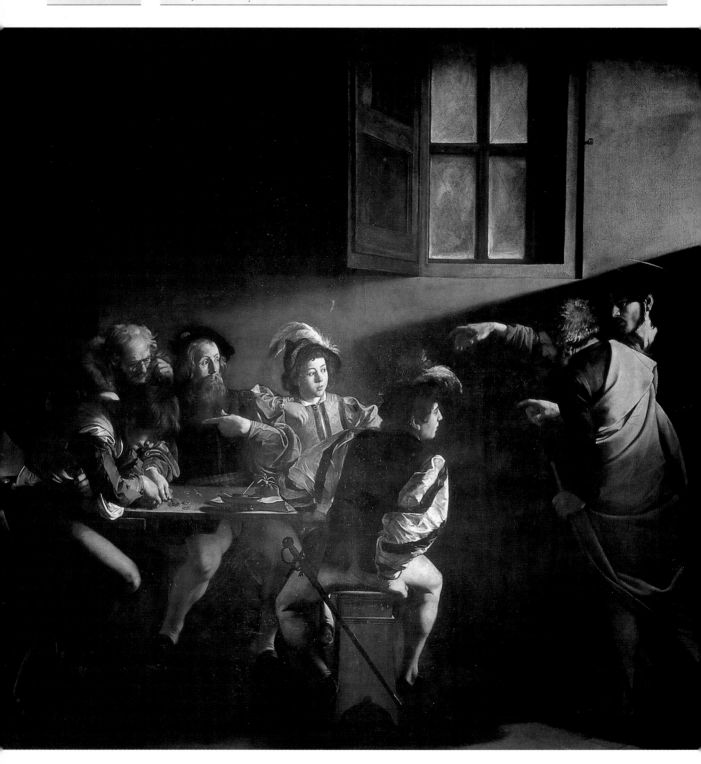

In this down-to-earth encounter, where the focus is on the figures and background detail is kept to a minimum, Caravaggio runs contrary to the Counter-Reformation objectives of art. Instead of inspiring a visionary experience, he simply wants you to draw a lesson from life.

Caravaggio was not interested in mystery plays. This is a real life story of self-knowledge – of conscious conscience. In pointing to St Matthew, Jesus shows that he wants all mankind to receive his love and follow him. This is real love, that created the universe and allowed itself to be sacrificed for the sins that occur in a world where men and women are given the freedom to chose between good and evil. This all-embracing love wants to fill everyone with the fullness of life. St Matthew was a tax collector – not the most salubrious profession in those days, for tax collectors were known to cheat and bully. But God, who made him, knew his potential and wanted to use it to the utmost. The tax collector became an apostle and the writer of the first gospel in the New Testament, a gospel which has been of profound value and significance for 2,000 years. Caravaggio captures the moment when he is chosen and called, just as Caravaggio himself was called, despite his violent temperament, and transformed through his paintings into a purveyor of truth. Every action affects others. As St Matthew responds to Christ's call, the two young men closest to Christ are attentive – alert – to the new challenge. The others are so concentrated on counting the money, so shut in on themselves, they are completely oblivious to the magnitude of the event.

This first, mesmerizing painting focuses on the beginning of St Matthew's spiritual experience. In the second equally enormous oil painting, *Martyrdom of St Matthew*, Caravaggio captures the violent end of his life in this world. The colour tones have changed from warm to chilly. Again he attacks the subject with astonishing rapidity. He made no drawings, but painted straight onto the canvas, reworking, rejecting, or changing ideas, pushing the paint around until he reached the final conclusion. It is perhaps another reflection of his complex character: headstrong and provocative, but painting the tiniest detail with compassion. Reality has to be lived.

The calling of St Matthew is described in his gospel. The story of his martyrdom is told in *The Golden Legend*. St Matthew had enraged the king of Ethiopia when preaching one Sunday about the inviolability of marriage, saying that the woman the king wanted to marry was already wedded to Christ. As a result, St Matthew was stabbed in the back while praying before the altar.

The action in *Martyrdom of St Matthew* again takes place in half light, adding to the sense of drama, and your eyes are swept around the canvas by diagonals of light and movement. The classical influence of Raphael lingers. St Matthew is an old man. He lies defenceless on the ground while his assassin, clasping a heavy sword, grabs his upraised arm with vindictive hatred. This is to prevent him receiving the palm of victory from the angel, who swoops down in a cacophony of cloud (in a pose taken from Michelangelo's *Last Judgment*) to bestow this mark of martyrdom.

Michelangelo Merisi da Caravaggio (1571–1610): *Calling of St Matthew*, San Luigi dei Francesi, Rome.

Caravaggio's The Supper at Emmaus (1601)

Painted in the middle period of Caravaggio's career, *The Supper at Emmaus* is another flashpoint of perception, capturing the moment when Cleopas and his companion recognize the risen Christ. They had met a stranger on the road and, during the journey to Emmaus, had told him about the crucifixion of Jesus Christ, the empty tomb, and their hopes that one day he would redeem Israel. Sometimes we are so busy hanging on to our preconceived ideas, 'We're likely to pass God by without even noticing him' (Abbot of St Benoit-sur-Loire, *The Work of St Benedict*). When they reached the village, the stranger accepted their invitation to stay with them. 'When he was at table with them, he took the bread and blessed, and broke it, and gave it to them. And their eyes were opened and they recognized him' (Luke 24:30–31). You can almost hear the scraping of the chair legs on the floor as Cleopas, his sleeve torn, pushes it back in astonishment. The other disciple, with broken nose, sunburnt face and a scallop shell (symbol of pilgrims) attached to his leather collar, stretches his arms back – like St John in Giotto's *Lamentation*. And the light leaps down from above as if God himself is present at this joyous moment of revelation. This is Christ – after death – alive!

Christ's face is young and clean-shaven like that of Michelangelo's Christ in *Last Judgment*. But there the comparison ends. Far from a classical ideal, this is a particular face, perhaps of a young Jew Caravaggio had spotted in the street. He leans forward slightly, his face lowered in prayer, one hand raised to bless his companions, the other blessing the bread, while the innkeeper looks on uncomprehendingly. For this is simultaneously the last supper of Christ on earth and the first celebration of the risen Christ in the eucharist. The golden thread is unbroken. Christ was, and is, and is to come.

Michelangelo Merisi da Caravaggio (1571–1610): *The Supper at Emmaus*.

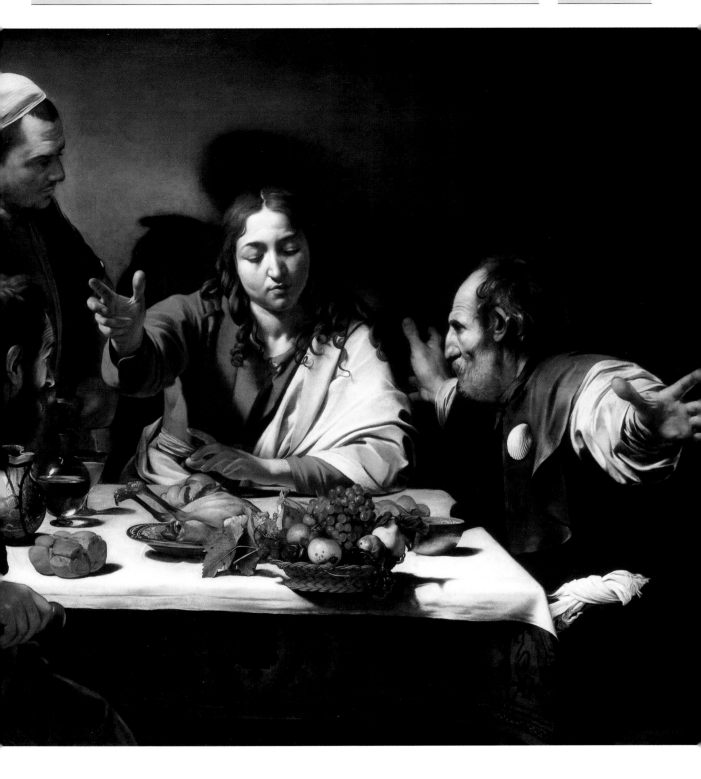

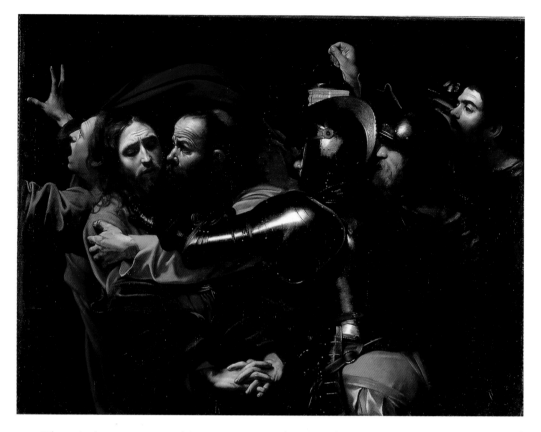

Michelangelo Merisi
da Caravaggio
(1571–1610):
The Taking of Christ.

The missing partner to this painting was discovered in 1990, hanging unrecognized in a Jesuit community in Dublin. *The Taking of Christ* was commissioned by a Roman nobleman called Ciriaco Mattei. Here, Caravaggio zooms into close-up. You could be a disciple standing beside Christ as Judas clasps his friend's arm and moves to kiss him. St John turns his back to Jesus and screams in terror, while the armoured soldiers close in the darkness, and a lad lifts a lantern to light up Christ. 'Now the betrayer had given them a sign, saying, "The one I shall kiss is the man; seize him." And he came up to Jesus at once and said, "Hail, Master!" And he kissed him... Then they came up and laid hands on Jesus and seized him' (Matthew 26:48–49, 50).

This was the ultimate betrayal. And Caravaggio frames the two protagonists within St John's cloak, which flaps over their heads, and the clinking, black arm of the soldier stretching out to take him. Judas looks searchingly at his master, his brow heavily furrowed. But Jesus, filled with profound sorrow and dread, can only look down as he interlaces his fingers with bone-crunching finality. He was a perfect man. He who abused neither his body nor his soul was to receive the worst excesses of cruelty that humanity could conceive, capped by the desolation of seeming abandonment by his Father.

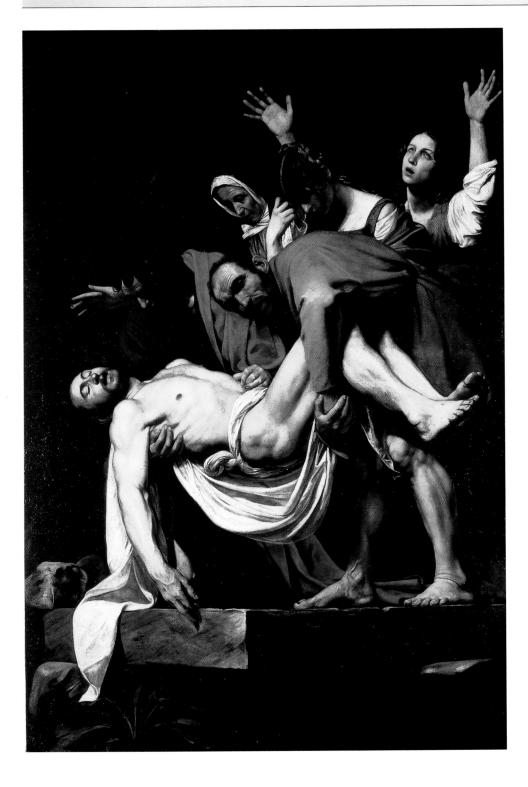

Michelangelo Merisi
da Caravaggio
(1571–1610):
Deposition.

Caravaggio's last years (1602–10)

In the early years of the seventeenth century, Caravaggio's troubles in Rome increased. He was sued for assault and defamation, and spent time in prison. His dagger and sword were confiscated. At the same time he painted *Deposition* (p. 139) for the church of Santa Maria in Valicella. The other side of Caravaggio's character produced this painting which became, ironically, one of the most admired and copied pictures of its age. The scene is balanced and restrained. He who said, 'Come to me, all who labour and are heavy laden, and I will give you rest' (Matthew 11:28) is being lowered into his earthly resting place. This dark place lies beneath the stone that will cover the tomb and be rolled away on the third day, Easter Day. Nicodemus, bending under the weight of Christ's body, the dead weight of the world, turns his face towards us. Is the Pharisee mulling over the conversation he had with Jesus about eternal life? He was a ruler of the Jews, but he had not understood how to enter the kingdom of God: "'How can a man be born when he is old? Can he enter a second time into his mother's womb and be born?'" (John 3:4). And Jesus explained about baptism. "'Truly, truly, I say to you, unless one is born of water and the Spirit, he cannot enter the kingdom of God. That which is born of the flesh is flesh, and that which is born of the Spirit is spirit'" (John 3:5–6). Beside Nicodemus, St John withdraws into the shadow of his own grief as he holds his Saviour and friend. Breaking the blackness at the top of the picture, Mary Cleophas raises her hands in universal abhorrence, while the other two Marys, the contrasting Mother and Magdalene, watch silently, drained of emotion.

Two years later Caravaggio was involved in a murder and was forced to flee Rome. He joined the knights of Malta, insulted a superior, and found himself again on the run. He went to Sicily and Naples and, instead of composing a letter, sent a painting to the pope pleading for his pardon. Paul V duly sent it and in 1610, aged thirty-nine, Caravaggio set sail for Rome. His heart must have been light as he contemplated his return but his relief was short-lived. He contracted a fever, was taken off the ship and left on a sandy beach near Porto Ercole while the ship sailed on, carrying his possessions and his pardon. Caravaggio died alone.

While life stirred in him, he never stopped painting powerfully spiritual paintings. *The Beheading of St John the Baptist* still hangs in the Oratorio of St John's Cathedral in

Michelangelo Merisi da Caravaggio (1571–1610): *The Beheading of St John the Baptist*, St John's Cathedral, Valetta, Malta.

Valetta where, in 1608, Caravaggio signed his name in the blood flowing from the severed head.

This is the largest of all his canvasses (measuring 361 cm by 520 cm) a drama with few actors and fewer colours. It portrays the tragedy of Christ's cousin, who prepared the way for his ministry, being killed at a malicious woman's whim. St John had told King Herod it was not lawful to marry his brother's wife. At Herod's birthday party Salome, the daughter of Herodias, danced so beautifully that Herod promised to give her whatever she asked. Prompted by her mother she asked for the head of the imprisoned St John the Baptist. Caravaggio painted this example of gross injustice occurring outside in the

prison courtyard. The executioner grabs the victim's head, while the prison warder impatiently points to the basket which the servant girl holds, in readiness to receive the head. Two prisoners silently witness the scene, across an acre of empty space which anticipates Rembrandt.

Caravaggio the fugitive paints with classical gravity in a meditative style as if he is revealing private experience to the public gaze. Each element is charged with meaning: the rope with which St John was bound; the executioner's sword lying on the ground; the keys jangling from the warder's belt; and the old woman's hands clasped to her head. He painted rapidly, as other masters tended to do in their late works, as if he knew intuitively that he would die young.

CHAPTER 8

Two Sides of the Christian Coin

My soul, there is a country
Far beyond the stars,
Where stands a winged sentry
All skilful in the wars:
There, above noise and danger,
Sweet Peace sits crown'd with smiles,
And one born in a manger
Commands the beauteous files.

Henry Vaughan (1621–95), 'Peace', *Silex Scintillans*

W hile Tintoretto was painting the interior of the Scuola Grande di San Rocco in Venice, dramatic events were unfolding in the Low Countries. The seventeen provinces (now mostly in Holland and Belgium) had only united at the start of the fifteenth century under the Duke of Burgundy. As we have seen, the court of Philip the Good was brilliant and his state was rich. But the Reformation had sent ripples of discontent throughout the northern provinces, for the Dutch were temperamentally attracted to the strict and structured Calvinism, a brand of Protestantism, which gave them new impetus to rebel against their Catholic Spanish overlords. The Calvinist ideas of predestination of the elect, coupled with their strong belief in salvation, gave them a feeling of superiority which added strength, if not humility, to their cause. The Scottish Calvinist John Knox even encouraged uprisings against Catholic sovereigns whose overthrow, he believed, should be the 'duty of every man in his vocation'.

The situation was worsened by Philip II, who succeeded his father Charles V to the Spanish throne. He was a fanatical Catholic who utterly failed to understand the needs and aspirations of his subjects in the north, and was blind to the injustices his increasingly repressive measures imposed.

Civil war between the seven northern provinces, which became Calvinist Holland, and the Flemish, who remained loyal to Spain and the Catholic Church, erupted on 19 August

1566. In town after town, from Antwerp to the Hague, Utrecht to Delft, Protestants sacked churches. Holy objects and stained glass were smashed, vestments torn. There is still a mutilated stone carving in Utrecht Cathedral; the heads of saints have been hacked off and their bodies disfigured – a poignant reminder of those bitter days.

When Protestant Holland finally gained its independence from Spain and the Roman

Catholic Church, the country grew rich in trade and commerce. There was a demand not for large ecstatic paintings commissioned by popes and cardinals, but for little pictures of everyday life. These could be enjoyed in the intimacy of the home, within the context of the Calvinist belief in plain living, high moral thinking, hard work, down-to-earth sermons and Bible reading.

Pieter Bruegel the Elder (c.1525–69)

Pieter Bruegel the Elder painted his masterpieces in this environment. Like other northern artists he travelled to Italy. But, instead of spending his time copying famous Italian pictures, he went outside and painted the landscape. He was entranced by the light, the space, the colour of the sea, and the enormity of the mountains.

He returned to Flanders in 1553, living first in Antwerp and then, after his marriage, in Brussels. Despite their down-to-earth 'country' qualities, Bruegel's paintings are far from simple. Like Shakespeare, another Renaissance scholar well-versed in ancient literature and contemporary philosophy, he used the coarse earthiness of the peasant to communicate profound ethical values. Thoughts and comments from *In Praise of Folly*, which Erasmus had written in 1509, pervade his artistic output, and patrons included cultured art collectors like Cardinal de Granvelle, King Philip's representative in Brussels.

Landscape continued to captivate Bruegel throughout his life, and he was one of the first to introduce it into art as a subject in its own right. In 1565 he was commissioned by Nicholas Jongelinck, an enlightened Antwerp merchant, to paint a series of paintings entitled *Months* or *Seasons*. In these magnificent landscapes, designed to hang as a frieze, Bruegel was able to express his ideas of humanity's place in God's natural world – and he painted them on the eve of the cataclysm. In *Haymaking*, traditionally related to the month of July, the light is soft and everything is green. The peasants move quietly about their business with single-minded determination, in a landscape which extends across hills and valleys – those wide plains on the border region between Holland and Belgium where houses nestle in clumps, a church points to its village and a river snakes along to a distant horizon. The sun shines; all is well in a world of abundance where everything is lush in early summer – the last hot summer before the war.

Hillaire Belloc, historian and author of *Nonsense Verse*, described making hay before the First World War, which changed an ancient agrarian way of life for ever:

Pieter Bruegel the Elder (c.1525–69): *Haymaking*, Nelahozeves Chateau, Prague.

When I got into the long grass the sun was not yet risen… and I made haste to sharpen my scythe, so that I might get to the cutting before the dew should dry… The good mower, serene and able, stands nearly as straight as the shape of the scythe will let him, and follows every stroke closely, moving his left foot forward… mowing should be like one's prayers – all of a sort and always the same, and so made that you can establish a monotony and work them, as it were, with half your mind: that happier half, the half that does not bother ('The Mowing of a Field' from *Hills and the Sea*).

Peasants experienced every nuance of the weather at the grass roots level of life: the snow that gave them chilblains; the rain that soaked them to the bone; and the sun

Pieter Bruegel the
Elder
(c.1525–69):
Census at Bethlehem.

that warmed their weathered faces. How they must have appreciated haymaking: scything the rich lay grass and forking it, warm, sweet-smelling and laden with wild flowers, into the waggon; piling it higher and higher while the horses, strong and patient, swished their tails; listening to the sweet song of the lark, the soporific sounds of buzzing bees, swooping dragonflies, and the church clock marking the passing hours. As they wiped the sweat off their brows, they must have been conscious of their oneness with all God's creation. Bruegel, the country boy-turned-artist and scholar, like Giotto before him, was able, uniquely and brilliantly, to reproduce the rural life with his brush, entering wholeheartedly into the cosmic wisdom of the writer of Ecclesiastes:

> For everything there is a season, and a time for every matter under heaven:
> a time to be born, and a time to die;
> a time to plant, and a time to pluck up what is planted…
> a time to weep, and a time to laugh;
> a time to mourn, and a time to dance…
> a time for war, and a time for peace…
> [God] has made everything beautiful in its time
> (Ecclesiastes 3:1–2, 4, 8, 11).

Turning his back on tradition, Bruegel also brought biblical subjects into a very human, everyday environment, sometimes even into a secondary position within a spacious landscape. You have to look carefully at *Census at Bethlehem* to see the biblical context:

> In those days a decree went out from Caesar Augustus that all the world should be enrolled… And Joseph also went up from Galilee, from the city of Nazareth, to Judea, to the city of David, which is called Bethlehem, because he was of the house and lineage of David, to be enrolled with Mary, his betrothed, who was with child (Luke 2:1, 4–5).

It is very cold. Snow lies on the ground and the lakes are frozen. An evening light bathes the Brabant village as the sun sets; people shuffle home at the end of a day's labour while children play. Attention is focused on the Green Wreath Inn on the left of the picture, where tightly packed people jostle at the entrance to give their names to the official – and hand over their pennies. The coat of arms of Emperor Charles V hangs on the wall, insignia of a latter-day Caesar. In the centre of the picture, partly eclipsed by a clump of wheeled barrels, Joseph leads the donkey on which Mary sits, accompanied by an ox, the symbolic attribute of St Luke. This is how the gospel unfolded, with the protagonists following an unknown way, their mission longed for but unrecognized. They were, to all outward appearances, just like everyone else going about their business. Yet life – and death – was to be changed for ever.

Pieter Bruegel the
Elder
(c.1525–69):
Parable of the Blind.

The Massacre of the Innocents might have been painted as a pendant to *Census at Bethlehem*. A troop of soldiers, their armour glinting menacingly in the wintry sun, wait in a tightly packed bunch, while individual men seek out innocent children in the village cottages and put them to the sword. A woman clutching her baby flees in terror, chased by an armed rider. Others uselessly beseech the commander for mercy on bended knee. This painting had a double meaning and an immediate resonance, for such events were actually happening in Bruegel's day.

The bitterness of civil war and the increasingly entrenched intolerant and self-righteous religious views of the opponents inspired Bruegel to illustrate Christ's description of the Pharisees: 'they are blind guides. And if a blind man leads a blind man, both will fall into a pit' (Matthew 15:14).

In *Parable of the Blind* Bruegel portrays six sightless men. They walk, hand on the shoulder of the man in front, in a strong diagonal line across the canvas. While the apex of a thatched roof and the tip of the church spire thrust heavenwards, the deceived men, helpless in their sightlessness, lunge forwards into the village pond where fools and miscreants were ducked. Victims of fate, abandoned, they fall like petals from a flower – an image of man's ineluctable destiny for 'he cannot find out what God has done from the beginning to the end' (Ecclesiastes 3:11). That was the old way, but now we can rest in God's love, we can trust in God's power, and we can endure in God's timing, if we follow Jesus Christ, who is 'the way, the truth and the life', who wants to keep us in perfect peace and lead us to eternal life.

Peter Paul Rubens (1577–1640)

Peter Paul Rubens owned Bruegel's *Flight into Egypt*. He also loved his native soil with the particular passion one has for an intrinsic part of life that is under threat. Throughout his busy and highly successful public career, Rubens privately painted the countryside around him. He celebrated the fecundity of nature in panoramic visions of abundance and harmony, in the Flemish tradition. Like Bruegel and, later, Poussin, he sometimes set a biblical subject in a rural scene with such delicacy that the title of the painting was the only clue to its identity. Such is the case with *The Prodigal Son*. Later we shall see how incredibly differently Rembrandt tackled the same subject.

In a large timber-beamed barn, farm animals settle down for the night as dusk falls. Horses flick off the last flies, cows chew the cud, and chickens prepare their perch for the night. Only the swine in the right-hand corner of the picture are still alert as they drop their snouts into their freshly filled trough. This is where the drama unfolds: beside the jostling, greedy pigs a half-dressed young Jew begs the young serving girl for some of their swill.

The Pharisees constantly criticized Jesus for consorting with the worst elements of society. In response the teacher explained, through vivid parables, his moral and spiritual message — and above all how much God loved mankind. *The Prodigal Son* illustrates one of the most unforgettable of his parables. In it Jesus drew a picture of what joy there is in heaven when a lost soul is found. Jesus said, 'There was a man who had two sons... the

Peter Paul Rubens
(1577–1640):
The Prodigal Son.

younger son gathered all he had and took his journey into a far country, and there he squandered his property in loose living... And he would gladly have fed on the pods that the swine ate' (Luke 15:11, 13, 16). The youth's greed, which had led him to demand his inheritance before the due time, had not only brought out the worst in him, but had also finally abandoned him in the mire, penniless and alone. He realized how superficial his values had been and how, by removing himself from reality, he had lost everything worthwhile. Not only his money and his position in society, but also his family, his self-respect, his peace of mind – his whole future. Unlike the animals among which he lived, he had found himself at a dead end. Rubens focused on this part of the story.

Rubens' father Jan also nearly lost everything. He had trained as a lawyer in Rome and became an alderman of his native city of Antwerp, until he converted to Protestantism and was forced to leave the Spanish Netherlands. He moved to Cologne, and then to Siegen where he had an affair with William the Silent's irresponsible second wife, Anna of Saxony. By rights William, Prince of Orange, should have had him executed. Instead this honourable and industrious man (who was eventually forced by Philip II's intransigence to lead the Protestant Dutch in the north against their Spanish overlords) sent Rubens to prison for a few years. Later, Peter Paul Rubens was born. When he was ten his father died and the widow took her two sons back to Antwerp. The brothers, like their mother, remained devout Catholics all their lives, but they had seen the Protestant point of view from their father.

Rubens trained as a painter and, after completing his apprenticeship, entered the Antwerp Guild of St Luke as a master in 1598. Two years later he set off for Italy to study classical sculpture and contemporary Italian art, and he spent eight years exploring the great artistic centres. He worked for the Duke of Mantua and stayed in Rome with his brother Philip, who was a distinguished scholar of classical literature and philosophy. The young Flemish artist discovered Titian's light, Tintoretto's spirituality, and Michelangelo's strength. By some miraculous synthesis he developed his own opulent and energetic Baroque style, which lent a 'painterliness', fluidity, and rhythm to his compositions which has never been surpassed. His vast output included portraits, mythologies, allegories, historical scenes, and religious paintings.

Small-scale paintings were traditional in the Low Countries, so when Rubens returned to Flanders in 1608 there was really no one else who could produce what was required in the new climate. He was appointed court painter to the regents of the Spanish Netherlands, the Archdukes Albert and Isabella who, in contrast to their predecessors, were compassionate rulers. As the boundary between Protestant Holland in the north and the Roman Catholic Spanish Netherlands in the south had been effectively drawn, and both sides were exhausted after decades of fighting, Albert entered peace negotiations with the Dutch. The truce of 1609 was to last for only twelve years, but at the time it was seen as the prelude to permanent peace.

The Spanish Netherlands had suffered far more than the north from the ravages of war and, with a new mood of confidence, the rebuilding of church and state began.

Talented young Flemings like the Rubens brothers, who wanted to be peacemakers, were able to play an active part in the regeneration of their battered land. Philip served as one of the secretaries of the city of Antwerp, which had become depressed and depopulated. His younger brother created enormous monumental altarpieces for churches in several towns which, having suffered from destruction, were now filled with Counter-Reformation fervour inspired by the Jesuits and Dominicans.

Rubens' Descent from the Cross (1611–14)

Rubens painted his first great commissions, *Raising of the Cross* and *Descent from the Cross*, for Antwerp Cathedral. These, together with a later *Assumption* for the high altar, display echoes

Peter Paul Rubens (1577–1640): *Descent from the Cross*, Onze Lieve Vrouwkerk, Antwerp Cathedral, Antwerp.

of Tintoretto, Caravaggio, and Titian combined with Rubens' distinctly Flemish tendencies in the tradition of Van Eyck, Rogier van der Weyden, and Bruegel. The raising of the cross is a subject that is glossed over in all the gospels with the words, 'there they crucified him'. In *Raising of the Cross*, completed in 1611, Rubens enters fully into the pathos of the event, as Tintoretto had in the Scuola Grande di San Rocco. He emphasizes the rippling muscles of the executioners as they strain to lift the planks of wood, which carry their precious load, into an upright position, and the trust of Jesus as he looks up to his Father in heaven, faithful to the end. As the writer of the letter to the Hebrews underlines, 'Although he was a Son, he learned obedience through what he suffered; and being made perfect he became the source of eternal salvation to all who obey him' (Hebrews 5:8–9).

Rubens had greatly admired Caravaggio's paintings in Rome, including his famous *Deposition*. In his own painting of the same subject, *Descent from the Cross* for Antwerp Cathedral, he also brought the protagonists to the forefront of the picture plane, and heightened the drama with chiaroscuro. But while Caravaggio holds the moment before the Saviour is lowered into his tomb in suspension, Rubens paints the dead Christ in

Peter Paul Rubens (1577–1640): *Coup de Lance* or *Christ Crucified between two Wrongdoers*.

an avalanche of movement. The sweeping, diagonal rhythms that Rubens invented escalate the complete abandonment of death as Jesus is brought down from the cross. The earthiness of Caravaggio's figures, nursing their own private griefs, has been transmuted into a Baroque grandeur, into a pictorial oneness designed to inspire and encourage the faithful. The soldiers had cast lots for his clothes, and now Christ is about to be wrapped in a swathe of linen cloth that sweeps, blood-stained, from the horizontal bars of his instrument of torture, down into the woeful world of everlasting darkness to which he is travelling.

But the women look up in hope and faith, believing his promise that after death he would be reborn. How precious birth is to women! They perhaps found it easier to understand what he meant when he prophesied that in dying and descending he was laying the foundations for a renewed community: the church. As people pour into Antwerp Cathedral today to partake of the mass, the bread of life is still presented on an altar beneath this majestic painting of the creator of life.

After these triumphs Rubens was flooded with commissions. He was an organized and efficient man, and quickly founded his prolific studio in Antwerp, incorporating it within the Italianate house he designed. Here his assistants (artists of the highest calibre like Jacob Jordaens, Anthony van Dyck, and Snyders) worked from his vibrant oil sketches to produce large, painted canvasses which, with a few last minute touches, the genius transformed into masterpieces.

In one of the ambulatory chapels in St Bavo Cathedral in Ghent, not far from where Van Eyck's *The Adoration of the Lamb* was first placed, is Rubens' large oil painting, *The Conversion of St Bavo*. St Bavo can be seen in armour, ascending the stairs of the abbey that the cathedral replaced. He walks towards St Amand (a rich local landowner who gave up everything to become a monk), who is waiting to welcome him into the monastic life of prayer, worship, and study. A soldier was strictly forbidden to become a monk by imperial decree in St Bavo's time. Rubens painted this picture at another moment in history when to follow your faith was fraught with danger. As the poor put out their hands in supplication, the Roman soldier-turned-saint gives his treasure to them (a subject much loved by Rubens). St Bavo was, perhaps, strengthening the faithful with Juvenal's advice, 'God loves us better than we love ourselves.' Therefore they should seek peace despite the bad example of their leaders. There was another political connotation attached: the people should be comforted because Albert and Isabella were shielding the local church community from their overlords in Spain.

Rubens' Coup de Lance (1620)

Rubens painted *Coup de Lance* or *Christ Crucified between Two Wrongdoers* for the high altar of the Church of the Friars Minor-recollets in Antwerp. Like many other works of art, it was looted by Napoleon's troops and taken to Paris. There it stayed until the congress of Vienna in 1815 when, where possible, precious objects were sent back to their place of origin.

This painting of the crucifixion now hangs in the Koninklijk Museum voor Schöne Kunsten of Antwerp, a veritable gold mine of spiritual paintings, where to wander around

is a bit like embarking on a religious pilgrimage. Rubens can be viewed here beside his great Flemish predecessors. Entering the huge gallery that is dedicated to his paintings commissioned by churches during his lifetime is a stimulating experience.

Christ hangs on the cross, on which a piece of parched scroll proclaims, much to the Jewish leaders' disgust, 'Jesus of Nazareth, the King of the Jews' in Hebrew, Greek, and Latin. In order to get rid of Jesus the Jews had put Pilate in a political corner. Since it was not expedient to save Christ from death, he could at least put up this mark of respect. As Christ dies in agony, his head droops. Beneath the cross Mary his mother stands, wringing her hands as she looks beseechingly up to heaven, while Mary Cleophas supports her in prayer. St John, the beloved friend to whom Jesus had entrusted his mother, leans against her, his eyes shut – as if he can take no more.

It is the eve of the Passover festival. It was not proper to have bodies hanging on a cross on the sabbath, and so soldiers were ordered to break the legs of the condemned. Rubens painted a soldier steadying himself on a ladder propped up against the unrepentant criminal's cross. With his free hand he is bashing the man's legs with an iron bar. The victim is screaming in agony and trying to tear his legs loose from the heavy nails. Meanwhile the repentant thief (whose legs were also broken) looks up to heaven for strength.

Jesus was already dead. As the scriptures prophesied, 'He keeps all his bones; not one of them is broken' (Psalm 34:20). Instead St Longinus pierces his right side with his lance, despite the futile attempts of a youthful Mary Magdalene to prevent him. St Longinus (Greek for lance) was the name and honour given both to this Roman officer and to the centurion who was on duty at the crucifixion and the resurrection; the centurion who cried out as Jesus breathed his last, 'Truly this was the Son of God!' (Matthew 27:54) and, while guarding the sepulchre, was astonished to see the tomb suddenly empty.

St John describes in powerful detail in his gospel how, after the death of Christ, the mounted officer pierced his side – and blood and water poured out, confirming his death. St John wrote how he witnessed this event 'that you also may believe' (John 19:35). The water of baptism and the wine of redemption in the communion chalice are the two greatest sacraments of the church.

Rubens' Ascent to Calvary (1636–37)

In the Musée Royale des Beaux-Arts in Brussels, after marvelling at paintings by Van der Weyden, Van der Goes, Memling, Bosch, and the magnificent Bruegel, you arrive, physically and emotionally exhausted, in the great Rubens room. Several of the late masterpieces here were executed by Rubens' hand alone; the brushwork is swift and sure, even when he was crippled by arthritis. Of course a gallery is not a church, but as you look at them, a new dimension reveals itself, a new pathos in this Christian artist who never let his worldly success diminish his desire for truth. His integrity grew and deepened as he was spurred on, not by fame and fortune, but by the desire to use his prodigious talent in the service of the church.

Peter Paul Rubens
(1577–1640):
Ascent to Calvary.

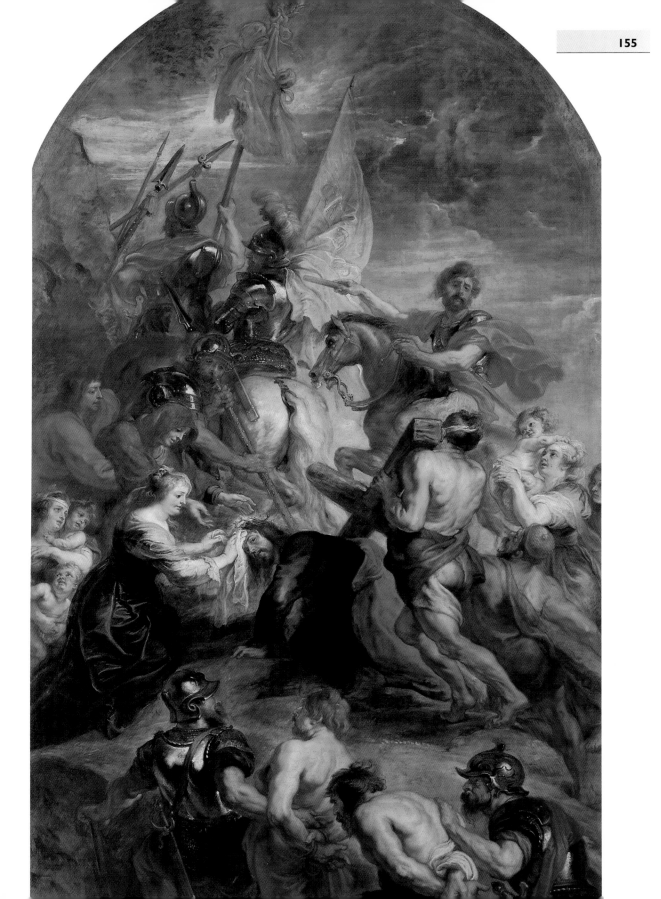

The *Coup de Lance* is full of violence and symbolism, and the events unfolding in the foreground of the picture draw you into the drama. In *Ascent to Calvary* (p. 155), which Rubens painted in the last years of his life for the Abbey church of Afflighem near Brussels, the action carries you away. The two handcuffed murderers are being manhandled by their captors up the hill to Golgotha, as they follow the procession from the foot of the picture. But this is no ordinary ascent to Calvary. Even as Jesus falls under the weight of the cross, Rubens has transformed the scene, in his own inimitable way, into a glorious and true apotheosis, deifying not an emperor, as in ancient pagan custom, but the Son of God in his moment of weakness. A burly Simon of Cyrene lifts the heavy bars of wood from the precious back and, as Jesus begins to lift himself up, an elegant St Veronica lovingly wipes the sweat from his brow, above which a crown of thorns glows on the godly head. According to legend the veil that Veronica – or *vera icon* – used was imprinted with a miraculous image, and it has been kept in St Peter's in Rome since the eighth century. This episode, represented in the sixth station of the cross, was popularized by the Franciscans. In front of Christ, lifting the picture plane to yet another height, mounted soldiers gallop on, lances raised, banners fluttering in a wind which quickens as the clouds whirl and darken amid a flurry of worldly colour, and a heavenly light gathers everyone and everything to its centre.

Rembrandt van Rijn (1606–69): *Adoration of the Shepherds*, Alte Pinakothek, Munich.

An artist and a scholar, Rubens also worked unceasingly for peace as a courtier and diplomat in the midst of the Thirty Years War. As everyone liked and trusted him, he was able to intervene on political matters. With his artistic sensitivity and cultured background, he was able to accomplish on an unofficial level what ambassadors with all their bureaucracy were unable to. In London, where Charles I knighted him, Rubens managed to effect peace between England and Spain. For a man whose whole life was directed towards healing divisions, this success must have been sweet.

Rembrandt van Rijn (1606–69)

As the buying public were the new patrons, competent Dutch artists made their names by specializing in still life, landscape, genre scenes – paintings of everday life – or seascapes. They sold these domestic scenes of comfortable materialism, in which any hint of the strange or mystical was purged, at markets and fairs. Apart from the fashion for detailed still life paintings in which an hourglass, skull, flowers, or other such symbols of the fleetingness of existence reminded the purchaser that 'all is vanity', few artists attempted to dig into the hidden depths of the Bible.

Rembrandt van Rijn was the exception. Even as a young artist he was fascinated by old people, and endeavoured to portray the personality behind a very 'lived-in' face. His Shakespearean understanding of humanity was extraordinary when you consider the artistic climate in which he lived.

In *Adoration of the Shepherds* the sleeping babe looks very small and vulnerable in his straw

cradle. His mother puts her arm protectively around him, while Joseph leans over to light a candle. The carpenter, his peasant wife, and their little son are illuminated and, by some spark of genius, transformed unmistakably into the holy family in the very earthy barn. Here chickens roost, and rude, simple country folk come in and watch the baby with humble awe.

The *Descent from the Cross* is not an essay in diagonals and symbols, as with Rubens, but an atmospheric observation of Christ being gently lowered from the cross in the darkness, overseen by Joseph of Arimathea who had asked Pilate for the body. Joseph was a member of the council but, being a good and upright man, had disagreed with their schemes to get rid of Jesus. Perhaps, in recompense, he wanted to lay Christ's body in the tomb he had prepared for himself. A deep, shocked silence pervades the scene as the five men perform their painful task wordlessly. In contrast to the grieving Marys submerged in shadow, the body of Christ is lit up by some natural light which, in the dark gloom, seems mystical.

It is this fusion of the everyday with the holy which makes Rembrandt's religious paintings, drawings, and etchings unique. They could only have been painted by a man who spent a lifetime in solitary reading and brooding over the Bible, and to whom church ritual had little meaning.

Rembrandt experienced passion and pain, wealth and poverty, success and rejection. And he transformed these feelings into the strokes of his brush with such potency that few people can look at his paintings and remain unmoved. For part of their power is that they reach us where we are at, scratching around in the farmyard of life.

As a young man he had many of the attributes of the prodigal son. He lived life to the full, spending money with a brash self-confidence. He even painted his self-portrait in a brothel in the red-light district of Amsterdam with his first wife, Saskia, looking equally lustful. Life was fun! He painted himself attired in all manner of rich and rare dress, inlaid with gold chains, and extravagant hats, helmets, and turbans.

But life caught up with him. His daughters followed his first-born son to an early grave and, when Saskia died, he was left to look after his nine-month-old baby Titus.

At this time of grief Rembrandt painted *David and Jonathan*. King Saul, jealous and concerned that David was more popular among the people than him, plotted his death. But his son Jonathan loved and respected David, warned him of his father's plans, and eventually helped him to escape into exile. Rembrandt paints that poignant moment when the two friends are parting, perhaps for ever: 'they kissed one another, and wept' (1 Samuel 20:41). Rembrandt put his own agony into this theme of people taking leave of their loved ones; Jonathan is a self-portrait and stands stiffly erect, while David, with golden locks like Saskia's, leans against the bosom of his friend and embraces him passionately. Their exotic, Oriental clothes, glittering with gold embroidery, highlight their emotions as a black, vaporous cloud behind threatens to overwhelm and conceal them from the city.

Rembrandt's The Good Samaritan (c.1638)

Like Rubens, Rembrandt also painted landscapes with a biblical theme. His interpretation of a great parable in *The Good Samaritan* is particularly fine. Although the panel is small in

size, Rembrandt enlarges the story into cosmic proportions by incorporating the elements to express 'mood' in early Romantic style. And more than that, he uses the storm and the sun as a sign of God's response to men's heartlessness and warmth. A traveller has been attacked in the woods by robbers and left half dead; now a storm gathers pace. A priest and a Levite pass by on the other side, for they are only justified by obeying the Law, and under Jewish law it was forbidden to touch a dead man. Other people in Rembrandt's painting also go about their business – shooting birds, embracing – oblivious of the victim's needs. But then a Samaritan comes along. Jesus lashed his message home, for the Jews considered Samaritans to be unclean and had no contact with them. But this kind-hearted man thought nothing of tribal politics. He only saw someone in distress. He bathed the victim's wounds and gently lifted him onto his own donkey. In the story he took the man to an inn and paid for his food and lodging, but Rembrandt focuses on the point of rescue: the moment when humanity's love and generosity supersede selfishness. The clouds part and a shaft of sunlight pours into the valley, highlighting the priest and Levite on the other side of the road, and a grand carriage bowling along behind four grey

Rembrandt van Rijn (1606–69):
The Good Samaritan.

horses. They did not stop, but God pours his love on the unjust as well as the just, and one person's goodness benefits many.

When Rembrandt took Hendrickje Stoffels into his house to look after Titus, she became his mistress. When she bore him a daughter she was summoned to the church Council in Amsterdam, condemned for 'living like a whore', and banned from the communion table. None of their children lived long.

By this time Rembrandt's popularity as a painter had nose-dived, despite the odd perceptive critic who recognized his genius. Middle-aged, he was close to bankruptcy and was only saved by handing over all his possessions – his home, his furniture, and his art collection – which were sold in auction in 1657 and 1658. And still the tragic events unfolded: Hendrickje died, to be followed shortly afterwards by his beloved son Titus. Rembrandt died poor and lonely, owning nothing yet possessing everything.

Rembrandt's Return of the Prodigal Son *(c.1668)*

In his poverty, he found peace. A warmth and new depth entered his work, as if his disasters had not embittered but purified his soul. In his last years, stripped of worldly pride, he produced his most profound and spiritual paintings. Among them was *Return of the Prodigal Son*. Rubens portrayed the youth among the pigs, at his moment of degradation; Rembrandt paints the reconciliation. The youth knew he was no longer worthy to be called a son; he hoped to be accepted as a servant. But, even before he gets home, before that painful wait as he knocks on the door, the father, who has been looking out for him, sees him and comes running to meet and embrace him. What a different atmosphere to that of David and Jonathan! They were parting; here the lost one has been found! There is no criticism, no sermon, just total forgiveness and acceptance as the old man puts his hands protectively around his beloved son and draws him into the warmth of his arch-like cloak. Memories of God's past promises leap into life: 'I have called you by name, you are mine,' the Lord said to his prophet (Isaiah 43:1). He continued, 'I will not forget you. Behold, I have graven you on the palms of my hands' (Isaiah 49:15–16). And David, who understood this love, burst out with joy, 'How precious is thy steadfast love, O God! The children of men take refuge in the shadow of thy wings. They feast on the abundance of thy house' (Psalm 36:7–8).

And the ecstatic father of the prodigal son gave orders for the best clothes, a ring, and shoes (which from Rembrandt's painting it seems he desperately needed) to be brought, and for the fatted calf to be killed. He wanted to give a party to celebrate his son's return. How overwhelmed the broken youth must have been to receive such affirmation. The dutiful elder son, whom Rembrandt paints witnessing the reunion, looks aggrieved. But Jesus warned, 'Judge not, that you be not judged' (Matthew 7:1).

Some years ago a woman who was dying of cancer was interviewed on BBC radio. She was very peaceful, even though she was leaving teenage sons, because she knew the Lord would look after them. Her only regret was that she had not loved enough or prayed enough, and she said, 'I would rather have God's mercy than his justice.' Rembrandt

Rembrandt van Rijn (1606–69): *Return of the Prodigal Son.*

challenges us to consider this as we look at his painting, and to remember that the father never stopped waiting for his errant son, just as God waits for each one of us to come to him, receive his love, and discover our true selves.

Rembrandt's Simeon and the Child Jesus in the Temple (1669)

Rembrandt's last, unfinished oil painting is *Simeon and the Child Jesus in the Temple*. Here the artist's near blindness and inner sight combine in the manipulation of paint to produce a picture of rare pathos. Simeon was one of the 'quiet in the land', waiting with constant prayer and watchfulness for God to reveal, as he had long promised, a saviour. For Simeon's faith had not atrophied in the peregrinations of Jewish law and politics.

When Jesus was presented by his parents in the temple in time-honoured custom, Simeon's humble mind and faithful heart equipped him to recognize Jesus as King and Saviour, and he was able to cry out in joy, 'Lord, now lettest thou thy servant depart in peace' (Luke 2:29).

Anna, who stands demurely beside Simeon in the picture, a female link in the divine purpose, was also in the temple at Jerusalem. At eighty-four years old she had long been widowed and sorrowful; but she was not resentful or self-pitying. Like Simeon she became kinder and softer as her trust grew – as she recognized God not as a tyrannical, legalistic master but a loving father. As her body weakened, her faith became increasingly rooted in a hope which age could not extinguish. She kindled her relationship with God, and in her ceaseless worship, fasting, and prayer in the temple she knew the best was yet to come.

God reveals himself to humanity in myriad ways: in the call that woke Samuel in the middle of the night; in the still small voice that Elijah recognized; in the physical blindness that swept Saul off his horse; in the books about saints that Ignatius Loyola read. The list goes on and will continue until the end of time. For a person's only true fulfilment, as Rembrandt realized and revealed so effectively in his art, is through God, not himself; it is in clinging to him whatever the pressures. For he ensures that we miss nothing that is really important.

Rubens and Rembrandt were two sparkling facets of the Christian coin, committed to their faith, art, and integrity. They expressed Catholic exuberance and Protestant austerity in their work, yet shared a common belief in the risen Christ.

Rembrandt van Rijn
(1606–69):
*Simeon and the
Child Jesus in the
Temple.*

CHAPTER 9

After the Age of Reason

God said to Moses, 'I AM WHO I AM.'
Exodus 3:14

'I think, therefore I am,' decided the Frenchman René Descartes, who grew to doubt everything except direct experience. As the orchestras played in the elegant salons of the Age of Reason, philosophers assumed priestly robes and, as man became the measure of all things, the secular world was born.

Baroque art and culture were swept away in the French Revolution. The new regime looked back to the heroic times of Greece and Rome, and art dressed itself up in cold neoclassicism. Art academies took over the teaching of students. (The word 'academy' derived from the name of the villa near the grove sacred to Academus, where the Greek philosopher Plato had taught his disciples about spiritual love.) Although the academies received royal patronage, artists needed buyers. Unfortunately Old Masters were in demand, both to copy and to purchase, and potential patrons were disinclined to commission contemporary talent. And so the academies, first in Paris and then in London, arranged annual exhibitions for members to sell their works to the public. These became part of the social season. Here, reputations were made and broken. Life changed radically for artists; in choosing their subject matter and style they now had to consider what they thought would sell. The Age of Reason opened the box of multiple choice.

By the end of the eighteenth century, a reaction against rationalism had set in. Jean Jacques Rousseau led people out into what he believed to be fresh air. 'I realized that our existence is nothing but a succession of moments perceived through the senses,' the solitary figure proclaimed. His ideas were eagerly pursued by poets and painters who followed Pan's pipes and celebrated nature as the new god. Romance was kindled in the grassy glades and eulogized in paint and poem.

In England, throughout the eighteenth and early nineteenth centuries, many Puritans and Evangelicals left the established church to form nonconformist sects, inspired by

preachers such as the dynamic John Wesley. The church was losing ground on all fronts. After a century of indifference, it was further undermined by new scientific discoveries, and alienation from the growing urban working class.

Then in the 1830s, under the influence of Keble, Pusey, and Newman, the Anglo-Catholic movement was born in Oxford. These theologians rediscovered the importance of beauty and ceremony in worship, and the need to respect tradition. In the process they woke up members of the Church of England – clergy and laity – who had slept through the Evangelical Revival. The effect of the Anglo-Catholic movement is still apparent in the many neo-Gothic churches, inspired by the architect Pugin, which sprang up all over the country as a new spirit of devotion, coupled with a zeal for social service, assailed the nation. Reunion between the Catholic and Protestant churches – in other words a return to a united Christendom – no longer seemed impossible.

By the end of the Victorian era, Christianity had weathered the storms of the century in a remarkable way, and Great Britain could call itself a truly Christian country for the first time since the Reformation. Churches of all denominations were regularly well attended, and faith in Christ was the backbone of family life. Christian good works permeated the community, missionary efforts overseas were well supported, and there was a strong sense of duty and integrity in public life.

The Pre-Raphaelite Brotherhood

John Everett Millais, William Holman-Hunt, and Dante Gabriel Rossetti lived in this environment. They were barely out of their teens when they, with others, formed the Pre-Raphaelite Brotherhood in 1848. With the passion of youth they reacted against the dull, sentimental copies of Renaissance paintings that cluttered the Academy's walls in the 1840s, and they resolved to return to a realism not attempted since before Raphael's time, when art was emerging from the chrysalis of Primitivism. They painted serious subjects using pure colour untarnished by heavy dark shadows, in which each object, painted with intense detail, had meaning. Their youthful aims were rather muddled, their backgrounds and personalities very varied, and the Pre-Raphaelites soon went their separate ways, but they produced some Christian paintings that have become embedded in the British psyche. As individuals, each continued to combine a sense of the mysterious with reality in poetic paintings.

Caspar David Friedrich (1774–1840)

A German Romantic artist, instead of revering the landscape as god, brought God into the landscape. Caspar David Friedrich used nature to symbolize the glory and majesty of the creator, as Vincent van Gogh was to do at the end of the nineteenth century. Both men grew up in staunch Protestant homes. Neither followed the Cartesian view that human

Caspar David
Friedrich
(1774–1840):
*The Cross in the
Mountains.*

reasoning gave man power to be the absolute master of nature. (The absurdity of this notion is apparent in man's absolute failure to control the elements; only Christ could calm the storm and walk on water.) On the eve of the Industrial Revolution, this view encouraged mass exploitation, poverty, and pollution.

Friedrich was a Christian. He listened to his heart and acted, not on impulse, but on feelings filtered through long periods of silent meditation and prayer, during which he 'saw' a finished picture. He then proceeded to paint what filled his mind, without any preliminary drawings or sketches, hoping the finished work would 'react on others from the outside inwards'.

Friedrich was born in 1774 in the small Baltic seaport of Greifswald, where his father was a prosperous soap boiler and candle maker. After studying at the prestigious Academy in Copenhagen, he moved to Dresden where he made his name producing meticulously observed, evocative landscape drawings. By 1807 he had mastered oil painting, and with this medium he developed a new pictorial idiom that enabled him both to symbolize his deeply held religious and political beliefs, and intensify his emotional response to nature. In contrast to the drama of nature that Turner portrayed, Friedrich's paintings are quiet and contemplative, gently whispering their mysterious message.

He liked to capture that moment of inner silence, when the world is hushed, before the sun slips below the horizon. You feel as one with the figures he paints, watching the yellowing light mingling with mauve, and Gothic spires becoming silhouetted against a deepening purple.

In his first major oil painting, *The Cross in the Mountains*, produced in 1808, Christ is alone in the landscape. Friedrich originally meant to present the painting to Gustavus Adolphus of Sweden as a token of his admiration for the king's stand against Napoleon. In the end, however, it was purchased for a private chapel.

Friedrich places his crucified Christ on a tall cross which rises up into the evening sky from the summit of a craggy rock. Fir trees stand sentinel. The light of the setting sun is reflected in rays emanating from a triangle carved in the gilded, traditional tabernacle frame which Friedrich designed. The triangle represents the Trinity, and encloses the all-seeing eye of God. But, just as the Pharisees consulted their law books when Jesus healed on the sabbath, the champions of neoclassical doctrine accused Friedrich of sacrilege for allowing a 'landscape to creep onto the altar'. They had missed the point. There are many shrines in the Central European countryside, especially in perilous mountain areas, which are signposts for prayer. Friedrich simply brought the crucifix and the landscape together, reflecting the ancient Judaeo-Christian concept of a loving interrelationship between God, man, and nature. This had been acted out for millennia in ritual: in the offering of the first fruits in the temple, and in participating in the sacrament of the bread and the wine. Yet in his innovative approach to an old subject, Friedrich created a metaphor which anticipated contemporary art.

Friedrich refused to be drawn into discussions about the painting. Instead he issued a simple explanation, a statement of faith. Part of it reads, 'The Cross stands erected on a rock, unshakeably firm like our faith in Jesus Christ. The fir trees stand

Caspar David
Friedrich
(1774–1840):
Winter Landscape.

around the cross, evergreen, enduring through all ages, like the hopes of man in Him, the Crucified.'

Friedrich sent two paintings, both entitled *Winter Landscape* to an exhibition in Weimar in 1811. They invoke Desolation and Consolation. In the first forlorn scene, two stark, gnarled, old oak trees twist away from their roots and grip the freezing air with icy claws. A line of tree stumps signifies the inevitability of death. Between them, frail and helpless, a cripple leans on his crutch and contemplates the snowy wasteland that threatens to engulf him.

The writer of the Book of Job understood desolation. Job lost his family, his home, his health – everything except his faith, which he knew was in God's hands. God alone determines how long we live. Honed by suffering and endurance Job asked the perennial question, 'If a man die, shall he live again?' (Job 14:14).

Feelings of death and emptiness can assault you in the bleak mid-winter, when the nights grow long and cold, and light barely brushes the day. The winter solstice was a pagan festival, inciting people to eat, drink and be merry, and forget the fear that lurks in

the depths. It is a good time to celebrate Christmas, Christ's birthday, when, 'The true light that enlightens every man was coming into the world' (John 1:9).

Friedrich interprets these thoughts in his own inimitable way, in the pendant picture which now hangs in The National Gallery in London. The cripple has survived his crisis. In his utter helplessness, perhaps even as a desperate last hope, he has cried to the Lord for help. Suddenly the eyes of his soul are opened and, abandoning his crutches, he leaps with joy as he realizes that he is redeemed. He rests on the ground exhausted but triumphant, his back against a rock, his hands in prayer, looking up expectantly at the crucifix shining in the morning light amid tall, luxuriant fir trees. Everything is fresh and new as the snow melts away winter and the first shoots of spring appear. Even an old man can be young if he is not crippled inside. In the background, behind a bridge, a Gothic church looms mysteriously out of the morning mist – a man-made house of prayer reaching up in unison with the trees to praise the creator, linking the visible with the invisible by an unbroken cord. Friedrich invites us, in the still intimacy of this moment, to transcend human reason and contemplate the perfect harmony between creator and created.

Caspar David
Friedrich
(1774–1840):
Winter Landscape.

John Martin (1789–1854)

John Martin
(1789–1854):
*The Great Day of
his Wrath.*

With the renewed interest in biblical subjects first stimulated by John Wesley, John Martin, who started his career in London in 1806 as a decorative painter of glass and china, produced large, melodramatic paintings of Old Testament subjects. *Joshua Commanding the Sun to Stand Still*, from 1816, and *Belshazzar's Feast*, from 1826, are steeped in historical accuracy, for Martin went to a great deal of trouble researching authentic texts and consulting biblical scholars. Later he produced mezzotints

which brought his panoramic pictures and his illustrations of Milton's *Paradise Lost* to a wider public.

In his twenty-four etchings for Milton's epic, Martin created open voids of creation, bottomless vaulted caverns of hell, contrasting the blackness of chaos with the beauty of heaven. It was a good preparation for the great trilogy of judgment paintings which completed his artistic output.

While Memling condensed eight chapters of Revelation into one panel of his altarpiece *The Mystic Marriage of St Catherine* four centuries earlier, Martin uses three huge canvasses. *The Great Day of his Wrath* is about cataclysm and fear: pandemonium disrupts the order of creation, and the delicate balances disintegrate into violent upheaval and destruction. As St John writes:

> When he opened the sixth seal, I looked, and behold, there was a great earthquake; and the sun became black as sackcloth, the full moon became like blood… the sky vanished like a scroll that is rolled up, and every mountain and island was removed from its place… for the great day of their wrath has come, and who can stand before it? (Revelation 6:12, 14, 17).

Jesus prophesied that wars, famines, and earthquakes would signal the beginning of the end of this world, when people would be led astray by false teachers, and that his real followers would be hated: 'because wickedness is multiplied, most men's love will grow cold' (Matthew 24:12).

Dante Gabriel Rossetti (1828–82)

Dante Gabriel Rossetti was three parts Latin. His father was professor of Italian at King's College, London and, with his brother and sisters, he grew up in a cosmopolitan, intellectual environment where art and literature were indivisible.

Rossetti originally planned a diptych on the life and death of Mary, but only completed the painting of the annunciation, which he entitled *Ecce Ancilla Domini* (p. 172). His sister Christina poses as Mary, sitting on the bed, dressed only in a white shift. Rossetti uses colour to express his concern for feminine purity and innocence: white prevails. Mary's gravity is accentuated by long tresses of hair that slide down her shoulders, and she seems to have withdrawn into herself. Simone Martini also captured this brief moment of awkward fearfulness, before Mary wholeheartedly accepted and obeyed, in his painting, *Annunciation*. William Michael, Rossetti's brother and fellow member of the Pre-Raphaelite Brotherhood, acts the part of the angel, standing in profile in the cramped room. There are many echoes of early Christian art and symbolism in this seemingly simple painting, and Rossetti implements the Brotherhood's creed with novel intensity. The dove signifying the

Dante Gabriel
Rossetti
(1828–82):
*Ecce Ancilla
Domini.*

Holy Spirit and the lily with one bud still closed bridge heaven and earth to impart the seed of life. Rossetti visualized the conception as 'Faith's Present, parting what had been / From what began with her, and is for ay'.

He dated the picture March 1850, the month the Feast of the Annunciation is celebrated. But this is not a Roman Catholic painting. Instead it is reminiscent of Rembrandt's homely scenes, and we could be eyewitnesses to an intimate, everyday human scene and a miracle simultaneously, for the feet of the wingless messenger are gilded in flames of love, and both figures are haloed with charity.

John Everett Millais (1829–96)

John Everett Millais was a fellow student of Holman-Hunt at the Royal Academy and received enthusiastic support from his wealthy parents. Millais was charming, unspoilt, and talented, and generous to his underprivileged friend.

Millais completed his first important religious painting, *Christ in the House of his Parents*, also known as *The Carpenter's Shop* (p. 174–75), in 1850. According to Holman-Hunt, he was inspired by a sermon given by the Anglo-Catholic theologian E.B. Pusey in Oxford during the previous summer. You have the impression that you are participating in the action, and that the child Jesus is sharing with you the secret meaning of his injury. Placed centrally in the composition, he bends to receive the kiss from his concerned mother, while Joseph (a portrait of Millais' own father) examines the wound with carpenter's hands. St Anne points, with wrinkled fingers, to the nail on which he had cut himself, and a young St John the Baptist brings a bowl of water to bathe the wound, careful not to spill a drop as he circumnavigates the piles of wood chippings on the floor. Jesus leans against the workbench, as later he will lean against the wooden cross, pierced with nails – the sacrifice upon the altar of faith. A young apprentice presses forward. Like the penned flock of sheep, visible through the open door, he can join the holy family through faith. Millais manages to combine a Gothic angularity with the deeper humanity of Giotto and the detailed realism of Van Eyck in this picture. He had also unwittingly trodden on a minefield. When the picture was exhibited at the Academy it caused an uproar as some people considered it blasphemous. The Catholic revival in the Church of England had already alarmed those of 'low' church convictions, and this picture added fuel to the fire. Charles Dickens described the Christ child as 'a hideous, wry-necked, blubbering, red-haired boy in a night-gown', and Queen Victoria had the picture removed from the exhibition and brought to her for a special viewing. 'I hope it will not have any bad effects on her mind,' Millais mischievously wrote to Holman-Hunt. Fortunately Prince Albert defended the Pre-Raphaelites, and the following year Ruskin wrote a letter to *The Times* praising 'the power, truth and finish' of Holman-Hunt's picture in the Academy, *A Converted British Family Sheltering a Christian Missionary*

from the Persecution of the Druids. Millais was also praised for his anti-Catholic *The Huguenot.* But the Brotherhood came to the conclusion they could express their ideas more easily with literary subjects. By 1880 Millais had become the foremost British portraitist. Among the eminent men he consigned to immortality in paint was Cardinal Newman, who converted to the Roman Catholic Church in 1845.

William Holman-Hunt (1827–1910)

William Holman-Hunt was captivated by the art critic John Ruskin's series of books called *Modern Painters.* Like Ruskin, Holman-Hunt came from an Evangelical background and the Bible's heavy use of symbolism attracted him. He was also ambitious and somewhat arrogant, perhaps on the defensive because his father was a warehouse manager in Cheapside, and the family was always short of money.

Of the Brotherhood, Holman-Hunt alone continued, throughout his career, to concentrate on religious subjects, such as in his best-known painting, *The Light of the World* (p. 176). The picture was shown at the Academy in 1854 with the text: 'Behold, I stand at the door and knock; if any one hears my voice and opens the door, I will come in to him and eat with him, and he with me' (Revelation 3:20). Thirty years later, Holman-Hunt explained to a fellow artist how he 'painted the picture with what I thought, unworthy that I was, to be a divine command, and not simply as a good subject'.

Holman-Hunt originally planned a daylight scene, but his desire to emphasize God's mercy as well as his grace, attributes symbolized by the stigmata, drew him to a verse in Romans: 'the night is far gone, the day is at hand' (Romans 13:12). And as he excitedly

John Everett Millais
(1829–96):
*Christ in the House
of his Parents* or *The
Carpenter's Shop.*

turned the pages of his Bible his eyes lighted upon: 'Thy word is a lamp to my feet and a light to my path' (Psalm 119:105).

Despite the mystical nature of the subject Holman-Hunt was keen to paint everything accurately. He stayed with Millais, who described in his diary how he posed with a lantern in his orchard on a cold, moonlit night to give Holman-Hunt some ideas and impressions.

Christ stands beside the creeper-covered door in the starlit night. Trees loom up silently behind him, beside still waters. Eve's apples lie on the grass. The light from his lantern illuminates his pensive face and his hand gently rapping on the door of wood; a

stony heart he would fain fill with life and love. He knocks, but will not enter unless invited. His crown of thorns, symbolizing the piercing pain of lovelessness, is silhouetted by an aureole. Christ waits and listens. And in the silence the whole of heaven waits too, longing for another soul to open the window of their heart, to enable God's love to shine back into his own house, and reflect out into a world starved of love.

The picture received poor notices at the exhibition. Holman-Hunt was criticized for painting a spiritual metaphor in such a literal way. But his friend Ruskin considered the painting 'one of the very noblest works of sacred art ever produced in this or any other age'.

The painting increased in popularity due to huge sales of the engravings made by W.H. Simmons and W. Ridgeway, and numerous illegal photographic copies. Later, Holman-Hunt painted a larger replica which toured the colonies in 1905–7 and was ultimately presented to St Paul's Cathedral, a fitting resting place for a Protestant icon.

Holman-Hunt had few followers and, despite a long career, he produced few paintings. By the time *The Light of the World* and its secular counterpart *The Awakening Conscience* were hanging in the Academy, Holman-Hunt was in the Holy Land, following in the footsteps of David Wilkie and James Tissot, artists who searched for alternatives to the idealized religious paintings the Catholic Revival was producing. Like David Roberts they went to the Holy Land to paint the people, dress, and customs in the places Christ had known.

It was a dangerous exercise, for Christians were not welcomed by either Arabs or Jews. Roberts wrote about being 'transmogrified into an Arab' in order to sketch local communities, and Holman-Hunt described how he had to hold a shotgun in his left hand to defend himself from bandits while he painted with his right!

Wilkie realized the importance of these links with the past when he noticed that the Arabs had not changed their customs or dress since the days of Abraham. He died on the way back to England in 1841, convinced that a Protestant painter was needed to combat the growing papism in Anglican theology.

Holman-Hunt stepped into the breach. He painted many watercolours of the landscape around Jerusalem (where an Anglican bishopric was established in 1844) and used them back in England to give his oil paintings an authentic touch. Holman-Hunt thought that by painting literally what he read in the Bible, he would be transmitting the message faithfully in paint. But truth is not literal; we see through a glass darkly. If you forget fancy, you fence in freedom and everything frays. Even Jesus, who is truth, was not wholly understood by his closest friends.

Searching the Bible for suitable subjects on his arrival in Jerusalem, Holman-Hunt settled on the scapegoat, somewhat surprised the subject of the Jewish ritual Day of Atonement had not been tackled before. According to Jewish custom two goats were chosen for Israel's annual expiation of sins. One was sacrificed in the temple and the other 'shall be presented alive before the Lord to make atonement over it, that it may be sent away into the wilderness... The goat shall bear all their iniquities upon him to a solitary land' (Leviticus 16:10, 22).

But in *The Scapegoat* Holman-Hunt could not be too exact, as the wilderness, according to the Talmud, was a very steep and high promontory about twelve miles from the city. From this point the goat was pushed to its death. Holman-Hunt decided to paint the goat at the southern end of the Dead Sea which had been identified as the site of Sodom, that wicked city which went up in smoke. One of his travelling companions described the view:

> The mountains beyond the sea... under the light of the evening sun, shone
> in a livery of crimson and gold, except where a floating cloud cast its
> shadow on their sides... and then as if to complete the magnificence of the
> scene, a lofty and most perfect rainbow... spanned the wide but desolate
> space of intervening sea and land – the symbol of God's covenant of mercy
> (William Beaumont, *A Diary of a Journey to the East*).

The goat stands against this background, its feet in the mire, its head heavy with fear, panting. The scarlet fillet around its horns alludes not to Jewish custom but to Christ's crown of thorns, for he became the ultimate scapegoat for the sins of the world.

William Holman-Hunt
(1827–1910):
The Light of the World, Keble College, Oxford.

Jean-François Millet
(1814–75):
The Gleaners.

'So [Ruth] set forth
and went and
gleaned in the field
after the reapers'
(Ruth 2:3).

Jean-François Millet (1814–75)

There were also artists in France who reacted to Academic attitudes, who wanted to return to the age of faith when artists were 'honest to God' craftsmen. Jean-François Millet turned his attention to the peasants working in the fields, highlighting, as Bruegel had, the rhythm of the seasons of life. There is no drama or passion in *The Gleaners*, just three solid women silhouetted against a bright, sunlit plain, working hard in a flat field. They move with monumental dignity, braver than a gallery full of painted heroes. They state in a solemn way that picking up the remnants of the harvest may be back-breaking, but it sustains poorer members of society.

Millet also meditated on the importance of prayer. In *The Angelus* peasants stand in the fields with bowed heads as the village bells ring out in the dusky light. Morning, noon, and night they reminded the faithful of the incarnation. Quietly, in fellowship, the people repeat the angel's message, give thanks, and glorify the Trinity.

Vincent van Gogh (1853–90)

Vincent van Gogh greatly admired the religious paintings of Millais, Holman-Hunt, and Rossetti. He also was deeply affected by the spiritual impact of paintings and prints by Rembrandt, Delacroix and Millet. Like Millet, he felt close to the soil and the simple people who worked it in all weather conditions; there was a subject worthy of painterly attention. Vincent had grown up in the beautiful Brabant countryside and, with his sisters and younger brother Theo, had grown to love the animals, cornfields, and flowers that burgeoned around them. Their father was a Protestant clergyman in a predominantly Catholic region, and the word of God was deeply embedded in their hearts. Following in the footsteps of three uncles, Vincent and Theo became employees of the international art dealers Goupil and Cie. Working for them in the Hague, Paris, and London, Vincent was able to visit many art galleries and study paintings by Old Masters as well as contemporary artists.

He fell in love and into the role of the rejected suitor several times. Poor tragic Vincent van Gogh — created with such a huge capacity for love, yet unable to find fulfilment with another human being. Only Theo truly understood him, and showed his love and respect for his brother's genius by supporting him financially when Vincent gave up his life in commerce and threw all his eggs into a basket of paint.

Van Gogh read voraciously. He found that reading and writing letters relaxed him after a day of concentrating on drawing or painting. Apart from the Bible he read great classics such as Shakespeare's plays and works by his contemporaries: George Eliot, Tolstoy, Dickens, and Dostoevsky. He passed through a pious stage and became a lay preacher among the Belgian coal miners. But by 1879, when he was twenty-six, drawing had become his main preoccupation. He gave up preaching and practised his faith in a strait-jacket of loneliness, poverty, and acute nervous strain, which provoked mental disorders, and after a career of only ten full years, drove him to suicide.

Van Gogh was not afraid to throw off social mores and follow his faith intuitively. In his humility he genuinely loved humanity: 'I cannot help thinking that the best way of knowing God is to love many things… with a sublime, genuine, profound sympathy, with devotion, with intelligence, and you must try all the time to understand Him more,' he wrote to Theo in July 1880. His letters reveal the beauty of his prose, the clarity of his mind, and the sweetness of his character. Indeed, out of compassion, he took in a pregnant prostitute and looked after both her and her baby, when it was born. And he became her lover.

But painting was his true passion and he lived for his work, striving endlessly for excellence. He would do ninety pencil sketches of a head before he thought it good enough to use in a drawing, worrying all the time about having enough money to buy materials and pay the model. He always appreciated his first masterpiece, *The Potato Eaters*, even after his painting technique and use of colour had changed radically. The five peasants sit at table in the glow of an oil-lamp, pouring tea and eating the steaming potatoes which 'they have dug up from the earth with the self-same hands they are now

putting into the dish, and it thus suggests manual labour and – a meal honestly earned', as he wrote to Theo in July 1885.

Van Gogh was concerned with the effect the Industrial Revolution was having on humanity, even though he respected scientific advances. He was profoundly aware that Christ alone 'has affirmed eternal life as the most important certainty, the infinity of time, the futility of death, the necessity and purpose of serenity and devotion'. And that 'He lived serenely, as an artist greater than all other artists, scorning marble and clay and paint, working in the living flesh' (Letter to Emile Bernard, June 1888).

Vincent van Gogh (1853–90): A Wheatfield, with Cypresses.

Although Van Gogh continued to paint people, including several self-portraits, he concentrated primarily on the countryside, searching out the beauty of cornfields and stubble, olive and cypress trees, hedgerows, flowers, and blossoms. As he wrote to his sister Wil, 'What the germinating force is to the grain, love is to us' (Letter to Wil, 1887). Perhaps 'being rooted and grounded in love' (Ephesians 3:17) helped him to hang on to serenity and devotion in the midst of great mental pressure.

In Paris he met the Impressionists; in Provence, where he escaped for much-needed rest, he discovered light. Van Gogh spent most of the last two years of his short life in the South of France. He wanted to set up a community of artists, a fellowship of like minds, that could share expenses and experiences. But Gauguin's long-awaited visit ended in further stress – Van Gogh cut off part of his ear – and he was admitted to an asylum. From this time on, he suffered intermittent mental illness. Van Gogh would only paint when his mind was lucid, and he made the most of those moments with intense gratitude.

With the introduction of manufactured paints in the mid-nineteenth century, everything changed for artists. They no longer had to rely on pigment grinders and paint mixers. Instead, bright, fresh colours came straight from the tube, and it was possible to paint outside, in the fresh air, looking directly at nature. You can see from the thick impasto of Impressionist paintings that paint was literally squeezed onto the canvas in dots and strokes, and Van Gogh absorbed this technique when he was in Paris. He became so emotionally involved with his painting that, as he wrote, 'the strokes come with a sequence and coherence like words in a speech or a letter'. Van Gogh was too humble to believe he was divinely inspired.

While he waited for Gauguin to visit him at the Yellow House in Arles, he painted the small room he slept in and discovered the importance of using colour to express feeling, 'to be suggestive here of rest or of sleep in general', as he wrote to Theo. When 'isms' entered the artistic vocabulary, Van Gogh was recognized as the inventor of Expressionism. In *A Wheatfield, with Cypresses*, short and tall cypress trees

nestle together, curling up into the swirling, sun-soaked sky as the wind ruffles the wheatfield and bushes sway to the rhythm of praise. Here, corn symbolizes perennial vitality, olive trees the oil of gladness, and cypresses, emblems of gratitude. He wanted everyone to feel the joy he felt in the countryside among living, growing things, to sing

praises in paint to the creator, on behalf of the created, as David had sung in the Psalms:

'The Lord Reigns!...'
Let the heavens be glad, and let the earth rejoice...
let the field exult, and everything in it!
Then shall all the trees... sing for joy
before the Lord, for he comes (Psalm 96:10, 11, 12–13).

Vincent van Gogh (1853–90): *Lilac Bush.*

Van Gogh was able to paint in the asylum in Provence. *Lilac Bush* is a riot of viridians, ultramarines, yellows, and creams, with a few touches of terracotta enlivening the undergrowth. Blooms shine like candles on a Christmas tree, reaching up to heaven. Like Hugo van der Goes, Van Gogh, in his distress, clung onto growing things, endeavouring

to get earthed into reality. He looks deep into the undergrowth then up and out through the joyful, glittering flowers. The sky is densely blue. The air is uncannily still, almost breathless. A footpath winds past tall irises leading to a brick wall – the enclosure. Van Gogh must have sat in the grass, remembering his experiences as a child with Theo, contemplating moss and lichen, blowing fluff off dandelions, watching insects walk down stems, revelling in just being:

> *If you learn to listen in the silence you can even hear the angels singing. If you listen in*
> *the silence you can hear my voice clearly as I take your hand and lead you in the silence.*
> *The path of silence is through the wood of clamour.*

Van Gogh lived long enough to read Albert Aurier's laudatory article about his paintings in an exhibition in Brussels, and to meet Theo's wife and baby son, who was named after him. Theo hoped the young Vincent might be 'as steadfast and courageous as you'.

But when the illness became more than he could bear he shot himself, in the countryside outside Auvers. Theo arrived from Paris in time to hold his dying brother in his arms, and then buried him with his easel, stool, and brushes in a sunny spot among the wheatfields. The artist Emile Bernard described to Aurier how the coffin had been covered with yellow flowers, 'his favourite colour... a symbol of the light of which he dreamed both in his heart and in his work'. Theo was broken by grief and died six months later.

Georges Rouault (1871–1958)

It is said that Georges Rouault was born to the crash of German shells bombarding Paris during the Franco-Prussian war. Perhaps the tinkling of shattered glass drew him unconsciously into the stained glass window workshops where he served his apprenticeship before becoming an art student, enabling him, during those formative teenage years, to contemplate the richness and depth of medieval glass and allow the radiance of those leaded Gothic lights to penetrate and illumine his soul.

Like Van Gogh, Rouault had a tender, Christian heart. But he was not crippled by financial crises, for his professor at the Ecole des Beaux Arts, Gustave Moreau, left instructions for his favourite pupil to become curator of the Musée Moreau, thus bequeathing him the means to tread his own artistic path unhampered by money worries.

Rouault had a deep and abiding concern for the grinding poverty and exploitation created by the Industrial Revolution. Instead of accepting commissions from the wealthy, he turned his attention to social outcasts, which led him into the seamier side of Parisian life. He was not in rebellion against an aristocratic background like Toulouse-Lautrec, but wanted to make his own statements about social injustices. He painted prostitutes and clowns – and the suffering face of Jesus.

Human degradation is not pretty. Rouault built up his perception of pain in layers of paint, stripped to essentials, and encompassed by heavy black lines reminiscent of glass leads. Underneath his painted mask, the clown is intolerably sad. Yet, like the prostitute, he plays his role with stoic courage, accepting the reality of a fallen world where man's frail capacity to love is so often strangled by pride, hypocrisy, and greed.

'Blessed are the poor in spirit, for theirs is the kingdom of heaven,' Jesus taught in the Sermon on the Mount (Matthew 5:3). Rouault became a compassionate friend of the morally wounded, and this aspect of unconditional love pervades the fifty-seven black and white plates entitled *Misère et Guerre* which he composed between 1914 and 1918. The prints contain all the depth and intensity of his oil paintings, and in them he conveys his favourite theme of Christ as the holy fool, the clown of God, who suffers rejection, agony, and death because of man's gross selfishness.

Rouault was unique among French painters in his Christian and ethical stance during the Catholic revival in France, which was spearheaded by Leon Bloy, Charles Péguy, and Jacques Maritain. Yet he only received his first commission from the church in 1939, when he designed a stained-glass window for the church of Notre-Dame-de-Toute-Grâce at Assy in Haute-Savoie.

CHAPTER 10

Hidden Pearls

What passing bells for these who die as cattle?
Only the monstrous anger of the guns…
What candles may be held to speed them all?…
The pallor of girls' brows shall be their pall;
Their flowers the tenderness of silent minds,
And each slow dusk a drawing down of blinds.
Wilfred Owen (1893–1918), 'Anthem for Doomed Youth'

The four horsemen of the apocalypse rode across Europe, staining the mud red and leaving the cream of youth dead in their millions on the fair fields of Flanders. Young men had volunteered to fight with crusader-like zeal, but the remnant returned home disillusioned and bitter to a land unfit for heroes.

While limbless, weary, old veterans begged in the streets, the values they fought for were being further undermined. Agnosticism was fostered by eminent writers and thinkers who debated the existence of God, and exacerbated by rapid technological progress. Decadence danced as the Jazz Age drowned out memories; self-expression flourished as civilization began to slide into nonsense. As the secular world expanded, many contenders came forward to grab Christ's crown: Marxism, Fascism, Racialism, and Materialism.

Before long, Stalin was murdering millions in Russia, and Hitler was flexing his muscles in Germany. Soon, the bulwarks of human civilization were again breached by war. Respect for the human soul, sanctified for millennia in myths and legends, and developed by religion, was sacrificed by atomic bombs and in the gas ovens of concentration camps. Man had indeed come of age – the age of destruction.

The Second World War compelled people to examine the fundamental questions of original sin, the reality of evil, and the judgment of God – and to consider the role of the church in twentieth-century society. The Lutheran pastor and theologian Dietrich Bonhoeffer grappled with these issues. After two years of imprisonment in Berlin he was hanged at Flossenburg prison camp, three weeks before Hitler committed suicide.

In a secular society, Bonhoeffer looked beyond religious belief in the power of God and the church to the weakness and suffering of Christ for mankind, prophesied by Isaiah in 600BC:

He was despised and rejected by men; a man of sorrows, and acquainted with grief... he was wounded for our transgressions, he was bruised for our iniquities; upon him was the chastisement that made us whole, and with his stripes we are healed (Isaiah 53:3, 5).

Bonhoeffer concluded that as Jesus lived only for others, so should we, not just preaching the gospel but living it, responsibly. This realization that humanity is created in the image of God – created by love for love – was a challenge to artists in an atheistic age, when there was no longer a shared language of faith. Illustrating Bible stories had become meaningless; plaster saints an anathema.

John Singer Sargent (1856–1952)

In April 1918, a few months after American troops had arrived at the front, the American artist John Singer Sargent was commissioned by the British War Memorials

John Singer Sargent (1856–1952): *Gassed*.

Committee to paint a large picture for a projected hall of remembrance. Sargent was a successful portrait painter, sought out by the rich and powerful, the beautiful and strong. Within two months, Sargent had been confronted by his subject: a crowd of soldiers waiting outside a dressing station after a blinding attack of mustard gas. In stark contrast to his colourful celebrations of life, his masterpiece *Gassed* shows this example of pitiless sacrifice, and depicts the lengthening shadows as the sun drops in the sky, and a centuries-old way of life is destroyed for ever. Soldiers are not gunned down but gassed blind – handsome, virile, young men doomed to a life of dark helplessness. Blindfolded, some lie on the ground in shock and exhaustion, and courageously contemplate their fate. Others move in pitiful crocodile lines, placing a hand on the shoulder of the man in front, as in Bruegel's *Parable of the Blind*, aided by orderlies. They listen to the slap of a leather ball and shrill cries of a football match, played in the distance by soldiers who have not been deprived of outer light. Their silence proclaims the virtues that underpin a healthy society: loyalty, courage, and endurance; beauty, goodness, and truth; freedom, justice, and mercy; faith, hope, and charity.

Stanley Spencer (1891–1959)

These virtues imbue the early paintings of Stanley Spencer. Spencer grew up in a Victorian home where music and the Bible were integrated into everyday life. The large family lived in a semi-detached house built for them by Spencer's grandfather, a master builder, in the idyllic Berkshire village of Cookham-upon-Thames. Spencer rarely left the village, being given a rudimentary education at home by two of his sisters. Even when he entered the Slade School of Fine Art in 1908 he commuted to London by train.

Spencer was filled with a sense of wonder and a naive simplicity which kept his vision free from cynicism. He discovered that every created thing was made for good – every blade of grass, every flower, every pebble – and he revelled in reproducing everything he saw with masterly draughtsmanship, developed under the brilliant tutelage of Professor Henry Tonks. Spencer knew and loved every street, every house, every garden in his village, and he brought a spiritual dimension into each nook and cranny. He used the village as the setting for his remarkable religious paintings, which he peopled with his neighbours.

Despite his unworldliness, Spencer was deeply patriotic and he volunteered for service when the First World War broke out. He was too puny in stature to join the infantry so, wisely taking his mother's advice, he enlisted in the Royal Army Medical Corps. After a year as an orderly at the Beaufort War Hospital in Bristol, he was posted to Macedonia. Later he transferred to the seventh battalion of the Berkshires and faced the front line.

Like Brother Lawrence, who in the seventeenth century encapsulated his everyday experiences in *Practising the Presence of God*, Spencer carried out the menial jobs assigned to him with a prayerful and willing heart. He scrubbed floors, made beds, cleaned baths, and tended the wounded, never looking for promotion – and never receiving it. Pencils and paper were sent from home and he kept his hand in, drawing portraits of his fellow workers and making sketches of the war front. He also read voraciously. Magazine comics were popular in the dormitories, but Spencer discovered a love for Milton, Shakespeare, Dante, Dickens, and Dostoevsky.

Spencer and the Sandham Memorial Chapel (1927–32)

On his return home in 1918 Spencer completed an official war picture, and worked on religious subjects in an attempt to regain his pre-war vision. But war memories would not go away. He dreamed up a design for a memorial chapel and sketched compositions of Bristol and Salonica. One day, while he was staying with Henry Lamb in Dorset, the two artists were visited by a Mr and Mrs Behrend. This couple was so inspired by Spencer's work, they decided to build a chapel to house his scheme as a memorial to Mrs Behrend's brother, Lieutenant Henry Willoughby Sandham, who had died in 1919 from an illness contracted at the front in Macedonia.

And so Spencer, a humble man like his hero Giotto, was given a similarly rare commission: to decorate a chapel built especially for the purpose in Burghclere. In 1927

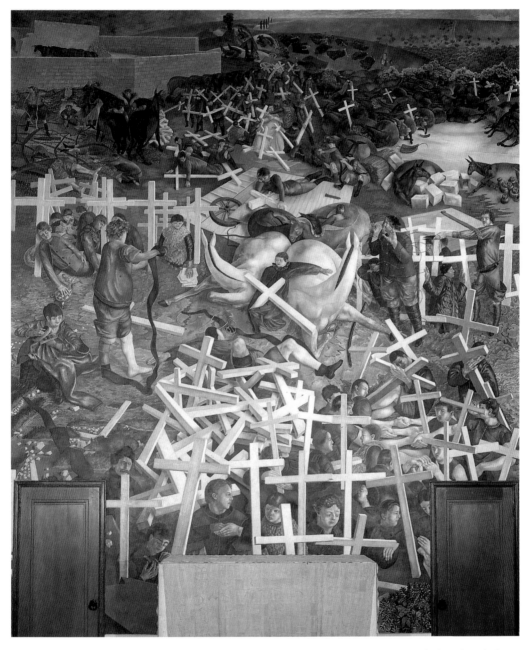

Stanley Spencer
(1891–1959):
*The Resurrection of
the Soldiers,*
Sandham Memorial
Chapel, Burghclere.

Spencer moved to Burghclere with his wife Hilda and baby daughter, and they lived there
for five years until the project was completed. Conscious of the British climate Spencer
wisely chose oil paint on canvas as his medium, rather than painting tempera directly onto
plaster. The eight arch-topped canvasses and the smaller ones placed beneath them, which
Spencer called the predellas, were painted on an easel and then battened onto the masonry,

but the canvas of the uppermost sections and the huge *The Resurrection of the Soldiers* were glued straight onto the walls and painted from scaffolding.

A straight, narrow brick path beside ancient apple trees, beneath which fruit lies rotting in the grass, leads to the angular brick memorial chapel, flanked by two almshouses. Behind, the Berkshire Downs cut off the horizon and the roar of distant traffic is redolent of shellfire. Three long, thin windows fill the west front, and the date 1926 is engraved in stone above the entrance lintel. Immediately inside an inscription reads, 'These paintings by Stanley Spencer and this oratory are the fulfilment of a design which he conceived whilst on active service 1914–18.'

The nineteen paintings, which span three walls, do not envelop you in violence or horror, but in peace and fullness of life. The desire to make for the focal point behind the altar has to be contained because Spencer's 'mixture of real and spiritual fact' is a series of stepping-stones, to be taken in sequence like a pilgrim's progress: a diary of his experiences.

Initially, earthy, autumnal tints predominate. Spencer compared his duties as a medical orderly at the hospital to the medieval 'labours of the months'. This sense of the seasons is realized in *Filling Water-Bottles* when the sun suddenly shines through the windows onto the crisp white tablecloth where men eat piles of bread and jam, and on the fountain where, from an angel's perspective, they fill water-bottles from the flowing stream, capturing the essence of spring and summer. The textures of nature so lovingly observed by Spencer in his youth symbolize a period in which time relates to eternity and man is not ruled by the clock.

In the first picture you see a snub-nosed truck, filled with wounded soldiers, waiting while the great red iron gates, used to contain inhabitants of the former mental hospital, are drawn open. The scene moves along dour, labyrinthine corridors into wards, where daily chores are re-enacted, then switches to dugouts and trenches at the front, where different daily duties are performed. Bundles of barbed wire replace shrubs, and mud is all that remains of grassy fields. Fear and soul-destroying weariness diminish hope, except in the few who see beyond kit inspections, marches, digging, and intermittent fighting to life beyond death.

And there, in the huge *The Resurrection of the Soldiers* (p. 189), soldiers arise from their graves as if for the last judgment. They climb out from behind the altar, their khaki uniforms redolent of brown Franciscan habits, framed by white crosses which pile up haphazardly behind them. When Spencer travelled back to the scenes of battle he would have seen the vast military cemeteries with their endless, serried ranks of white crosses. Here they have been pulled up and, instead of returning their rifles after service, men are presenting their crosses to Jesus who stands in the background of the composition, receiving them. The wise men brought the babe Jesus gold, frankincense, and myrrh, but here the soldiers offer their gifts of obedience, lowliness, and sacrifice to the Saviour, beyond the world of violence and war, where three cypress trees crest the hill of Calvary.

Brotherly love and comradeship predominate among these ordinary men who heard the call to arms and went out to serve their country, accompanied by the beasts of burden who served them. Two white mules lie where a shell had blown up their waggon. They, too, are alive again and they turn their heads towards the master while their handler strokes

them. Even here, in the promised land, homely tasks continue to be carried out: winding up puttees, cleaning buttons, reading instructions, or unscrambling barbed wire, as if the men are winding down their duties into the peace that is dawning at the end of a long, dark night in a timeless landscape. Burdens are laid to rest as all earthly responsibilities are handed over to Christ. And this sense of carrying one another's burdens in the knowledge and love of God goes with us as we leave the memorial chapel. God is with us so we can bring him to others. And the bugle call of reveille echoes in the crisp air.

Spencer's The Resurrection, Cookham (1924–25)

In Cookham churchyard, the church sits comfortably among grass and gravestones, and the air is filled with the dulcet tones of children's laughter as they bound down the path, accompanying their mothers and dogs towards the towpath beside the Thames. Nothing seems to have changed since Spencer painted his huge masterpiece, *The Resurrection, Cookham*, while he was waiting for the Sandham Memorial Chapel to be built. Again, he brought the people he knew into quiet joyfulness, for it is his friends and family who clamber out of the flower-decked graves and contemplate their new life together. Christ is dressed in white and stands in the porch, his father behind him. They are attended by Moses, with the stone tablets of the Law, and other prophets and philosophers who sit in stone seats along the sunny southern church wall. Spencer wrote, 'No one is in a hurry in

Stanley Spencer
(1891–1959):
*The Resurrection,
Cookham.*

SAINT JOHN THE BAPTIST THE PARABLE OF THE GREAT SUPPER: "BRING IN HITHER T

this painting... In this life we experience a kind of resurrection when we arrive at a state of awareness, a state of being in love, and at such times we like to do again what we have done many times in the past, because now we do it anew in heaven.' This painting was the focal point of a one-man show in 1927 at the Goupil Gallery, where Vincent van Gogh had worked, which established Spencer's reputation.

A few weeks later, on 25 March 1927, the Oratory of All Soul's in Sandham Memorial Chapel, Burghclere, was dedicated by the Bishop of Guildford. Spencer could now begin work there. It was the Feast of the Annunciation, the same day Giotto's chapel was consecrated in Padua more than 600 years earlier.

Cicely Mary Barker (1895–1973)

Nurtured in a devoutly Christian, secure, and loving home, light years away from mainstream art, Cicely Mary Barker developed her precocious talent for drawing. She became immersed in the private world she created, and revelled in her laborious work, out of which her well-known *Flower Fairies* books emerged.

ND THE MAIMED AND THE HALT AND THE BLIND. ST LUKE 14 SAINT GEORGE THE MARTYR

Cicely Mary Barker
(1895–1973):
*The Parable of the
Great Supper*,
St George's,
Waddon,
nr Croydon.

Her large triptych, *The Parable of the Great Supper*, spans one long wall of the lady chapel in St George's Church, Waddon, near Croydon, where Cicely and her sister Dorothy started the Sunday school soon after the church was built in 1932.

This parable was one of several that Jesus told at a very grand supper party to a group of social climbers. Its theme is that 'every one who exalts himself will be humbled, and he who humbles himself will be exalted' (Luke 14:11). With this particular story Jesus gives his host, a Pharisee ruler, food for thought: just as it is easier to love those who love you, it is agreeable to entertain friends who will repay your hospitality. Jesus suggested that the next time he gave a party he should 'invite the poor, the maimed, the lame, the blind, and you will be blessed, because they cannot repay you. You will be repaid at the resurrection of the just' (Luke 14:13–14).

When this triptych was unveiled in March 1935, the motley crowd, whom Jesus welcomes with open hands to his supper, was probably instantly recognizable to members of the congregation. Cicely's own mother has already been settled in her place by an adult angel. The gypsy woman with her basket of lavender and baby clasped to her bosom, the blind match-seller led by a little girl and by Cicely's own dog, the young man on crutches, possibly crippled in the First World War, wait with others to be seated. Everyone looks to Jesus with joyful recognition, loving trust, and hopeful expectation.

Three flower fairies with angels' wings, known to Cicely, no doubt, from the Sunday school, hold food and drink. They also reflect the tranquil, uneventful life typical of a quiet suburb in the thirties, when life moved at a slower pace, a village community was cohesive, and there was more reliance on your own God-given resources.

Roses lie scattered on the blue, tiled floor, as they were scattered for royalty in the *Wilton Diptych*. Garlands of laurel leaves gladden the walls. The damask tablecloth is spotless, reflecting the divinity of Jesus, the purity of the angels, and the freedom that derives from true humility, written simply on each ardent, honest face.

In the side panels are St John the Baptist and St George the Martyr, two idealized mythical heroes enlivened in the poetry of Tennyson and others, and in paintings by the Pre-Raphaelites and Burne-Jones. They encourage eager imaginations into a world of adventure, touching souls, in the universal mystery of courage, suffering, and death.

In 1946 Cicely painted another triptych called *Out of Great Tribulation* for the memorial chapel of Norbury Methodist Church. Christ stands with pierced hands open wide to receive the war-weary group. Service men and women, bearing their own wounds, come to him for comfort and hope, while a little girl runs joyfully forwards to embrace her friend.

Henry Moore (1898–1986)

Walter Hussey, whom Kenneth Clark described as 'the last great patron of art in the Church of England' had met and befriended leading artists, writers, and musicians while working as a curate in Kensington. After he succeeded his father as vicar of St Matthew's Church in Northampton in 1937, he commissioned Henry Moore to sculpt a Madonna and child to celebrate the fiftieth anniversary of the church, and as a thanksgiving for the long ministry of his father, the first vicar.

The commission was timely for Moore. He had not picked up a chisel since hostilities erupted in 1939. Like Stanley Spencer, during the First World War he concentrated his artistic energies into works on paper. In fact it was his drawings of underground shelters, exhibited at The National Gallery where Kenneth Clark was director in 1942, that had brought him to Hussey's notice. Hussey enlisted the sturdy support of Clark, the art critic Eric Newton, and the art-loving Bishop Bell of Chichester (coincidentally a friend of Bonhoeffer and his co-worker in the ecumenical movement) to persuade his parishioners that his choice of the avant-garde sculptor Moore was valid. Clark wrote that Moore was 'the greatest living sculptor, and it is of the utmost importance that the Church should employ artists of first-rate talent instead of the mediocrities usually employed'.

But how should Moore portray the Madonna and child? He made huge quantities of sketches and twelve clay models, drawing on the images of early Florentine sculpture. Patron and artist agreed that the figures should have, as Moore wrote to Hussey, 'an austerity and a nobility and some touch of grandeur (even hierarchical aloofness) which is missing in the "everyday" mother and child idea'. Even in the midst of the London

Henry Moore (1898–1986): *Madonna and Child*, St Matthew's Church, Northampton.

blitz, Moore emphasized the necessity of art to glorify life.

The Hornton stone from which the figures are hewn in the *Madonna and Child*, which Moore sculpted between 1943 and 1944, gradates from blue-grey to nearly orange; it is sheltered by the equally mellow Bath stone wall of the north transept, just as the Madonna protects her son, yet at the same time gives him to the world.

The ethereal quality of the glass neo-Gothic lights that rise up the wall to a rose window above emphasize the solidity of the figures. The Madonna transcends time. She is Mother Earth who has sustained humanity since the beginning, and she gazes across the millennia into the future. She is also a contemporary Yorkshire matriarch, the simplicity of her dress decorated with a bordered neckline. Moore sculpted this work while his own mother lay mortally ill.

Rounded, patient, primeval, she is the eternal mother, the sum total of security for a vulnerable child, and she steadies her son upon her ample lap – the continuation of human-kind and redeemer of our race. Christ looks directly at us and through us with serious, silent gaze, compelling us to stop, and think, 'What is this life if, full of care / We have no time to stand and stare?' (William Henry Davies, 'Leisure').

This element of stillness emanating from Moore's massive sculpture invites you to touch the monumental knees, polished over decades by hands that want to touch mystery. It is an ancient custom. A thirteenth-century bronze of Peter in St Peter's Basilica in Rome also shines from many venerating fingers seeking solace.

It is a moment of self-discovery, to stand in the exterior silence beneath the lofty vault long enough to feel time fly, then falter into relativity as you move beyond it; dropping petty preoccupations as you discard yesterday's newspaper and take a step of faith into an abyss of interior solitude, where the soul is nourished into wholeness and harmony with the whole universe – inside and outside.

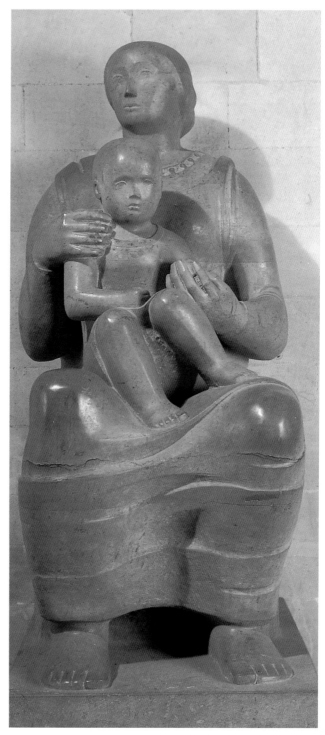

Graham Sutherland (1903–80)

Moore's *Madonna and Child* embodies creation. Across the nave, in the south transept, Graham Sutherland's life-size oil painting, *The Crucifixion*, painted in 1946, cries out for re-creation.

Unless a seed dies, new life cannot germinate. 'Everything in the world can hurt us until we love God perfectly,' wrote the Trappist monk Thomas Merton in *Seeds of Contemplation*. He continued:

> Christ's physical body was crucified outside Jerusalem 2,000 years ago. His mystical body is drawn and quartered from age to age by the devils in the agony of that disunion which is bred and vegetates in our souls prone to selfishness and sin… Christ is massacred in his members, torn from limb to limb; God is murdered in man… It is principally in the suffering and sacrifice that are demanded for men to live together in peace and harmony that love is perfected in us.

Sutherland's excruciating *The Crucifixion* encapsulates all the horrors that hatred can devise. Nailed to a modern-looking cross, Christ's whole body shudders, blood spurts out, and his hands curl up in agony as his rib cage is pulled away from his torso. Christ is still dying. Sutherland studied Grünewald's altarpieces but, by ignoring the German artist's obsession with gratuitous details, he increases the impact.

Sutherland's *The Crucifixion* formalizes the destructiveness of sin so recently suffered in the war, so poignantly glimpsed by the war artist in photographs of tortured bodies in Belsen, Auschwitz, and Buchenwald.

If you sit on the chancel steps and contemplate our sacrificial Saviour, the high relief of the figure set against the flat background evokes Cimabue's icon. But here Christ is desperately alone, roped off from humanity, brick-walled into a bombed and bleeding city beneath his bloody feet. Yet he looks stunningly majestic, set against a background of rich, regal blues: spiritual stones that keep step with those of the transept wall and take you, like Jacob's ladder, into the tall neo-Gothic lights that soar up into glimpses of blue sky. On these, royal robes radiate out like ripples from a symbolic tree of Jesse, a tree of the church, where the true vine burgeons and enscrolled words proclaim, 'By this my Father is glorified, that you bear much fruit' (John 15:8).

'As the Father has loved me, so have I loved you, abide in my love,' Jesus counselled his disciples at the Last Supper (John 15:9). And through this hideous torture everything his people owed to his Father was wiped away for ever from the book of remembrance. Christ, to the uttermost, satisfied divine justice. The account is settled, the handwriting nailed to the cross, the receipt given.

Hussey's commissions proved to be a watershed. Moore's international reputation was established, and Sutherland became first choice for several other major church commissions, including the Coventry Cathedral Tapestry. Hussey himself had set the tone for a vital contemporary Christian art; later as Dean of Chichester he commissioned *Noli Me Tangere* from Sutherland, a Chagall window, and a John Piper tapestry.

Graham Sutherland (1903–80): *The Crucifixion*, St Matthew's Church, Northampton.

Polish Artists

A century ago the Polish artist Jan Matejko wrote, 'Art is a weapon, not to be separated from love of our country.' In his romantic, historical paintings, laden with symbolism, Matejko created a vision of Poland's patriotic past to 'inspire depressed hearts'. When Poland was partitioned by her powerful neighbours in the eighteenth century, the church became a patriotic, as well as a spiritual, bastion in the face of foreign rulers.

The cooperation between art and the church re-emerged after the Second World War, when Poland was sucked into the Soviet empire after twenty years of freedom. Professor Janusz Bogucki was one of the prime movers in bringing artists and churchmen together. He was well fitted for this role, for although, like many artists in the 1950s, he started out from a Marxist position, over the years his awareness of spiritual truths matured. He ran the State Sztuki Gallery in Warsaw, where every artist of note wanted to exhibit, and Bogucki's strong character became a shelter for new ideas. Bogucki was also a respected art critic and a teacher at the celebrated Academy of Fine Art at Torun. In the mid 1970s he organized special meetings at the Franciscan Institute at Laski for artists interested in communicating their faith, which led to an exhibition in a small village outside Warsaw. Workers from a nearby agricultural factory, peasants from the outlying areas, and intellectuals from the city were all invited. Here was an opportunity to look at paintings with a spiritual message and through them communicate with each other. Bogucki encouraged artists, working with priests and locals, to restore the crypt of a bombed-out church on the edge of the Warsaw ghetto in Zytnia Street so they had a permanent exhibition centre. It was a provident move. After the defeat of Solidarity and the introduction of martial law in December 1981, most artists left their union, thereby cutting themselves off from state patronage.

Over the years Bogucki became an important rock for artists. They trusted his integrity and relied on his judgment. Shortly after the pope's second visit to his homeland in 1983, the professor initiated an exhibition at Zytnia Street called 'Sign of the Cross'. Its aim, to promote positive spiritual and social renewal, was seen by many as a light in the darkness. Foremost artists utilized the fabric of the crypt – the burnt brickwork, the scars, the character of the walls and spaces – as part of their work. For example, in his *Last Supper*, Kalina placed an ordinary table and some chairs beside a pile of rubble. He put potatoes on the table, and hung a red and white Polish flag, cut half way through so that it resembled a 'V' sign, above it. Stark and precise, it brought the message of Christ's Last Supper right to the present day in a way people could identify with at gut level. New leaves grew up around Jalowczyk's beautifully painted *Cross of Life*.

But a year later this sense of hope was utterly absent from Bogucki's exhibition 'Apocalypse'. Father Jerzy Popieluszko, a gentle, charismatic priest who spoke of fearing 'not those who kill the body but the soul' had been murdered by the authorities, his body weighted down and dumped into the Vistula river after being severely beaten. Again, eminent artists used the body of the crypt for their 'happenings'. Brzozowski slung ropes from six columns in the shape of his nightmare, splattering red paint like blood onto a mirror on the floor; Waniek arranged black soutanes to signify death robes; Kalina filled

a sandpit on the floor with little lights and crosses, and built a pyramid beside this 'desert'. Documentary photographs ranged from naked women on their way to the gas chambers, hope still shining in their faces, to the White Mass held in the great square in Cracow after the attempted assassination of the pope. This art was not simply to shock

Jacek Waltos
(b.1938):
On Both Sides of the Gate: The Gdansk August Sunday
1980.

or to manipulate the emotions for political or religious ends. Too often, Bogucki warned, simplistic answers can overshadow truth. But these exhibitions proved what an important role art can play in a world filled with materialism and poverty, increasing violence and injustice. They make you think and search for deeper reality.

The church became the most strategic place to make artistic statements all over Poland. Portraits of Maximilian Kolbe, the Franciscan friar who took the place of a family man in the death queue at Auschwitz, wearing prison stripes and glasses, are everywhere, a reminder of self-sacrifice.

Leszek Sobocki
(b.1934):
The Pole.

Fifteen artists contributed paintings and graphics to an exhibition called 'Towards the People' in a cloister of the Gothic Dominican Church in Cracow, including three members of the now disbanded Wprost ('Direct') group, whose work can be seen in museums all over Poland. Grzywacz, Bieniasz, Jacek Waltos, and Leszek Sobocki formed Wprost in 1966 out of frustration.

While other artists experimented with current trends from the West, these four angry young men wanted, as the sculptor Waltos explained, 'to evoke the traditions of Polish art, to portray the personal and social problems which were absent from art at this time'. A year later Sobocki won the prestigious Norwid prize for his linocut *Eat Bread*. The red loaf lies in a black supermarket basket, stark and simple. Since that series, called *Bread of Life*, Sobocki has captured significant events – Solidarity, the pope's first visit, Popieluszko's murder – in a series of black and white graphics. His portraits of Lech Walesa and Cardinal Stefan Wyszynski hang in the museum at Jasna Gora monastery.

Jacek Waltos (b.1938)

Jacek Waltos is a sculptor who also works in other media. His poignant oil painting, *On Both Sides of the Gate: The Gdansk August Sunday 1980* (p. 199), was first shown in a church, as it could not be displayed officially. Men kneel and stand under a search light, hands clasped in prayer. This painting conjures up an atmosphere of Christian faith and courage – the catalysts that transformed a workers' strike in the Lenin Shipyard in Gdansk in 1980, a thousand years after the founding of the city, into the flowering of Solidarity. Waltos painted this picture a few months after the imposition of martial law – which could not stop people praying.

Leszek Sobocki (b.1934)

Leszek Sobocki's most powerful painting is called *The Pole*. It was painted in 1978, soon after its subject, Karol Wojtyla, became the first ever Slav, and first non-Italian for 450 years, to be voted onto the papal throne. Academic, sportsman, poet, and man of God, quiet determination blends with righteous anger on the furrowed brow and piercing eyes of this most Polish of Poles, stripped of everything except the faint suggestion of a papal cap. He was a man, like many others, whose youth was splintered by the war; after the German occupation of Cracow, the university was closed, and Wojtyla was forced underground, like the other students, and sent to work in the limestone quarries. He was a man who loved freedom, who watched his beloved country groan under the yoke of Communism. He never lost hope, as Sobocki reveals by the blue sky that fills his breast, despite the surrounding darkness. 'The Son of God is always present in the history of

humanity as Redeemer... it is the light that "shines in the darkness, and the darkness has not overcome it",' wrote the pope.

Sobocki captures these images, the clenched fist harnessed by prayer symbolizing the incredible strength and acumen that was to be instrumental in moving the mountain that was the Soviet empire.

The trumpet sounded as God called his chosen people to the foot of Mount Sinai and Moses went up to receive the ten commandments amid fire, smoke, and the quaking of rock. Jesus warned that when the Last Trumpet rang out, mankind would be judged by how we respond to the two commandments, 'You shall love the Lord your God with all your heart, and with all your soul, and with all your mind... You shall love your neighbour as yourself' (Matthew 22:37, 39).

Roger Wagner (b.1957)

When he was a schoolboy, Roger Wagner visited Florence. He sat in the cells of San Marco convent, where Fra Angelico had prayed his frescoes into life, and discovered for himself the interaction of faith and art in everyday life. Later, he achieved a first-class degree in English literature at Oxford, and then became a student at the Royal Academy of Art. Wagner studied the classic themes of Renaissance painting and modified them, following William Blake, Palmer, Nash, and Stanley Spencer in the English pastoral tradition – into the countryside of Suffolk, where he grew up, and Oxford where he lives and works.

Wagner is a quiet, modest man of intense faith, who transforms his inner visions into poetry and paint:

Roger Wagner
(b.1957):
*The Harvest is the
End of the World,
and the Reapers
are Angels* (detail).

*I saw the cherubim one summer's night
Reaping it seemed an endless field of wheat.
I heard their voices through the fading light
Wild, strange and yet intolerably sweet.
The hour such beauty first was born on earth
The dawn of judgment had that hour begun
For some would not endure love's second birth
Preferring their own darkness to that sun.
And still love's sun must rise upon our night
For nothing can be hidden from its heat...* (II, Fire Sonnets).

Ten years were to pass before this inner picture became a painting. *The Harvest is the End of the World, and the Reapers are Angels* is taken from the parable of the sower, which Jesus used to teach the people about the mysteries of heaven. Jesus spoke in parables. He used the natural world as a metaphor for the spiritual life. The good seed was sown in love by him who is the bread of life; the weeds, as every farmer and gardener knows, tend to spring up

and choke. These are sown by Satan, the enemy of truth, the ruler of this present world, the reason evil seems to flourish. Jesus did not mince his words: the weeds were destined for the furnace, where there would be wailing and gnashing of teeth. The good seed of faith is destined for heaven, and even a tiny mustard seed has the capacity to become a tree where birds can build their nests.

Wagner turned away from the terrors of the damned, from such gruelling images as Michelangelo's *Last Judgment* in the Sistine Chapel. His God is loving and just, the light shining in the darkness. As a blue-black sky bereft of stars heralds impending doom, an unearthly light transfigures the fully ripened grain being harvested by a trinity of workman-like angels in silent concentration. Everything in this unpolluted landscape nourishes hope; the lushness of God's glory and the beauty of his peace are winsomely reflected, from the great expanse of yellow corn to the little flowers blossoming discreetly on a grassy bank, from the lean-stemmed sycamores to the mighty oak of faith.

Narrow paths cross the corn and indent the shadow of redeeming love. 'If any man would come after me, let him deny himself and take up his cross and follow me,' Christ told his disciples (Matthew 16:24), as he foretold his own death, resurrection, and return. This cross of obedience faithfully accepts the diverse challenges of life with humble joy and childlike trust.

Craigie Aitchison
(b.1926):
Calvary, Chapel of
St Margaret, Truro
Cathedral, Truro.

Craigie Aitchison (b.1926)

Art, as the eastern church discovered through icon painting, can be a force that takes us beyond knowledge and into prayer. And this vital role that art can play in the spiritual life of the church is undergoing re-examination in England, following the example of patrons such as George Bell and Walter Hussey. The Jerusalem Trust, for example, has recently commissioned artworks for cathedrals and churches across the land, including *Calvary* by Craigie Aitchison for Truro Cathedral.

Aitchison was born with a physical disability. He was also a born painter. Unable to develop his talent by traditional methods, when he was a part-time student at the Slade and, later, on a scholarship in Rome, he invented his own, inimitable style. The triangular hills, rising majestically above the extensive plain near Kincardine-on-Forth where he grew up, became etched on his mind and integrated into his art as poems of colour and shape. These images envelop all the senses and lead you into a deeper sense of being. In *Calvary* the lifeblood of our Saviour on the cross ebbs away in the midst of liturgical colours which spread into infinity. They lift you up from the valley of fear into the hills of faith, where, like the psalmist, you can sing, 'My help comes from the Lord, / who made heaven and earth' (Psalm 121:2).

Aitchison has been painting crucifixions since 1958, but *Calvary* was the first to be painted for a church. It hangs in four sections between the Gothic arches on the eastern wall of the Chapel of St Margaret in Truro Cathedral. The four panels are drawn together by the continuous view of Goatfell, the Isle of Arran's highest peak, rising in purple majesty out of a green plain beneath a vermilion sky. Yet there is a feeling of separateness. In three panels Christ and the two thieves bear their torture against this brilliant background, alone. Only Christ is illuminated by a star, and comforted by the presence of a dog. The thieves hang limply, lacking inner substance. And in the fourth panel on the right, a tree as spare and white as the three victims, a family tree, reaches out to the light, recalling Job's revelation, 'there is hope for a tree, if it be cut down, that it will sprout again, and that its shoots will not cease' (Job 14:7).

Epilogue

'Be not afraid!' exhorted Karol Wojtyla in his first message in St Peter's Square as Pope John Paul II in 1978. 'The power of Christ's cross and resurrection is greater than any evil which man could or should fear' (*Crossing the Threshold of Hope*).

His words resonate back across the millennia, to when the first Christians were persecuted for their faith under the Roman empire. They resound in the twentieth century when evil has multiplied and more Christians have been martyred (under totalitarian regimes) than in any other period in history.

Westminster Abbey stood watch as Christianity grew and blossomed across Europe in the Middle Ages. Now, at the end of the twentieth century, the empty niches on the West Front of the Abbey have at last been filled. Six traditional saints and four allegorical female figures of vital values — peace, justice, mercy, and truth — accompany full-length portraits of ten men and women who bear witness to the cost of Christian discipleship in our troubled times, from the Russian Revolution to the persecution of the church in Latin America in the 1980s.

Gleaming white in their newly hewn state, they dignify the family of Christ; reminiscent of *Christ Stands on a Lion and a Serpent* from Ravenna, they symbolize all those who follow the Master's example in the fight against sin and evil.

Martin Luther King and Oscar Romero stand side by side over the apex of the great West Door. They are surrounded by children, for the Baptist African-American and the Roman Catholic Archbishop of San Salvador were both murdered for protecting the poor and persecuted. The Franciscan friar Maximilian Kolbe and the Lutheran Dietrich Bonhoeffer were exterminated by the Nazis, and the Chinese pastor Wang Zhiming fell foul of the Red Guards during the Cultural Revolution. Like Janani Luwum, Anglican Archbishop of Uganda under the dictator Idi Amin, they were prepared to die in the army of Jesus. When they reached the crossroads of choice, these heroic men and women relied not on their own strength, but on the will of Abba, our Father in heaven, to keep them steadfast on the path of faith, which is the way of love.

MUSEUM AND CHURCH LISTINGS

Austria

SALZBURG AND ENVIRONS

St Wolfgang Church
Michael Pacher: St Wolfgang Altarpiece

VIENNA

Kunsthistorische Museum
Pieter Bruegel the Elder: *Hunters in the Snow, The Massacre of the Innocents, The Return of the Herd, The Tower of Babel*
Michelangelo Merisi da Caravaggio: *David with Head of Goliath*
Raphael: *Madonna in the Meadow*
Peter Paul Rubens: Ildefonso Altarpiece

Belgium

ANTWERP

Antwerp Cathedral
Peter Paul Rubens: *Assumption, Descent from the Cross, Raising of the Cross*

Koninklijk Museum voor Schöne Kunsten
Jan van Eyck: *St Barbara*
Hans Memling: *Christ among Angels*
Peter Paul Rubens: *Coup de Lance, Incredulity of St Thomas, The Prodigal Son*
Rogier van der Weyden: Altar of the Seven Sacraments

BRUGES

Memling Museum
Hans Memling: *The Mystic Marriage of St Catherine*, St Ursula Reliquary

BRUSSELS

Musées Royaux des Beaux-Arts de Belgique
Hieronymus Bosch: *Christ on the Cross*

Pieter Bruegel the Elder: *Adoration of the Magi, Census at Bethlehem, Landscape with Fall of Icarus*
Hugo van der Goes: *The Virgin and Child with St Anne*
Hans Memling: *Martyrdom of St Sebastian*
Peter Paul Rubens: *Ascent to Calvary, Christ and the Adulteress*
Rogier van der Weyden: *Pietà*

GHENT

St Bavo Cathedral
Jan van Eyck: *The Adoration of the Lamb*, Ghent Altarpiece
Peter Paul Rubens: *The Conversion of St Bavo*

Czech Republic

BOHEMIA

Ales Gallery, Hluboká Castle
The Master of the Trebon Altarpiece: *Adoration of the Child*

PRAGUE

Lobkowicz Collection, Nelahozeves Château
Pieter Bruegel the Elder: *Haymaking*

National Museum
Albrecht Dürer: *The Feast of the Rosary*
The Master of the Trebon Altarpiece: *Resurrection*

England

BURGHCLERE

Sandham Memorial Chapel
Stanley Spencer: *The Resurrection of the Soldiers*

LONDON

The British Museum
Albrecht Dürer: *Apocalypse*

Courtauld Institute Galleries
Pieter Bruegel the Elder: *Flight into Egypt*

Imperial War Museum
John Singer Sargent: *Gassed*

The National Gallery
Albrecht Altdorfer: *Christ Taking Leave of his Mother*
Gentile Bellini: *Sultan Mehmet II*
Giovanni Bellini: *The Agony in the Garden, The Doge Leonardo Loredan*
Sandro Botticelli: *The Adoration of the Kings, The Nativity*
Pieter Bruegel the Elder: *The Adoration of the Kings*
Michelangelo Merisi da Caravaggio: *The Supper at Emmaus*
Duccio di Buoninsegna: *Annunciation, Jesus Opens the Eyes of a Man Born Blind, Transfiguration, The Virgin and Child with Saints*
Caspar David Friedrich: *Winter Landscape*
Giotto di Bondone: *Pentecost*
Vincent van Gogh: *A Wheatfield, with Cypresses*
Benozzo di Lese di Sandro Gozzoli: *The Virgin and Child Enthroned among Angels and Saints*
Leonardo da Vinci: *The Virgin of the Rocks*
Stephan Lochner: *St Matthew, St Catherine and St John the Evangelist*
Andrea Mantegna: *The Agony in the Garden, The Virgin and Child with the Magdalene and St John the Baptist*
Tommaso Masaccio: *The Virgin and Child*
Hans Memling: The Donne Triptych
Michelangelo Buonarroti: *The Entombment, The Manchester Madonna*

Piero della Francesca: *The Baptism of Christ, St Michael, The Nativity*
Raphael: *St Catherine of Alexandria*
Rembrandt van Rijn: *Belshazzar's Feast*
Peter Paul Rubens: *An Autumn Landscape*
Tintoretto: *Christ Washing his Disciples' Feet*
Titian: *Noli Me Tangere*
Rogier van der Weyden: *The Magdalene Reading*
The *Wilton Diptych: Richard II presented to the Virgin and Child by his patron Saint John the Baptist and St Edward and St Edmund*

St Paul's Cathedral
William Holman-Hunt: *The Light of the World*

Tate Gallery
William Holman-Hunt: *The Awakening Conscience*
John Martin: *The Great Day of his Wrath, The Last Judgment, The Plains of Heaven*
John Everett Millais: *Christ in the House of his Parents*
Dante Gabriel Rossetti: *Ecce Ancilla Domini*
Stanley Spencer: *The Resurrection, Cookham*

Victoria and Albert Museum
Raphael: cartoons depicting the lives of St Peter and St Paul

Westminster Abbey
Ten Martyrs

MANCHESTER

Manchester Art Gallery
William Holman-Hunt: *The Scapegoat*

NORTHAMPTON

St Matthew's Church
Henry Moore: *Madonna and Child*
Graham Sutherland: *The Crucifixion*

OXFORD

Keble College Chapel
William Holman-Hunt: *The Light of the World*

Magdalen College Chapel
Leonardo da Vinci: *Last Supper* (copy)

TRURO

Chapel of St Margaret, Truro Cathedral
Craigie Aitchison: *Calvary*

WADDON, CROYDON

St George's Church
Cicely Mary Barker: *The Parable of the Great Supper*

France

AVIGNON

Musée Calvet
The *Villeneuve Pietà*

BEAUNE

Hotel-Dieu
Rogier van der Weyden: *Last Judgment*

PARIS

Musée du Louvre
Fra Angelico: *Crowning of the Virgin*
Vittore Carpaccio: *St Stephen Preaching at Jerusalem*
Jan van Eyck: *The Virgin of Chancellor Rolin*
Leonardo da Vinci: *Mona Lisa, The Virgin of the Rocks*
Jean-François Millet: *The Angelus, The Gleaners*
Raphael: *St George Fighting the Dragon*
Titian: *The Supper at Emmaus*

Germany

COLMAR

Musée d'Unterlinden
Matthias Grünewald: Isenheim Altarpiece

COLOGNE

Wallraf-Richartz Museum
Stephan Lochner: *Madonna in the Rose Garden*

DRESDEN

Gemäldegalerie
Jan van Eyck: Altarpiece
Caspar David Friedrich: *The Cross in the Mountains, Two Men Gazing at the Moon*
Raphael: *The Sistine Madonna*
Titian: *The Betrayal*

MUNICH

Alte Pinakothek
Albrecht Altdorfer: *Susanna Bathing*
Sandro Botticelli: *Lamentation*
Albrecht Dürer: *The Four Apostles*, Paumgarten Altarpiece
El Greco: *Disrobing of Christ*
Hans Memling: *Mary in the Rose Bower*
Tintoretto: *Christ in the House of Mary and Martha*
Rembrandt van Rijn: *Adoration of the Shepherds, Descent from the Cross*
Peter Paul Rubens: *Last Judgment*
Rogier van der Weyden: Three Kings Altarpiece

SCHWERIN

Berlin-National Museum
Caspar David Friedrich: *Winter Landscape*

Holland

AMSTERDAM

Van Gogh Museum
Vincent Van Gogh: *The Harvest, Orchards in Blossom, The Potato Eaters*

The Rijksmuseum
Rembrandt van Rijn: *Jeremiah Lamenting*

Hungary

BUDAPEST

Szépmüvészeti Muzeum
Pieter Bruegel the Elder: *The Sermon of John the Baptist*

El Greco: *Agony in the Garden, Penitent Magdalene*
Raphael: *The Esterhazy Madonna*

Ireland

DUBLIN

The National Gallery of Ireland
Jan Bruegel: *Christ in House of Mary and Martha*
Michelangelo Merisi da Caravaggio: *The Taking of Christ*
Peter Paul Rubens: *Christ in House of Mary and Martha*
Titian: *Ecce Homo*

Italy

ASSISI

Basilica of St Francis
Giovanni Cimabue: frescoes
Duccio di Buoninsegna: frescoes
Giotto di Bondone: frescoes

CLASSE

Basilica of San Apollinare
Mosaics

FLORENCE

Brancacci Chapel, Santa Maria del Carmine
Tommaso Masaccio: *Life of St Peter*

Galleria degli Uffizi
Sandro Botticelli: *Adoration of the Magi*
Giovanni Cimabue: *Maestà*
Duccio di Buoninsegna: *Maestà*
Gentile da Fabriano: *Adoration of the Magi*
Giotto di Bondone: *Maestà*
Hugo van der Goes: Portinari Altarpiece
Leonardo da Vinci: *Annunciation*
Simone Martini: *Annunciation*
Michelangelo Buonarroti: *Holy Family, Tondo Doni*
Rogier van der Weyden: *Entombment*

Galleria dell'Accademia
Michelangelo Buonarroti: *David*

Museo di San Marco dell'Angelico
Fra Angelico: frescoes

Palazzo Medici-Riccardi
Benozzo di Lese di Sandro Gozzoli: *The Journey of the Magi to Bethlehem*

Santa Croce
Giovanni Cimabue: *Crucifixion*
Giotto di Bondone: *Life of St Francis*

Santa Maria Novella
Domenico Ghirlandaio: *Life of John the Baptist, Life of the Virgin*
Tommaso Masaccio: *The Holy Trinity with the Virgin and St John*

Santa Trinita
Domenico Ghirlandaio: *Adoration*

MILAN

Brera Gallery
Giovanni Bellini: *The Sermon of St Mark in Alexandria*
Vittore Carpaccio: *Dispute*

Santa Maria delle Grazie
Leonardo da Vinci: *Last Supper*

NAPLES

Museo e Gallerie Nazionali di Capodimonte
Pieter Bruegel the Elder: *Parable of the Blind*

PADUA

Scrovegni (Arena) Chapel
Giotto di Bondone: *Life of Mary and Jesus*

RAVENNA

Archiepiscopal Chapel
Mosaics

Basilica of San Apollinare Nuovo
Mosaics

Basilica of San Vitale
Mosaics

Battistero Neoniano
Mosaics

Mausoleo di Galla Placidia
Mosaics

ROME

Catacombe dei San Marcellino e San Pietro
Noah and the Dove

Catacombs of St Priscilla and St Domitilla
Wall-paintings

Galleria Doria Pamphili
Michelangelo Merisi da Caravaggio: *Penitent Magdalene, Rest on the Flight*

Lateran Museum
The Good Shepherd

San Luigi dei Francesi
Michelangelo Merisi da Caravaggio: *Calling of St Matthew, Martyrdom of St Matthew, St Matthew Writing His Gospel*

Sistine Chapel
Michelangelo Buonarroti: *Creation of Adam, The Flood, Last Judgment*

Vatican Museum
Michelangelo Merisi da Caravaggio: *Deposition*

SICILY

Cefalu Cathedral
Mosaics

Monreale Cathedral
Mosaics

Palatine Chapel
Mosaics

Temple of Athena – Syracuse Cathedral

SIENA

Museo dell'Opera del Duomo
Duccio di Buoninsegna: *Maestà*

Palazzo Pubblico
Ambrogio Lorenzetti: *Good and Bad Government*
Simone Martini: *Maestà*

TUSCANY

Civic Museum, San Sepolcro
Piero della Francesca: *Resurrection*

San Francesco, Arezzo
Piero della Francesca: The *True Cross Cycle*

Santa Maria Nomentana, Monterchi
Piero della Francesca: *Madonna del Parto*

VENICE

Accademia
Giovanni Bellini: *Annunciation, The Herald Angel*
Vittore Carpaccio: *Legend of St Ursula*
Andrea Mantegna: *St George*
Tintoretto: *The Creation of the Animals, The Crucifixion, The Dream of St Mark, The Transport of St Mark*

Correr Museum
Giovanni Bellini: *The Crucifixion, Madonna and Child, Pietà*

Doge's Palace
Vittore Carpaccio: *The Lion of St Mark*

St Mark's Basilica
Eleventh-century mosaics

San Silvestro
Tintoretto: *Baptism of Christ*

Santa Maria Gloriosa dei Frari
Bellini: *The Assumption of the Virgin, Madonna and Child with Musical Angels and Four Saints*

Scuola di San Giorgio degli Schiavoni
Vittore Carpaccio: *Lives of St Jerome, St Tryphon and St George*

Scuola Grande di San Rocco
Tintoretto: *The Fall of Manna, Last Supper,* Old and New Testament scenes

Malta

VALETTA

St John's Cathedral
Michelangelo Merisi da Caravaggio: *The Beheading of St John the Baptist, St Jerome*

Poland

CRACOW

Czartoryski Museum
Leonardo da Vinci: *Lady with an Ermine*
Rembrandt van Rijn: *The Good Samaritan*

National Museum
Leszek Sobocki: *The Pole*

St Mary's Parish Church
Veit Stoss: *St Mary's Altarpiece*

GDANSK

National Museum
Hans Memling: *The Last Judgment*

JASNA GORA

Czestochowa
Leszek Sobocki: *Lech Walesa, Cardinal Stefan Wyszynski*
Black Madonna icon

WROCLAW

National Museum
Jacek Waltos: *On Both Sides of the Gate: The Gdansk August Sunday 1980*

Russia

ST PETERSBURG

Hermitage Museum
El Greco: *Apostles Peter and Paul*
Vincent van Gogh: *Lilac Bush*
Leonardo da Vinci: *The Benois Madonna*
Simone Martini: *Annunciation, Madonna*
Raphael: *The Madonna Conestabile*
Rembrandt van Rijn: *David and Jonathan, Holy Family, Return of the Prodigal Son, Sacrifice of Isaac*

Spain

MADRID

Museo del Prado
Hieronymus Bosch: *Garden of Delights*

El Greco: *Adoration of the Shepherds, Resurrection, Trinity*
Peter Paul Rubens: *Adoration of the Magi*
Titian: *Emperor Charles V*
Rogier van der Weyden: *Deposition*

TOLEDO

Museum of the House of El Greco
El Greco: *Christ and the Apostles*
San Tome
El Greco: *Burial of Count Orgaz, The Disrobing of Christ*

Sweden

STOCKHOLM

National Museum
Rembrandt van Rijn: *Simeon and the Child Jesus in the Temple*

BIBLIOGRAPHY

General

Gombrich, E.H., *The Story of Art*, Oxford: Phaidon, 1960.

Kelly, John, *Oxford Dictionary of Popes*, New York: Oxford University Press, 1986.

Langmuir, Erika, *The National Gallery Companion Guide*, London: National Gallery Publications, 1994.

Levey, Michael, *Florence, A Portrait*, London: Jonathan Cape, 1996.

Macadam, Alta, *A Blue Guide to Italy*, London: A&C Black, 1991.

Morton, H.V., *A Traveller in Italy*, London: Methuen, 1964.

Murray, Peter and Linda, *Companion to Christian Art and Architecture*, Oxford: Oxford University Press, 1996.

Newton, Eric and Neil, William, *The Christian Faith in Art*, London: Hodder and Stoughton, 1966.

Vasari, Giorgio, *Lives of the Artists*, vols 1 and 2, trans. George Bull, London: Penguin Classics, 1965.

1 The Image of Christ

Bustacchini, Gianfranco, *Ravenna*, Cartolibreria Salbaroli, 1984.

Chierichetti, Sandro, *The Cathedral of Monreale, Palermo*, Dittar.

De Waal, Esther, *Seeking God, The Way of St Benedict*, London: Fount, 1984.

John Paul II, Pope, *Faith and Reason*, Encyclical Letter, Rome: The Vatican Publications, September 1998.

Macadam, Alta, *A Blue Guide to Sicily*, London: A&C Black, 1993.

Morton, H.V., *A Traveller in Rome*, London: Methuen, 1957.

Plato, *The Last Days of Socrates*, trans. Hugh Tredennick, London: Penguin Classics, 1954.

Roper, Hugh Trevor, *The Rise of Christian Europe*, London: Thames and Hudson, 1955.

2 The Rebirth of Realism

Baldini, U., *The Cimabue Crucifix*, Casazza Olivetti.

Caretto, Carlo, *I, Francis*, London: Collins, 1982.

Chesterton, G.K., *St Francis of Assisi*, London: Hodder and Stoughton, 1923.

Chesterton, G.K., *St Thomas Aquinas*, New York: Doubleday, 1956.

Dante, *Divine Comedy*, trans. John D. Sinclair, New York: Oxford University Press, 1961, 1963.

Ghiberti, Lorenzo, *Commentarii II*, c.1450.

Gordon, Dillian, *The Wilton Diptych, Making and Meaning*, London: National Gallery Publications, 1993.

Jannella, Cecilia, *Duccio di Buoninsegna*, Florence: Scala, 1991.

Julian of Norwich, *Revelations of Divine Love*, London: Penguin Classics.

Nouwen, Henri, *In the House of the Lord*, London: Darton, Longman and Todd, 1986.

Shakespeare, William, *Richard II*, 1595.

Zuffi, Stefano, *Giotto*, Milan: Electa, 1995.

3 The Humanization of Faith

Angelini, Alessandro, *Piero della Francesca*, Florence: Scala, 1985.

Boccaccio, Giovanni, *The Decameron*, trans. Guido Waldman, New York: Oxford University Press, 1993.

Casazza, Ornella, *Masaccio and the Brancacci Chapel*, Florence: Scala, 1990.

Catherine of Siena, *The Dialogue*, trans. Suzanne Noffke, New York: Paulist Press, 1980.

Olivari, Mariolina, *Giovanni Bellini*, Florence: Scala, 1990.

Pope-Hennessy, John, *Fra Angelico*, Florence: Scala, 1981.

4 The Flemish Altarpiece

Harbison, Craig, *The Art of the Northern Renaissance*, London: Everyman's Art Library, 1995.

Kempis, Thomas à, *The Imitation of Christ*, trans. Betty L. Knott, London: Collins, 1963.

Schmidt, Peter, *Adoration of the Lamb*, Leuven: Davidsfonds Uitgeverij, 1995.

Wilenski, R.H., *French Painting*, London: Medici Society, 1949.

Catalogue of the Royal Museums of Fine Arts, Brussels, 1986.

Meditations on the Life of Christ, trans. C.I. Ragusa, Princeton: Princeton University Press, 1961.

5 Before the Body Was Broken

Chrzanowski, Tadeusz, *The Marian Altar of Wit Stwosz*, Warsaw: Interpress, 1985.

Kaufmann, Thomas DaCosta, *Court, Cloister and City*, London: Weidenfeld and Nicolson, 1995.

Van der Osten, Tert and Zey, Horst, *Painting and Sculpture in Germany and the Netherlands 1500–1600*, London: Pelican History of Art, 1969.

Wider, Erich, *Der Pacher-Altar in St Wolfgang*, Verlag Hofstetter, 1982.

6 The Summit Unsurpassed

The Sonnets of Michelangelo, trans. Elizabeth Jennings, London: The Folio Society, 1961.

Leonardo da Vinci, exhibition catalogue, London: Hayward Gallery, 1989.

Clark, Kenneth, *Civilization*, London: John Murray, 1969.

Coughlan, Robert, *Michelangelo*, Alexandria: Time Life Library of Art, 1966.

7 Inner Fervour

Bonsanti, Giorgio, *Michelangelo Merisi da Caravaggio*, Florence: Scala, 1984.

Stoichita, Victor I., *Visionary Experience in the Golden Age of Spanish Art*, London: Reaktion Books, 1995.

Teresa of Avila, St, *The Life of St Teresa of Avila*, trans. E. Allison Peers, London: Sheed and Ward, 1979.

Valcanover, Francesco, *Jacopo Tintoretto and the Scuola Grande of San Rocco*, Venice: Storti Edizioni, 1994.

8 Two Sides of the Christian Coin

Abbot of St Benoit-sur-Loire, *The Work of St Benedict*.

Belloc, Hillaire, *Hills and the Sea*, London: Methuen, 1906.

Brown, Christopher, *Rubens's Landscapes*, London: National Gallery Publications, 1996.

Dillenberger, Jane, *Style and Content in Christian Art*, London: SCM Press, 1986.

Green, V.H.H., *Renaissance and Reformation*, London: Edward Arnold, 1952.

Nouwen, Henri, *The Return of the Prodigal Son*, London: Darton, Longman and Todd, 1994.

Vaughan, Henry, *Silex Scintillans*.

Wedgewood, C.V., *William the Silent*, London: 1944.

All the Paintings of Pieter Bruegel, ed. Valentine Denis, London: Oldbourne, 1961.

Old Masters in the Royal Museum of Antwerp, catalogue, 1980.

Merton, Thomas, *Seeds of Contemplation*, London: Burns and Oates, 1949.

Wagner, Roger, *Fire Sonnets*, Oxford: The Besalel Press, 1984.

Walker, Keith, *Images or Idols?: The Place of Sacred Art in Churches Today*, Norwich: Canterbury Press, 1996.

Images of Christ – Religious Iconography in 20th Century British Art, St Matthew's centenary exhibition catalogue, Northampton, 1993.

Stanley Spencer, exhibition catalogue, London: Royal Academy, 1980.

Stanley Spencer at Burghclere, London: The National Trust, 1991.

9 After the Age of Reason

Beaumont, William, *A Diary of a Journey to the East*, 1854.

Hamilton, G.H., *Painting and Sculpture in Europe 1880–1940*, New Haven: Yale University Press, 1967.

Leighton, John and Bailey, Colin J., *Caspar David Friedrich – Winter Landscape*, London: National Gallery Publications, 1990.

The Forest and Man, ed. Orazio Cianio, Florence: Accademia Italia di Scienze Forestali, 1997.

The Letters of Vincent van Gogh, ed. Ronald de Leeuw, Allen Lane, London: Penguin Press, 1996.

The Pre-Raphaelites, London: Tate Gallery Publishing/Penguin Books, 1984.

10 Hidden Pearls

Bethge, Eberhard, *Dietrich Bonhoeffer, an Illustrated Biography*, London: Fount, 1979.

John Paul II, Pope, *Crossing the Threshold of Hope*, London: Jonathan Cape, 1994.

Kinmouth, Patrick, *Craigie Aitchison*, Albemarle Gallery, 1987.

Laing, Jane, *Cicely Mary Barker and her Art*, Frederick Warne, 1995.

Martin, Rupert, *Roger Wagner's Visionary Landscapes*, Image, 1995.

LIST OF ILLUSTRATIONS

Rembrandt van Rijn (1606–69), *Simeon and the Child Jesus in the Temple*, NATIONALMUSEUM, Stockholm, p. 163.

9 After the Age of Reason

Caspar David Friedrich (1774–1840), *The Cross in the Mountains*, 1808, Gemäldegalerie, Dresden: Bridgeman Art Library, London/New York, p. 166.

Caspar David Friedrich (1774–1840), *Winter Landscape*, Berlin-National Museum, Schwerin. Photo: AKG London, p. 168.

Caspar David Friedrich (1774–1840), *Winter Landscape*, © The National Gallery, London, p. 169.

John Martin (1789–1854), *The Great Day of his Wrath*, © Tate Gallery, London, 1999, p. 170.

Dante Gabriel Rossetti (1828–82), *Ecce Ancilla Domini*, © Tate Gallery, London, 1999, p. 172.

John Everett Millais (1829–96), *Christ in the House of his Parents* or *The Carpenter's Shop*, © Tate Gallery, London, 1999, pp. 174–75.

William Holman-Hunt (1827–1910), *The Light of the World*, Keble College, Oxford: SuperStock, p. 176 (also on p. 4).

Jean-François Millet (1814–75), *The Gleaners*, Musée du Louvre, Paris: Giraudon/SuperStock, p. 178.

Vincent van Gogh (1853–90), *A Wheatfield, with Cypresses*, © The National Gallery, London, pp. 180–81.

Vincent van Gogh (1853–90), *Lilac Bush*, 1889, (oil on canvas), Hermitage Museum, St Petersburg: Bridgeman Art Library, London/New York, p. 182.

10 Hidden Pearls

John Singer Sargent (1856–1952), *Gassed*, Imperial War Museum, London, pp. 186–87.

Stanley Spencer (1891–1959), *The Resurrection of the Soldiers*, Sandham Memorial Chapel, Burghclere, © 1999 Estate of Sir Stanley Spencer. All rights reserved, DACS. National Trust Photographic Library/A.C. Cooper, p. 189.

Stanley Spencer (1891–1959), *The Resurrection, Cookham*, © Tate Gallery, London, 1999, p. 191.

Cicely Mary Barker (1895–1973), *The Parable of the Great Supper*, St George's Church, Waddon, nr Croydon, copyright © 1995 The Estate of Cicely Mary Barker. Reproduced by kind permission of Frederick Warne and Co. Photo: Lion Publishing/Michael Kay, pp. 192–93.

Henry Moore (1898–1986), *Madonna and Child*, St Matthew's Church, Northampton, reproduced by permission of the Henry Moore Foundation, p. 195.

Graham Sutherland (1903–80), *The Crucifixion*, St Matthew's Church, Northampton: Bridgeman Art Library, London/New York, p. 196.

Jacek Waltos (b.1938), *On Both Sides of the Gate: The Gdansk August Sunday 1980*, National Museum, Wroclaw, p. 199.

Leszek Sobocki (b.1934), *The Pole*, National Museum, Cracow, p. 200.

Roger Wagner (b.1957), *The Harvest is the End of the World, and the Reapers are Angels* (oil on canvas, 1989), Anthony Mould, London, p. 203.

Craigie Aitchison (b.1926), *Calvary*, Chapel of St Margaret, Truro Cathedral, Truro, pp. 204–5.

INDEX